THE LAW
(in Plain English)®
FOR
Photographers

Leonard D. DuBoff and Christy O. King

ALLWORTH PRESS
NEW YORK

It is possible that writings in this publication present information that may enable you to avoid legal problems. However, none of the information in this publication should be construed to be an opinion or solution to a specific legal problem or particular configuration of facts. Readers are urged to consult with an attorney when confronted with a legal question or issue.

14 13 12 11 10 7 6 5 4 3

Published by Allworth Press
An imprint of Allworth Communications
10 East 23rd Street, New York, NY 10010

Cover design by Mary Belibasakis

Interior design by Mary Belibasakis

Page composition/typography by Integra Software Services, Pvt., Ltd., Pondicherry, India

ISBN: 978-1-58115-712-3

Library of Congress Cataloging-in-Publication Data:
DuBoff, Leonard D.
 The law (in plain English)(r) for photographers / Leonard D. DuBoff and Christy O. King. — 3rd ed.
 p. cm.
Includes bibliographical references and index.
ISBN 978-1-58115-712-3 (pbk. : alk. paper)
1. Photography—Law and legislation—United State.
2. Photographers—United States—Handbooks, manuals, etc. I. King, Christy O., 1969- II. Title.
 KF2042.P45D75 2010
 343.73'07877—dc22 2010000542

Printed in the United States of America

Foreword

Copyright protection is very important to photographers; however, copyright law is complicated and perceived by many as difficult to comprehend. Leonard DuBoff and his coauthor, Christy King, however, demystify it, along with many other essential topics. Photographers, lawyers, and the public are the beneficiaries. DuBoff and King explain the basics of the copyright law: what it is; who it protects; who is considered the author and owner of a photograph, with an explanation of work made for hire; what rights are granted to authors, and what limitations are placed on those rights, for example, fair use and library exceptions; and how long copyright protection lasts.

Additionally, they cover copyright law from the business point of view, explaining the effect of transfers of copyright ownership (along with the legal requirements) and the termination provisions concerning termination of assignments and exclusive licenses made by photographers. Significant court decisions, including recent opinions, are included with explanations that everyone can understand.

On the practical side, they include information about the benefits of registration of copyright claims with the United States Copyright Office (*www.copyright.gov*), as well as practical advice on how to apply for registration. They describe what constitutes infringement of a photographer's copyright and spell out the available remedies, including an explanation of actual and statutory damages. Criminal enforcement, that is, prosecution by the United States government, is also covered.

The Law (in Plain English)® *for Photographers* contains much more than information on copyright, the subject that I am most familiar with, for example, trademark law, the law of defamation and libel, the rights of privacy, and publicity. Many important business topics, such as organization, tax consequences, and insurance, are laid out. This book includes not only the law, but also practical advice and timely observations. DuBoff is a well-respected expert. Photographers, and those who deal with them or care about them, will value and appreciate this book.

Marybeth Peters
Register of Copyrights
U.S. Copyright Office
Library of Congress

Acknowledgments

The process of surveying photography professionals, collecting relevant material, processing it, analyzing it, and putting it in an understandable, useful form could not have been completed without the help of a number of friends, colleagues and associates. Their contributions to this book are truly appreciated and worthy of note. Unfortunately, it is not possible to identify all of the individuals who have contributed in some way to this volume, and we apologize to those who have been inadvertently omitted from this list of people who have aided in preparing this edition of *The Law (In Plain English)® for Photographers*.

We are deeply indebted to the following individuals for their help with this edition. Timothy J. Arkwright, J.D., Thomas M. Cooley Law School, 2009; and Paul T. Mayo, J.D., associate with the DuBoff Law Group, were extremely helpful in updating statutes and case law. Peggy M. Reckow, a legal assistant with this firm, skillfully converted our comments and interlineations into a cohesive manuscript and researched books and resources for the appendix. Grace E. Fross, a corporate paralegal with this firm, assisted with editing of the manuscript. Robert Courtney DuBoff helped update the appendix on organizations, and Colleen Rose DuBoff, a fine arts and graphic design major at Portland State University, offered her input and recommendations.

We also appreciate the time and effort of CPAs Thomas Napier, Mary Culshaw, and Thomas Jablonowski of Napier and Company of Portland, Oregon. Their skilled analysis of the tax material in this book and their thoughtful recommendations add a great deal to the quality of this work.

We would also like to thank the world-class photographers who were kind enough to review the manuscript and provide comments, recommendations, and the very flattering statements that appear on the work or have been used in connection with it. Victor Perlman, General Counsel of ASMP, was also kind enough to review this material and provide his favorable comments as well. We are also extremely honored that the Honorable Marybeth Peters, U.S. Register of Copyrights, was generous enough to take time out of her extraordinarily demanding schedule to review the manuscript for this volume and provide the foreword to this edition.

On behalf of Team DuBoff and the others whose handiwork contributed to this third edition, we hope you enjoy and benefit from this book.

Introduction

For years, I had been asked by the many photographers I represented to provide them with the title of a text that could help them understand the myriad legal issues present in the world of photography. At that time, I was unable to locate such a book, and therefore, I wrote this text. It was my hope that this fifth book in my *In Plain English*® series would fill the void.

As a law professor for almost a quarter of a century, I realized the benefit in preproblem counseling, and, therefore, much of the material in this volume is intended to enlighten photographers so that legal problems can be avoided. Unfortunately, even the most prudent individual may become entangled in the web of complex legal issues, and a good deal of attention has been devoted to this possibility as well.

There is no substitute for the skills of an experienced and knowledgeable attorney. This book is not intended to replace your lawyer. Rather, it is hoped that with the information contained in these pages, you will be in a better position to communicate with your attorney in order to maximize the benefits you can expect from effective representation.

Throughout the years, since long before the first edition of this book was published in 1995, I have been actively involved in photography law. Through feedback from clients and colleagues and through independent research, I have continued to update and revise this book so that it can remain current and relevant.

When it became clear that there had been significant changes in the law since the last edition of this book, I enlisted the aid of Christy King, an attorney I first met in the classroom and with whom I later had the privilege of associating with in my law firm, to assist with this update. We have devoted a great deal of time and energy in updating and reworking the material that now appears in this edition of *The Law (In Plain English)*® *for Photographers.*

I am also indebted to my wife, Mary Ann Crawford DuBoff, my partner in law and in life, for everything she does and for her aid in preparing this work for publication. It is impossible to list all of the work Mary Ann has undertaken in connection with this book, my other writings, and my work in general.

It is my hope that this, the third edition of *The Law (In Plain English)*® *for Photographers,* will continue to serve the needs of the photography community and provide you with a readable text covering the many legal issues you encounter in your chosen profession.

-1-
Intellectual Property

The professional photographer is hardly likely to have an in-house lawyer. So, in addition to becoming skilled at your work and getting word out to the rest of the world about your skills, you need to be aware of the potential legal problems that may be lurking in your business dealings. Once you are armed with the knowledge of what to look for, you can usually avoid potentially serious headaches.

Copyright Law

Copyright protection is a good topic for starting this book, because it is a subject about which most photographers have many questions. While it is always recommended that an attorney be retained to assist with copyright issues, this chapter will aid you in effectively working with your lawyer.

Copyright law in the United States has its foundations in the Constitution, which, in Article I, Section 8, provides that Congress shall have the power "To promote the Progress of Science and the useful Arts, by securing for limited Times to Authors and Inventors the exclusive Right to their respective Writings and Discoveries." The First Congress exercised this power and enacted a copyright law, which has been periodically revised by later Congresses.

The Copyright Act expressly provides for the registration of photographs. Furthermore, courts have held that photography is eligible for copyright protection because photography is a form of creative expression and each photograph involves artistic choices. According to the United States Supreme Court, a

photograph "must be deemed a work of art and its maker an author, inventor, or designer of it, within the meaning and protection of the copyright statute."

The Copyright Act of 1909 remained in effect for nearly three quarters of a century despite periodic complaints that it no longer reflected contemporary technology. At the time the 1909 Act was passed, the printing press was still the primary means of disseminating information, but new technology, such as improved printing processes, radio, television, videotape, computer software, and microfilm, created the need for a revision that would provide specific statutory copyright protection for newer information systems.

The 1909 Act was substantially revised in 1976. The Copyright Revision Act of 1976 became effective on January 1, 1978, and covers works created or published on or after that date. The creation of copyright in all works published prior to January 1, 1978, is governed by the 1909 Act. Rights other than creation, such as duration of copyright, infringement penalties, and infringement remedies, are governed by the revised law. It is important to be aware of the basic differences in the two laws and which law applies to a given work.

In 1988, Congress once again amended the statute so that the United States could become a party to an international copyright treaty known as the Berne Convention.

Federal Preemption of State Copyright Law

One of the problems with the 1909 Act was that it was not the exclusive source of copyright law. Copyright protection (or its equivalent) was also provided by common law (that body of law developed by the courts independent of statutes), as well as by various state laws. This caused considerable confusion since securing copyright protection or avoiding copyright infringement required careful examination of a smorgasbord of different laws.

The 1976 Act largely resolved this problem by preempting and nullifying all other copyright laws. In other words, it is now the only legislation generally governing copyright protection.

What Is Copyright?

A copyright is actually a collection of five exclusive, intangible rights. These are:

1. The right to reproduce the work

2. The right to prepare derivative works

3. The right of distribution

4. The right to perform the work

5. The right to display the work

The first right allows the owner to reproduce the work by any means. The scope of this right can be hard to define, especially when it involves photocopying,

microfiche, videotape, and the like. Under the Copyright Act of 1976, others may reproduce protected works only if such reproduction involves either a *fair use* or an *exempted use* as defined by the Act, which will be discussed later in this chapter.

Second is the right to prepare derivative works based on the copyrighted work. A derivative work is one that transforms or adapts the subject matter of one or more preexisting works. Thus, derivative works of a photograph might include use in a composite and adaptations into another medium, such as television, film, or a painting.

Third is the right to distribute copies to the public for sale or lease. However, once a photographer sells a print, the right to control the further distribution of that very print is usually ended. This rule, known as the *first-sale doctrine*, does not apply if the work is merely in the possession of someone else temporarily, such as by bailment, rental, lease, or loan. *Bailment* is the legal term for temporary possession of someone else's property. That is, the *bailee*, or person holding the property, is deemed entitled to possess or hold that property, which actually belongs to someone else, known as the *bailor*. Leaving a camera with the repair shop establishes a bailment; so does leaving your photograph with a lab for purposes of it having it enlarged. In the latter instance, the copyright owner retains the right to control the further sale or other disposition of the photograph. If the copyright owner has a contract with the purchaser that restricts the purchaser's freedom to dispose of the work, and if the purchaser exceeds those restrictions, there may be liability. In this situation, the copyright owner's remedy will be governed by contract law rather than by copyright law.

You should distinguish between the sale of a print and the sale of the copyright in that print. If nothing is said about the copyright when the print is sold, you will retain the copyright. Since purchasers may not be aware of this, you may wish to call it to their attention either in the sales memorandum or on the back of the photograph.

Fourth is the right to perform the work publicly—for example, in the case of an audio/visual work, to broadcast a film on television, show it in a theater, or stream it on the Web.

Fifth is the right to display the work publicly. Once the copyright owner has sold a copy of the photograph, however, the owner of the copy has the right to display that copy.

Who Owns the Copyright?

The general rule regarding ownership of copyright is that the creator of an image—the photographer—is the owner of the copyright in it. Under the old copyright law, when a photograph was sold, ownership of a common law copyright was presumed to pass to the purchaser of that tangible photograph unless the photographer explicitly provided otherwise in a written agreement. In other words, there was a presumption in the law that a sale included not only the

photograph itself, but also all rights in that work. Before the Copyright Act of 1976, the customer owned the negative, all prints, and all use rights in a photograph unless the parties contractually agreed otherwise, and the photographer would be unable to print additional copies of a photograph, even if he or she retained possession of the negative. Thus, unless otherwise specified, the customer owned the negative, the right to sell or license the use of the negative, and the right to use the image commercially.

The Copyright Act of 1976 reverses the presumption that the sale of a photograph carries the copyright with it. Since January 1, 1978, unless there is a written agreement that transfers the copyright to the customer, the photographer retains the copyright, and the customer obtains only the tangible item and any rights expressly granted by the photographer. Notwithstanding this fact, the photographer may still not be able to reproduce the work for commercial purposes without the consent of the person photographed because of publicity or privacy laws (see chapter 3).

Joint Works. The creators of a joint work are co-owners of the copyright in the work. A joint work is a work prepared by two or more people "with the intention that their contributions be merged into inseparable or interdependent parts of a unitary whole." Theatrical works, for example, are generally considered joint works under the Act: co-authored by the script writer, composer, lyricist, set designer, choreographer, director, and others who contribute their talent to the final production. The owners of the copyrights in a theatrical work may vary according to the contracts between the producer and the individual authors who contribute to the work.

Whatever profit one creator makes from use of the work must be shared equally with the others unless they have a written agreement that states otherwise. If there is no intention to create a unitary, or indivisible, work, each creator may own the copyright to that creator's individual contribution. For example, one creator may own the rights to written material and another the rights in the illustrative photographs.

Works Made for Hire. Works considered to be works made for hire are an important exception to the general rule that a photographer owns the copyright in an image he or she has created. If a photograph was taken by an employee in the scope of employment, the law considers the picture to be a work made for hire, and the employer will own the copyright. The parties involved may avoid application of this rule in some circumstances, however, if they draft their contract carefully. If the employment contract itself provides, for example, that creating the copyrightable material in question is not part of the "scope of employment," the employee will likely be considered the owner of the copyright and the work-made-for-hire doctrine will not apply, e.g., if a fashion photographer working for a fashion magazine takes pictures on his or her own time of an accident scene. Another method of achieving this same result is for the employee to have the copyright in the work expressly assigned back to him or her by the employer.

If the photographer is an independent contractor, the photographs will be considered works made for hire only if:

- The parties have signed a written agreement to that effect, and
- The work is specially ordered or commissioned as a contribution to a collective work, as part of a motion picture or other audiovisual work, as a supplementary work, as a compilation, as a translation, as an instructional text, as answer material for a test, or as an atlas

Thus, if there is no contractual agreement to the contrary, the photographer who is an independent contractor will own the copyright in these works.

In *Community for Creative Non-violence v. Reid* (1989), the court made it clear that a determination of the status of the person creating the work as either an employee or independent contractor must be made by considering the following factors:

- The hiring party's right to control the manner and means by which the product is accomplished
- The skill required
- The source of the instrumentalities and tools
- The location of the work
- The duration of the relationship between the parties
- Whether the hiring party has the right to assign additional projects to the hired party
- The extent of the hired party's discretion over when and how long to work
- The method of payment
- The hired party's role in hiring and paying assistants
- Whether the work is part of the regular business of the hiring party
- Whether the hiring party is in business
- The provision of employee benefits
- The tax treatment of the hired party

In 1991, in a case entitled *Marco v. Accent Publishing Co.*, the United States Court of Appeals for the Third Circuit held that a freelance photographer working for a client on a commission basis could not be considered the client's employee but, rather, was an independent contractor. As such, the photographer retained the copyright in his images. The court, in agreeing with the American Society of Media Photographers (ASMP), which had filed an amicus brief for the purpose of informing the court about its position, held that almost every aspect of the photographer's relationship with the client supported this conclusion: the photographer used his own equipment, worked at his own studio, paid his own

overhead, kept his own hours, paid his own taxes, received no employee benefits, and was a skilled worker.

Transferring or Licensing the Copyright. A copyright owner may sell the entire copyright or any part of it. In accomplishing this, there must be a written document, signed by the copyright owner or the owner's duly authorized agent, that describes the rights conveyed. Only a nonexclusive license authorizing a particular use of a work can be granted orally, but it will be revocable at the will of the copyright owner. All other licensing arrangements must be in writing. The scope of rights granted should be made clear. For instance, is the purchaser of a license permitted only a one-time use or multiple uses? By specifying the exact uses conveyed, a battle over rights often can be avoided. (For a discussion on licensing photographs, see chapter 12.)

It is not uncommon for a photographer to become the assignee or licensee of another person's copyright. This could happen, say, when a photographer wishes to incorporate another person's illustrations, photographs, recordings, writings, or other work into the photographer's work. In this case, the photographer will often enter into a licensing agreement or assignment of ownership with the other person.

Both an assignment of ownership and a licensing agreement can, and should, be recorded with the Copyright Office. The rights of the assignee or licensee are protected by recording an assignment in much the same way as the rights of an owner of real estate are protected by recording a real property deed with the county clerk's office. In a case of conflicting transfers of rights, if two or more transactions are recorded within one month of the execution, the person whose transaction was signed first will prevail. If the transactions are not recorded within one month, the one who records first will prevail. In some circumstances, a nonexclusive license will prevail over any unrecorded transfer of ownership. The cost to record a transfer is only $105 for the first title, plus $30 for each group of ten titles after the first, and is tax deductible if it is a business expense.

One section of the 1976 Copyright Act pertains to the involuntary transfer of a copyright. This section, which states that such a transfer will be held invalid, was included primarily because of problems arising from U.S. recognition of foreign copyrights. For example, if a country did not want a photographer's controversial work to be published, it could claim to be the copyright owner and, thereby, refuse to license foreign publications. Under the Act, the foreign government must produce a signed record of the transfer before its ownership will be recognized. This section of the Act does not apply to a transfer by the courts in a bankruptcy proceeding or a foreclosure of a mortgage secured by a copyright.

Termination of Copyright Transfers and Licenses. It is not unusual for a photographer confronted with an unequal bargaining position vis-à-vis an advertising agency

to transfer all rights in the copyright to the agency for a pittance, only to see the work become valuable at a later date. The 1976 Copyright Act, in response to this kind of apparent injustice, provides that after a certain period has lapsed, the photographer or certain other parties identified in the law may terminate the transfer of the copyright and reclaim the rights. Thus, the photographer is granted a second chance to exploit a work after the original transfer of copyright. This right to terminate a transfer is called a *termination interest*.

In most cases, the termination interest will belong to the photographer, but if the photographer is no longer alive and is survived by a spouse but no children, the surviving spouse owns the termination interest. If the deceased photographer is not survived by a spouse, ownership of the interest belongs to any surviving children in equal shares. If the decedent is survived by both spouse and children, the interest is divided so that the spouse receives 50 percent and the children receive the remaining 50 percent in equal proportions.

Where the termination interest is owned by more than one party, be they other photographers or a photographer's survivors, a majority of the owners must agree to terminate the transfer. Under the current law, the general rule is that termination may be effected at any time within a five-year period beginning at the end of the thirty-fifth year from the date on which the rights were transferred. If, however, the transfer included the right of publication, termination may go into effect at any time within a five-year period beginning at the end of thirty-five years from the date of publication or forty years from the date of transfer, whichever is shorter.

The party wishing to terminate the transferred interest must first serve written notice on the transferee, stating the intended termination date. This notice must be served not less than two and no more than ten years prior to the stated termination date. Also, a copy of the notice must be recorded in the Copyright Office before the effective date of termination.

What Can Be Copyrighted?

The Constitution authorizes Congress to provide protection for a limited time to "authors" for their "writings." An *author*, from the point of view of copyright law, is either the creator—be it a photographer, sculptor, or writer—or the employer in a work-made-for-hire situation. There have been debates over what constitutes a *writing*, but it is now clear that this term includes photographic images. Congress avoided use of the word "writings" in describing the scope of copyright protection. Instead, it grants copyright protection to "original works of authorship fixed in any tangible medium of expression." Legislative comments on this section of the Act suggest that Congress chose to use this wording rather than "writings" in order to have more leeway to legislate in the copyright field.

Within these broad limits, the medium in which a work is executed does not affect its copyrightability. Section 102 contains a list of copyrightable subject matter, which includes:

- Literary works
- Musical works, including any accompanying words
- Dramatic works, including any accompanying music
- Pantomimes and choreographic works
- Pictorial, graphic, and sculptural works
- Motion pictures and other audiovisual works
- Sound recordings
- Architectural works

This list is not intended to be exhaustive, and courts are free to recognize as protectable types of works not expressly included in the list.

The 1976 Act expressly exempts from copyright protection "any idea, procedure, process, system, method of operation, concept, principle, or discovery." In short, a copyright extends only to the expression of creations of the mind, not to the *ideas* themselves. Frequently, there is no clear line of division between an idea and its expression, a problem that will be considered in greater detail in the Copyright Infringement and Remedies section of this chapter. For now, it is sufficient to note that a pure idea, such as a plan to photograph something in a certain manner, cannot be copyrighted—no matter how original or creative it is.

The law and the courts generally avoid using copyright law to arbitrate the public's taste. Thus, a work is not denied a copyright even if it makes no pretense to aesthetic or academic merit. The only requirements are that a work be original and show some creativity. Originality—as distinguished from uniqueness—requires that a photograph be taken independently but does not require that it be the only one of its kind. In other words, a photograph of underwater algae in the Antarctic is copyrightable for its creative aspects; the unusual, hard-to-shoot subject matter is irrelevant.

Nonetheless, in *Ets-Hokin v. Skyy Spirits*, the district court held that photographs of a vodka bottle were not entitled to copyright protection since, said the court, the photograph was merely a derivative work of a vodka bottle, which did not display sufficient variation from the bottle itself to be copyrightable. However, on appeal, the United States Court of Appeals for the Ninth Circuit disagreed, pointing out that photography generally contains sufficient creative choices so as to enjoy copyright protection. This is particularly true in the context of commercial photography where lighting, layout, and overall subject matter are evaluated and the photographer's artistic plan is implemented. The appellate court also held

that the photographs were not derivative works because the underlying work, the vodka bottle, was a "useful article" and thus not copyrightable.

Approximately a month after the Ninth Circuit decision was announced, the United States District Court for the Southern District of New York was presented with a similar situation. In *SHL Imaging, Inc. v. Artisan House, Inc.*, the court was presented with a dispute involving photographer Stephen Lindner, who had been hired to photograph Artisan's mirrored picture frames. The photographer alleged that he retained all rights and had merely licensed Artisan the right to reproduce a limited number of photographs for use by salespersons, but Artisan had used the photographs in thousands of brochures, catalogs, and the like. Lindner filed a lawsuit for copyright infringement, and Artisan argued that the photographs were not entitled to copyright protection since they were merely derivatives of the uncopyrightable frames.

The court disagreed, holding that the photographs were not *derivative works*, as that term is used in the statute. All photographs, said the court, merely depict their subject matter, not "recast, transform, or adopt" preexisting works. It is clear, said the judge, that the authorship of a photographic work is entirely different and separate from the authorship of the underlying work. Thus, the New York court held that photographs, even of functional works, are entitled to copyright protection. The court described only two situations in which a photograph could be a derivative work:

1. A cropped photograph of an earlier photograph
2. Reshooting an earlier photograph with some alteration of the expressive elements

On the other hand, in *Schrock v. Learning Curve International, Inc.*, an Illinois federal court held that marketing photographs of a defendant's Thomas the Tank Engine toys were derivative works because they "recast, transform[ed] or adapt[ed]" the toys into another medium.

Unfortunately, the introduction of new technologies can bring about complications. For example, a 2008 case, *Meshwerks, Inc. v. Toyota Motor Sales U.S.A., Inc.*, involved creation of digital 3D models of Toyota vehicles to be used on Toyota's Web site. Meshwerks created the computer-generated digital models in part using measurements from the vehicles. The court held that because Meshwerks did not make decisions regarding lighting, shading, background, etc., and because Meshwerks' purpose was to depict "the car as car," Meshwerks had no copyright in its models, as Meshwerks contributed no original expression.

Obscenity. In the past, the Copyright Office occasionally denied protection to works considered immoral or obscene, even though it had no express authority for doing so. Today, this practice has changed. The Copyright Office will not attempt to decide whether a work is obscene, and copyright registration will not

be refused because of the questionable character of any work. (For a discussion on censorship and obscenity, see chapter 4.)

Titles. Photographers should be aware that not everything in a copyrighted work is protected. For example, the title of a photograph cannot be copyrighted. It is protectable, if at all, as a trademark.

Notice. Under the 1909 Act, most photographs that qualified for copyright had to be published with the proper notice attached in order to get statutory protection. The 1976 Act dramatically changed the law in this respect. A photographer's images are now automatically copyrighted once they are "fixed in a tangible medium of expression." The photographer's product is considered to have been "fixed in a tangible medium of expression" as soon as he or she clicks the shutter. The photograph need not be developed or printed to be protected. However, after the 1976 Act and prior to the 1988 amendment (effective March 1, 1989), a copyright could be lost if a photograph were published without the proper notice, unless the "savings clause" from Section 405 of the Act applied to save the copyright. This section of the law allowed a copyright that would otherwise be lost due to publication without notice to be "saved" in certain circumstances.

Public Domain. Once the copyright on a work has expired, or been lost, the work enters the public domain, where it can be exploited by anyone in any manner. A photographer may, however, have a copyright on a work that is derived from a work in the public domain if a distinguishable variation is created. This means, for example, that Rembrandt's *Night Watch* cannot be copyrighted, but a photograph of it may so long as the photographer somehow transforms the work. As a result, no one would be able to reproduce the photograph, whereas anyone can copy Rembrandt's original. Other examples include collages, photographs of photographs, and film versions. If the copy was identical in all particulars so as to be indistinguishable from the original and the copying involved no creativity or originality, it would not be copyrightable.

Compilations. Compilations, such as magazines, are copyrightable as a whole, as long as the preexisting materials are gathered and arranged in a new or original form, even though individual contributions or photographs are individually copyrighted.

Publication

In copyright law, the concept of *publication* is different from what a layperson might expect it to be. Publication, according to the 1976 Act, is the distribution of copies of a work to the public by sale or other transfer of ownership or by rental, lease, or loan. Thus, a public performance or display of a work does not of itself constitute publication; and, under the doctrine of limited publication, which was part of the 1909 Act, publication would not be deemed to have occurred when a

photographer displayed a work only "to a definitely selected group and for a limited purpose, without the right of diffusion, reproduction, distribution or sale."

When a photographer showed copies of a picture to close friends or associates with the understanding that such copies would not be further reproduced and distributed, the photographer had not published the pictures. Nor did the distribution of pictures to agents or customers for purposes of review and criticism constitute a publication. Thus, according to the Supreme Court in *American Tobacco Co. v. Werckmeister*, even an exhibition in a gallery or museum did not constitute publication if copying or photographing the work was prohibited.

The Revised Act of 1976 makes no specific reference to this doctrine of limited publication. The statutory definition of publication does, however, require a "distribution of copies or phonorecords of a work to the public." Moreover, a congressional report on the Revised Act states that "the public" in this context refers to people who are under no explicit or implicit restrictions with respect to disclosure of the work's contents. This appears to suggest a continuation of the 1909 doctrine of limited publication under the current Act. As will be seen later, publication is important since it identifies the point when proper use of the copyright notice, discussed later in this chapter, will defeat certain defenses that may be raised to excuse an unauthorized use of a copyrighted work. It also determines copyright duration in some instances.

Duration of Copyright

The duration of copyright depends upon when and how the work was created. In general, if the author is an individual, works created on or after January 1, 1978, will have copyright protection from the instant of creation until 70 years after the author's death. The same term applies for works created before 1978 but not published or registered before then. For works created jointly, the period is measured by the life of the last surviving author plus 70 years. The copyright in works made for hire and for anonymous or pseudonymous works lasts 95 years from the year of first publication or 120 years from the year of the work's creation, whichever period expires first. Unlike the 1909 Act, the 1976 Act requires no renewal. Renewal of copyrights in works first published prior to January 1, 1978, however, was required in the 28th year after first publication until a law providing for the automatic renewal of such works was enacted in June 1992.

Copyright Notice

Works published under the 1909 Act had to contain the proper notice in order to be copyrighted. With few exceptions, any omission, misplacement, or imperfection in the notice on any copy of a work distributed by authority of the copyright owner placed the work forever in the public domain. Thus, it was important for a copyright owner signing a contract to make sure that the grant of a license

to publish be conditioned on the publisher's inclusion of the proper copyright notice. That way, if the publisher made a mistake in the notice, the publication might be deemed unauthorized, and the copyright would not be affected. In addition, the publisher could be liable to the copyright owner for the loss of copyright if it did occur.

Even though the 1976 Act allowed the photographer to save the copyright on works published without notice and the 1989 revision does not require notice, someone who copies a work believing it in the public domain because there is no notice may be considered an *innocent infringer*. In this situation, the photographer whose work was copied may be unable to recover damages. In fact, with respect to statutory damages, while the minimum award is usually $750, the court may reduce the award to as low as $200 in a case of innocent infringement. The court might even allow the copier to continue using the work. The 1989 amendment provides that if the notice is used, then there is a presumption that an infringer cannot be innocent.

Location of Copyright Notice. The 1909 Act contained complicated rules for the proper placement of the copyright notice within the work. Improper placement was one more error that was fatal to the copyright. Since March 1, 1989, a copyright notice is no longer required to be affixed to a work; nevertheless, it is a good idea to use the notice since it will make others aware of your rights, and use of the notice will prevent anyone from claiming that copying the work was innocent. Although it is customary to place a notice at the bottom of a work, you may now place the notice anywhere, so long as it is on or immediately adjacent to your photograph.

Wording of a Copyright Notice. Even though it is no longer necessary to place a notice on your work, it still should be used whenever possible. A copyright notice has three elements:

- First, there must be the word "copyright," the abbreviation "copr.," or the letter "c" in a circle —©. No variations are permitted.

- Second is the year of first publication (or, in the case of unpublished works governed by the 1909 Act, the year in which the copyright was registered). This date may be expressed in Arabic or Roman numerals or in words.

- The third necessary element is the name of the copyright owner. If there are several, one name is sufficient. Usually the author's full name is used, but if the author is well known by a last name, the last name can be used alone or with initials. The same is true if the author is known by initials alone. A business that owns a copyright may use its trade name if the name is legally recognized in its state.

Thus, an example of a proper copyright notice is:

© [copyright owner's name] [year the work was first published]

Errors in or Omission of a Copyright Notice. Failure to give copyright notice or publishing an erroneous notice had very serious consequences under the old law. Under the 1909 Act, the copyright was lost if the wrong name appeared in the notice. If the creator sold the copyright and recorded the sale, either the creator's or the new owner's name could be used, but if the sale was not recorded with the Copyright Office, use of the subsequent owner's name in the notice destroyed the copyright.

Under current law, a mistake in the name appearing in the notice is not fatal to the copyright. However, an infringer who was honestly misled by the incorrect name could use this as a defense to a lawsuit for copyright infringement if the proper name was not on record with the Copyright Office. This is obviously another incentive for registering a sale or license of a copyright with the Copyright Office.

Under the 1909 Act, a mistake in the year of the first publication could also have had serious consequences. If a date earlier than the actual date was used, the copyright term would be measured from that year, thereby decreasing the duration of protection. If a later date was used, the copyright was forfeited and the work entered the public domain, but because of the harsh consequences of losing a copyright, a mistake of one year was not penalized.

Under the current law, using an earlier date will not be of any consequence when the duration of the copyright is determined by the author's life. When the duration of the copyright is determined by the date of first publication, as in the case of a composite work or work made for hire, the earlier date will be used to measure how long the copyright will last. If a later year is used, the work is considered to have been published without notice.

If a work was published between January 1, 1978, and March 1, 1989, without notice, the copyright owner was still protected for five years. If, during those five years, the owner registered the copyright with the Copyright Office and made a reasonable effort to place a notice on copies of the photograph that were initially published without notice and distributed within the United States, full copyright protection was granted for the appropriate duration of the published work.

A copyright owner is forgiven for omitting the notice if the omission was in violation of a licensing contract containing a provision that gave the licensee the right to publish the work but required the proper notice to be included as a condition of publication. In other words, the copyright holder fulfilled his or her responsibility for notice by requiring the licensee to publish it, and the copyright owner will not be held responsible for the licensee's mistake. Also, if the notice was removed or obliterated by an unauthorized person, this will have no effect on the validity of the copyright.

Since the purpose of the notice is to inform members of the public that the copyright owner possesses the exclusive rights granted by the statute, it is logical that someone who infringes these rights could be consider "innocent" if the error was made because of the absence of the notice. Providing notice, though no longer required, helps prevent claims of *innocent infringement*, and, in some cases, the innocent infringer may be compelled to give up any profits made from the infringement. However, if the innocent infringer has made a sizable investment for future production, the court may compel the copyright owner to grant a license to such an infringer.

Deposit and Registration

While a copyright notice on a photograph tells viewers who holds the copyright, it does not constitute official notice to the U.S. government. Once a photograph has been published, you should deposit (that is, deliver) the work and submit an application for copyright registration with the U.S. Copyright Office.

Depositing a work and registering an application are two different acts. Neither is a prerequisite for creating a federal copyright. As a general rule, copyright protection is automatic when an original idea is "fixed in a tangible medium of expression." The obvious question, then, is why bother to deposit the work and file the application? As will be seen later, registration is required as a prerequisite to filing a lawsuit for a "U.S. work" and is also necessary in order for you to obtain certain remedies for infringement. A "U.S. work" is any work by a U.S. author, any work first published in the United States, or any foreign work published in the United States on the same day it was published in a foreign country. In addition, there is a statutory presumption that the copyright is valid if the work has been registered within five years of its first publication. If you do not register the copyright at the time you make the mandatory deposit, it will be necessary to deposit additional copies when you register the work.

Mandatory Deposit. Under the deposit provisions of the current law, the owner of the copyright or the owner of the exclusive right of publication must deposit with the Copyright Office for the use of the Library of Congress two copies of the "best edition" of the work within three months after the work has been published. The copies should be sent to the Library of Congress, Copyright Office, Attention: 407 Deposits, 101 Independence Avenue, S.E., Washington D.C. 20559-6600. For more information on deposits, visit the U.S. Copyright Office Web site (*www.loc.gov/copyright/title37/202/index.html*). This basic deposit requirement also applies to works published abroad when such works are either imported into the United States or become part of an American publication.

If the two copies are not deposited within the requisite three-month period, the Register of Copyrights may demand them. The Register of Copyrights is not omniscient, but the Copyright Office may know that a particular photograph

had been published because of other correspondence with a publisher. If you have published a photograph on your own and never corresponded with the Copyright Office, it is not likely that this demand will be made, and you will thus need to deposit the copies only in connection with an application for registration.

If the copies are not submitted within three months after demand, the person upon whom demand was made may be subject to a fine of up to $250 for each unsubmitted work. In addition, such person may be required to pay the Library of Congress an amount equal to the retail cost of the work or, if no retail cost has been established, reasonable costs incurred by the Library in acquiring the work. Finally, a copyright proprietor who willfully and repeatedly refuses to comply with a demand may be liable for an additional fine of $2,500.

Depositing copies is no longer a condition of copyright protection, but in light of the penalty provisions, it would indeed be foolish not to comply if asked.

Registration. The registration provisions of the 1976 Act require that the copyright proprietor complete an application form (available from the Library of Congress) and pay a registration fee. Filing may be done by mailing a traditional paper form, submitting an electronic application online, or by printing and mailing a "Form CO," which is filled out online and includes a bar code. The fee for filing of an electronic form is only $35; the filing fee for a Form CO is $50; and filing of a traditional paper form is $65. Forms and online filings are available on the U.S. Copyright Office Web site (*www.copyright.gov/forms*).

If you need to file an expedited registration, as is often done before bringing a lawsuit when the work has not already been registered, the fee to expedite (which is in addition to the registration fee) is $760. Because the time for processing a traditional paper application is now around eighteen months, and even an electronic application with an electronic deposit is likely to take about five months, expedited registrations are becoming more important. As a result of the significant delay in processing copyright applications, the Copyright Office has determined that the fee to expedite will not be charged when converting a pending application to expedited status where the application has been pending for more than six months and the applicant can show expedited handling is necessary in connection with an infringement suit. This rule is effective through July 1, 2011.

The copyright application is brief, but it is helpful to have an attorney teach you how to properly complete it. In addition, as noted above, the proprietor must deposit two copies of the "best edition" of the work to be registered (one copy if the photograph is unpublished). The media that will be accepted for copies now include multiple electronic formats. Because the list of acceptable formats is likely to change regularly as technology evolves, if you plan to submit the copies of your work in an electronic format, you should check the Copyright Office's Web site when you are ready to register your copyright.

The photographer must title each picture registered. If, however, you have many pictures to register, you can save time and money by registering and copyrighting them as a single group and titling the group, rather than titling each photograph individually. The title need not be impressive; it can be as simple as "2010 photographs." All works in such a group must be created in the same year by the same photographer and, if published, must have been published together. It is also essential that the images be clear and that the assemblage have a sufficiently orderly form and consistency of theme to bear a single title. The specific date of publication must be provided for each photograph. Such application must include no more than 50 continuation sheets identifying no more than 750 photographs.

Copyright Office regulations also allow bulk registration without a specific publication date, provided that all of the photographs in the group were first published within three months of the date that the application, fee, and deposit are received by the Copyright Office. In this event, a range of publication dates is provided by the photographer. Because internal rules of the Copyright Office are subject to change, a photographer should check with the Copyright Office regarding currently acceptable bulk registration practices. Bulk filings of published works may be subject to stricter requirements than bulk filings of unpublished works.

As an alternative to bulk filing in group form, the photographer could print many images on a single contact sheet and thus register the copyright in all of the photographs on the single sheet for the cost of only one registration. Again, each photograph need not be separately titled as long as the contact sheet includes an appropriate title.

Once a work has been registered as unpublished, it does not need to be registered again when published. Often, a photograph's first public appearance is as part of a copyrighted collective work, such as a book or magazine. If, as is usually the case, the author or publisher of the collective work and the photographer intend that the photographer will own the copyright in the photographs, the photographer can register the copyright directly. However, the photographer must file a copy of the entire collective work in which the photograph appears.

Also, a large collection of one photographer's contributions to various collective works can be registered under a single application if all of the work was published within a twelve-month period and a copy of each photograph, as it appeared in each collective work, is deposited with the application. In order to accomplish this type of bulk registration, the photographer must complete a form and then list each photograph separately on a "Form GR/CP."

There is an alternative method of protecting photographs that appear in separately copyrighted collective works, such as books or an agency's catalog. The publisher of the collective work and the photographer may choose to view the publisher as holding the copyright to the photographs, subject to a contractual

obligation to assign the copyright to the photographer. This assignment should then be executed in writing and filed with the Copyright Office. The advantage of using the assignment process to establish the photographer's copyright is that there is no need for the photographer to submit a copy of the collective work or photograph to the Copyright Office. This method presupposes that the collective work was deposited and registered by the publisher before the photographer registers the assignment.

You may plan to rely on the publisher's copyright registration of the collective work. Unfortunately, many cases have held that such a "compilation copyright" does not protect the individual works found in the compilation. See, for example, *Morris v. Business Concepts, Inc.*, which involved the registration of an issue of a magazine as a collective work. The court held that the registration protected only the magazine issue, not the individual or discrete works that made up the compilation, since the publisher did not own the copyright in the article at issue. Other cases, such as *Szabo v. Errisson*, determined that the compilation registration does register the items comprising the compilation, though in this case, the owner of the copyright in the original songs was the same as the owner of the copyright in the compilation. Copyright Office regulations require registration in the name of the copyright claimant on the date the application is submitted, and the claimant is defined as the author of the work or someone who has obtained all of the rights from the author. Thus, it is likely that most courts will follow the *Morris* case, and it would be safer for you to register your work yourself, unless you have assigned all of your rights to a publisher.

When your claim to copyright has been accepted by the Copyright Office, you will receive a certificate of registration, which will include the registration number as well as the effective date of the registration. The effective date of registration is when the form, fee, and deposit are received together at the Copyright Office.

It can take several months or more for you to receive the certificate, so you should consider sending the application either electronically or by certified mail/return-receipt requested so you will be sure your application reached the Copyright Office. There will probably be no accompanying information with the certificate. The certificate is an official document that should be stored in a safe place.

Again, although registration is not a condition to copyright protection, the 1976 Act specifies that the copyright owner cannot bring a lawsuit to enforce his or her copyright in a "U.S. work" until the copyright has been registered.

Additionally, if the copyright is registered after an infringement occurs, the owner's legal remedies will be limited. If the copyright was registered prior to the infringement, the owner may be entitled to more complete remedies, including attorneys' fees and statutory damages. No remedies will be lost if registration is made within three months of publication. Thus, the owner of a copyright has a

strong incentive to register the copyright at the earliest possible time and certainly within the three-month grace period.

Another reason to register a copyright promptly is that if registration is made within five years of publication or if the registration is of an unpublished work, the facts contained in the registration are presumed to be true. That is, unless the alleged infringer is able to present evidence that those facts are untrue, you will not have to present evidence of their accuracy.

Copyright Infringement and Remedies

A copyright infringement occurs any time an unauthorized person exercises any of the exclusive rights reserved to the copyright holder. The fact that the infringing party did not intend to infringe is relevant only with respect to the penalty. All actions for infringement of copyright must be brought in a federal court within three years of the date of the infringement. Since different jurisdictions calculate the time for this statute of limitations in different ways, you should promptly contact a copyright lawyer when you believe your work has been infringed. In order to establish that there has been an infringement, the copyright owner will need to prove that the work is copyrighted and registered, that the infringer had access to the copyrighted work, and that the infringer copied a "substantial and material" portion of the copyrighted work. In order to demonstrate the extent of the damage caused by the infringement, the copyright owner must also provide evidence that shows how widely the infringing copies were distributed.

The copyright owner must prove that the infringer had access to the protected work because an independent creation of an identical work is not an infringement. However, infringement can occur even if a work has not been copied in its entirety because any unauthorized copying of a substantial portion of a work constitutes an infringement.

Obviously, direct reproduction of a photograph without the copyright holder's permission constitutes infringement. In *Olan Mills, Inc. v. Linn Photo Co.*, Linn Photo was held to be infringing Olan Mills' photographs when it made reproductions of portraits without Olan Mills' consent. Less obviously, a drawing or painting based entirely on a copyrighted photograph can constitute an infringement if it is substantially similar. Also, a photographer might be guilty of infringement by the marketing of prints, postcards, posters, or the like featuring copyrighted images of another, such as paintings or sculptures. A photographer who copies a copyrighted photograph of another by shooting a substantially similar photograph is also guilty of infringing the copyright. Note that while the copyright statute prohibits others from making a substantial copy of a protected work, it does not define *substantial copy*.

In *Leigh v. Warner Bros., Inc.*, the U.S. Court of Appeals for the Eleventh Circuit was presented with a case involving Jack Leigh's shooting of a photograph of the Bird Girl sculpture that was used as the cover of the novel

Midnight in the Garden of Good and Evil. When Warner Brothers produced a movie based on the book, it used some of the same images of the sculpture both in the movie and in advertising for the movie. Warner Brothers shot its own images of the sculpture, and none of Leigh's images were actually used by the movie company.

The court pointed out that the photographer's copyright does not encompass the appearance of the sculpture itself. Nor did the photographer have any rights in the sculpture's setting. The court pointed out that Leigh's selection of lighting, shading, timing, angle, and film were protectable and should be considered, along with the overall combination of these elements and the mood they convey. The appellate court agreed with Warner Brothers that the images in the movie were not substantially similar to the photograph on the book cover, and thus no infringement occurred. When comparing the photographer's work to the motion picture company's still shots used in advertising materials, however, the court found that there were enough similarities between the protectable portions of the works so that the question of copyright protection should be considered at trial.

Photographers should be aware that in certain circumstances they may even be liable for infringing copyrights of pictures they shot themselves. In *Gross v. Seligman,* the court held that a photographer infringed the copyright owned by a publisher of a photograph the same photographer had taken earlier. When the photographer reshot the same model in a similar pose, infringement occurred. (The court noted that the later picture differed from the earlier one only in that the model was older and had more wrinkles.)

Similarity of ideas alone will be insufficient to establish infringement. If the expression of ideas (rather than simply the ideas alone) is found to be similar, the court must then decide whether the similarity is substantial. This is done in two steps. First, the court looks at the more general similarities of the works, such as subject matter, setting, materials used, and the like. Expert testimony may be offered here. The second step involves a so-called "subjective" judgment of the work's *intrinsic similarity;* that is, would a lay observer recognize that the defendant's work had been copied from the copyrighted work? No expert testimony is allowed in making this determination.

In *Kaplan v. Stock Market Photo Agency, Inc.,* the court held that the defendant's photograph of a businessman wearing wing tip shoes poised to jump from a tall building onto a car-lined street did not infringe the plaintiff's copyrighted photograph of the same scene because the similarities between the photographs involved elements not protected by copyright. That is, the only similarities arose from nonprotectable elements of the photographs. Similarly, the court held in *Bill Diodato Photography, LLC v. Kate Spade, LLC,* that a photograph showing the calves and feet of a female model, as well as fashionable shoes and a handbag, under a closed toilet stall door did not infringe a photograph with the same elements, since copyright does not protect general ideas.

A case in the late 1980s, *Horgan v. Macmillan, Inc.*, held that the substantial-similarity test applies even when the allegedly infringing material is in a different medium. This case involved *The Nutcracker* ballet choreographed by George Balanchine, whose estate receives royalties every time the ballet is performed. Macmillan prepared a book of photographs that included sixty color pictures of scenes from a performance of *The Nutcracker*. In determining whether this constituted infringement, the court of appeals noted that the correct test is whether "the ordinary observer, unless he set out to detect the disparities, would be disposed to overlook them, and regard their aesthetic appeal as the same." Furthermore, the court noted, "Even a small amount of the original, if it is qualitatively significant, may be sufficient to be an infringement, although the full original could not be recreated from the excerpt."

The First Circuit addressed an interesting infringement matter in *Bruce v. Weekly World News*. The photographer had taken a photograph of Bill Clinton shaking hands with a Secret Service agent. The *Weekly World News* modified the photograph, without consent, to superimpose the Space Alien popularized by the *Weekly World News* onto the image of the Secret Service agent. Ultimately, Bruce was paid for the use, but the *Weekly World News* then used the same image on T-shirts and in other issues of the tabloid without consent. Bruce sought $359,000 but was awarded only $25,642.42 for the infringing use. Because the images were not registered with the U.S. Copyright Office before the infringement took place (or within three months of first publication), he was not able to recoup his attorney fees.

In 1995, The American Society of Media Photographers, the Professional Photographers of America, Photo Marketing Association International, the Professional School Photographers Association International, and other organizations adopted guidelines which, among other things, are intended to reduce the unauthorized copying of professional photographs. Contact one of these associations for a copy of the guidelines (see appendix 3).

Unfortunately, these guidelines are of little help when it comes to digital photographs and, as a result, photography labs, on the lookout for copyright infringements, are refusing to print digital images that appear to have been shot by a professional—not on the basis of copyright notices, but on quality of the shot. Without appropriate guidelines, labs set their own standards, sometimes refusing to print the photographer's own images. Stories of amateur photographers who were told by labs that their photographs were "too good" to have been taken by anyone other than a professional abound.

Note that Section 113(c) of the Copyright Act provides that "[i]n the case of a work lawfully reproduced in useful articles that have been offered for sale or other distribution to the public, copyright does not include any right to prevent the making, distribution, or display of pictures or photographs of such articles in connection with advertisements or commentaries related to the distribution or

display of such articles, or in connection with news reports." This means that it is not an infringement to make or display photographs of useful items, such as a lamp or a bowl, in advertising or news reports.

Injunctive Relief. Even before trial, a copyright owner may be able to obtain a preliminary court order against an infringer. The copyright owner can petition the court to seize all copies of the alleged infringing work and the negatives that produced them. To do this, the copyright owner must file a sworn statement that the work is an infringement and provide a substantial bond, approved by the court, as well as establish that he or she is likely to succeed in the lawsuit. After the seizure, the alleged infringer has a chance to object to the amount or form of the bond.

After the trial, if the work is held to be an infringement, the court can order the destruction of all copies and negatives and prohibit future infringement. If the work is held not to be an infringement, the alleged infringer may be able to recover its damages out of the bond.

Actual Damages. The copyright owner may request that the court award actual damages or, if the infringed work was registered prior to the infringement, statutory damages—a choice that can be made any time before the final judgment is rendered.

Actual damages are the amount of the financial injury sustained by the copyright owner or, as in most cases, the profits made by the infringer. In proving the infringer's profits, the copyright owner need only establish the gross revenues received for the illegal exploitation of the work. The infringer then must prove any deductible expenses.

Statutory Damages. The amount of statutory damages is decided by the court, within specified limits: no less than $750 and no more than $30,000 per work infringed. The maximum possible recovery is increased to $150,000 if the copyright owner proves that the infringement was committed willfully. The minimum possible recovery is reduced to $200 if the infringer proves ignorance of the fact that the work was copyrighted. The court has the option to award the prevailing party its costs and attorneys' fees if the copyright was registered prior to the infringement. As noted above, registration within three months of publication is treated as having occurred on the date of publication.

Criminal Enforcement. The U.S. Justice Department can prosecute a copyright infringer. If the prosecutor proves beyond a reasonable doubt that the infringement was committed willfully and for commercial gain, the infringer can be fined up to $250,000 and imprisoned for up to six years for a first offense and up to ten years for a second offense. There is also a fine of up to $2,500 for fraudulently placing a false copyright notice on a work, for removing or obliterating a copyright notice, or for knowingly making a false statement in connection with an application for a copyright.

Fair Use. Not every copying of a protected work will constitute an infringement. There are two basic types of noninfringing use: fair use and exempted use.

The Copyright Act of 1976 recognizes that copies of a protected work "for purposes such as criticism, comment, news reporting, teaching (including multiple copies for classroom use), scholarship or research" can be considered fair use and, therefore, not an infringement. However, this list is not intended to be complete; nor is it intended as a definition of fair use. *Fair use,* in fact, is not defined by the Act. Instead, the Act cites four factors to be considered in determining whether a particular use is or is not fair:

1. The purpose and character of the use, including whether it is for commercial use or for nonprofit educational purposes

2. The nature of the copyrighted work

3. The amount and substantiality of the portion used in relation to the copyrighted work as a whole

4. The effect of the use upon the potential market for, or value of, the copyrighted work

The Act does not rank these four factors, nor does it exclude other factors in determining the question of fair use. In effect, the Act leaves the doctrine of fair use to be developed by the courts.

A classic example of fair use would be reproduction of one photograph from a photography book in a newspaper or magazine review of that book. Another would be the photographing of a copyrighted photograph as background.

Because of the fact that fair use is determined on a case-by-case basis, it is a good idea to be familiar with the facts and results of some of those cases.

In *Rogers v. Koons*, the Court of Appeals for the Second Circuit rejected a sculptor's argument that his use of a photograph as a model to make a sculpture was fair use. Before sending the photograph to a workshop for the purpose of having a maquette created, the sculptor removed the plaintiff's copyright notice. The sculptor subsequently sold three wooden copies of the maquette for a total of $367,000. The court held that the use was commercial, the original was a work of art, Koons copied the essence of the photograph and the sculpture could impact the market for the original photograph.

Jeff Koons was, however, successful in defending a later lawsuit, *Blanch v. Koons*, brought by a fashion photographer. Koons had adapted a photograph of a model's lower legs and feet resting on a man's lap in an airplane, using only the legs and feet in a collage painting, along with three other pairs of legs. The court felt this use was transformative.

The 1968 case of *Time, Inc. v. Bernard Geis Associates* involved Abraham Zapruder of Dallas, Texas, who took home movies of President Kennedy's arrival in Dallas. Zapruder started the film as the motorcade approached; when the assassination

occurred, he caught it all. Zapruder had three copies made of this film: Two he gave to the Secret Service solely for government use; he sold the other to *Life Magazine*. *Life* registered the copyright to the films and refused to allow publisher Bernard Geis Associates the right to use pictures from the film in a book. When the publisher reproduced frames in the film by charcoal sketches, *Life* sued for copyright infringement. The court found, however, that the publisher's use of the pictures was a fair use and outside the limits of copyright protection, reasoning that the public had an interest in having the fullest possible information available on the murder of President Kennedy. The court also noted that the book would have had intrinsic merit and salability without the pictures and that the publisher had offered to pay *Life* for its permission to use the pictures. The court also noted that *Life* sustained no injury because the publisher was not in competition with it.

When, however, a Boston CBS affiliate station reused a photograph of mobster Stephen Flemmi without permission in connection with a news story about a different mobster, the court in *Fitzgerald v. CBS Broadcasting, Inc.* rejected the fair use defense, finding that in both instances, the photograph was used for the same purpose (news reporting) and, thus, the reuse affected the potential market for the photograph.

A use of a copyrighted work in the background is discussed in the *Sandoval v. New Line Cinema Corp.* case, which involved inclusion of a photographer's images in the motion picture *Seven*. The photographic transparencies were visible only for about thirty-five seconds and then shown only from a distance with some blurring. The court held that the use of the photographs was *de minimus* and thus not an infringement.

Playboy was able to successfully argue that its reproduction of a Playmate's high school photograph on her Playmate bio page in the magazine was fair use. The court, in *Calkins v. Playboy Enterprises International*, found the use was incidental, as well as *transformative* (used in a new way), since *Playboy* used the photograph to inform and entertain its readers, whereas copies of the original photograph were used as gifts for family and friends. Further, the *Playboy* publication did not injure the market for the plaintiff's work.

In *Bill Graham Archives v. Dorling Kindersley, Ltd.*, the Second Circuit held that reproductions of Grateful Dead posters in a 480-page book about the Grateful Dead were fair use, since they were used as "historical artifacts" and were dramatically reduced in size and combined with textual material.

As is apparent from this brief discussion, fair use is a complex subject, and if you plan to rely on this defense, it would be a good idea to check with a copyright lawyer first.

Parody. Another area in which the fair use defense has been used successfully is in cases involving parody. The courts have generally been sympathetic to the parodying of copyrighted works, often permitting incorporation of a substantial portion

of a protected work. The test has traditionally been whether the amount copied exceeded that which was necessary to recall or "conjure up" in the mind of the viewers the work being parodied. In these cases, the substantiality of the copy, and particularly the "conjuring up" test, may be more important than the factor of economic harm to the copyright proprietor.

Walt Disney Productions v. Air Pirates involved publication of two magazines of cartoons entitled *Air Pirates Funnies* in which characters resembling Mickey and Minnie Mouse, Donald Duck, the Big Bad Wolf, and the Three Little Pigs were depicted as active members of a free-thinking, promiscuous, drug-ingesting counterculture. The court held that a parodist's First Amendment rights and desire to make the best parody must be balanced against the rights of the copyright owner and the protection of the owner's original expression. The judges explained that the balance is struck by giving the parodist the right to make a copy that is just accurate enough to conjure up the original. Since the Disney cartoon characters had widespread public recognition, a fairly inexact copy would have been sufficient to call them to mind to members of the viewing public. The court held that by copying the cartoon characters in their entirety, the defendants took more than what was necessary to place firmly in the reader's mind the parodied work and those specific attributes that were to be satirized. Thus, the Air Pirates cartoons were deemed an infringement.

In the *Campbell v. Acuff-Rose Music* case, however, the United States Supreme Court held that it was possible of the musical group 2 Live Crew's conversion of the popular song *Pretty Woman* into one that was overtly sexual, to be fair use despite the commercial nature of the parody and its copying of the "heart" of the original work.

Leibovitz v. Paramount Pictures, Inc., also found a photograph that incorporated a substantial portion of the original to be a parody. A photograph promoting the movie *Naked Gun: The Final Insult* spoofed the *Vanity Fair* nude photograph shot by Annie Leibovitz of Demi Moore at eight-months pregnant. The promotional shot superimposed the face of the movie's star, Leslie Nielsen, over the face of a pregnant woman in the same pose used in the Demi Moore photograph. The court held that while the photograph was commercial, it was a parody and transformative in character and, therefore, a fair use.

In another case, Mattel sued photographer Thomas Forsythe for his series of photographs, in which he depicted Barbie in various positions, often nude with kitchen appliances. For instance, *Barbie Enchiladas* depicts Barbie dolls wrapped in tortillas and covered with salsa. *Fondue a las Barbie* shows Barbie heads in a fondue pot. In *Mattel, Inc. v. Walking Mountain Productions*, the Ninth Circuit held that Forsythe's work is fair use as a parody, commenting on the harm Forsythe perceived in Barbie's influence on gender roles and the position of women in society.

Photocopying. One area in which the limits of fair use are hotly debated is the area of photocopying. The Copyright Act provides that "reproduction in copies. . .for purposes such as criticism, comment, news reporting, teaching (including multiple copies for classroom use), scholarship, or research" can be fair use, which leaves many questions. Reproduction of what? A piece of an image? Over half an image? An image no longer generally available? How many copies? To help answer these questions, several interested organizations drafted a set of guidelines for classroom copying in nonprofit educational institutions. These guidelines are not a part of the Copyright Act but are printed in the Act's legislative history. Even though the writers of the guidelines defined the guide as "minimum standards of educational fair use," major educational groups have publicly expressed the fear that publishers would attempt to establish the guidelines as maximum standards beyond which there could be no fair use.

Online education has become quite popular, and online educators realized that much of what takes place in the classroom might be unlawful if presented online. It was for this reason that the Technology, Education and Copyright Harmonization Act of 2002 (TEACH Act) was enacted by Congress. Many hoped that this law would "level the playing field" between online educators and those who teach in a traditional classroom. While the law does provide some protection for online educators, it is by no means the "safe harbor" for which educators had hoped. In fact, the TEACH Act makes it clear that if the educator is uncertain about whether an online use is permitted, then the educator should rely on the fair use doctrine if possible.

Fair Use in the Video Industry. The first U.S. Supreme Court case to address the fair use doctrine under the Copyright Revision Act of 1976 was *Sony Corporation of America v. Universal City Studios, Inc., et al.*, in 1984. This case deals with the effect of home video recorders on copyrighted movies aired on television, and it is an important step in defining the bounds of the fair use doctrine under the then-new law. Universal Studios sued Sony for manufacturing and selling home videotape recorders that used to record copyrighted works shown on television. In a five-to-four decision, the court stated that home video recording for non-commercial purposes is a fair use of copyrighted television programs.

The Supreme Court's analysis of fair use emphasized the economic consequences of home video recording to copyright owners. The court looked to the first of the four factors listed in the 1976 Copyright Act as relevant to the fair use defense, "[t]he purpose and character of the use." Consideration of this factor, reasoned the court, requires a weighing of the commercial or nonprofit character of the activity. If the recorders had been used to make copies for commercial or profit-making purposes, the use would be unfair, but since video recording of television programs for private home use is a noncommercial, nonprofit activity, the court found that the use was a fair use.

The court then considered "the effect of the use upon the potential market for or value of the copyrighted work," the fourth factor listed in the Act. Here,

the court found that although copying for noncommercial reasons may impair the copyright holder's ability to get the rewards Congress intended, to forbid a use that has no demonstrable effect upon the potential market or upon the value of the work would merely prohibit access to ideas without any benefit.

In this case, the alleged copyright infringement was the unauthorized recording or copying of the movies by home viewers. Other video cases involve a slightly different situation: members of the public viewing video movies in what is alleged to be an unauthorized public performance. At least one lower court has held that copyright is not infringed when guests at a resort are allowed to rent videodiscs and view them in their rooms. However, two other courts have held that copyright is infringed when owners of video rental stores provide viewing rooms where members of the public can view the movies they have rented. The primary issue in all of these cases was whether the uses constituted public performances, not whether the uses were fair. Nevertheless, like the *Sony* case, they illustrate the difficult copyright issue presented by the video industry.

New television recording technology has been treated similarly. In 2009, the Supreme Court declined to hear arguments on whether Cablevision System Corp.'s remote-storage DVR violates copyright laws, paving the way for cable system operators to offer DVR service to customers without a box in their homes.

Obtain Counsel. As all this demonstrates, it is not easy to define what sorts of uses are fair uses. Questions continue to be resolved on a case-by-case basis. Thus, you should consult an experienced copyright lawyer if it appears that one of your works has been infringed or if you intend to use someone else's copyrighted work. The lawyer can research what the courts have held in cases with similar facts.

Exempted Uses

In many instances, the ambiguities of the fair use doctrine have been resolved by statutory exemptions. *Exempted uses* are those specifically permitted by statute in situations where the public interest in making a copy outweighs any harm to the copyright holder.

Libraries and Archives. Perhaps the most significant of these exemptions is the library-and-archives exemption, which basically provides that libraries and archives may reproduce and distribute a single copy of a work provided that:

- Such reproduction and distribution is not for the purpose of direct or indirect commercial gain
- The collections of the library or archives are available to the public or available to researchers affiliated with the library or archives, as well as to others doing research in a specialized field
- The reproduction includes a copyright notice

According to the legislative history of the Copyright Act, Congress particularly encourages copying of films made before 1942 because these films are printed on film stock with a nitrate base that will decompose in time. Thus, so long as an organization is attempting to preserve our cultural heritage, copying of old films is allowed and encouraged under the fair use doctrine.

The exemption for libraries and archives is intended to cover only single copies of a work. It generally does not cover multiple reproductions of the same material, whether made on one occasion or over a period of time, and whether intended for use by one person or for separate use by the individual members of a group. Under interlibrary arrangements, various libraries may provide one another with works missing from their respective collections, unless these distribution arrangements substitute for a subscription or purchase of a given work.

This exemption in no way affects the applicability of fair use; nor does it serve to permit copying where it is prohibited in contractual arrangements agreed to by the library or archives when it obtained the work.

Sovereign Immunity. A number of comparatively recent cases have involved the question of whether or not the federal government or any state can be liable for copyright infringement. Thus far, because of the doctrine of sovereign immunity, federal and state governments have been found to be protected against liability for infringement when using copyrighted works. Since the U.S. government or a state government can be sued only when it consents to be sued, the plaintiff must establish that the government authorized or consented to the infringement and that the government agreed to be sued for it.

Although the Copyright Amendment of 1990 provides that states can be held liable for copyright infringement, many cases have held that this amendment is prohibited by the Eleventh Amendment to the U.S. Constitution.

Thus, a photographer may have work infringed by the state or federal government and have no redress. The immunity, however, may not extend to the individual responsible for the infringement. The U.S. Court of Appeals for the Fourth Circuit has held that the Eleventh Amendment may shield a state university from liability for copyright infringement, but the publication director who used the infringing photograph in the student catalogue may herself be sued. Such a lawsuit could be only for an injunction, not for damages.

The Computer Age and Copyright

With the advent of the Internet, many of the legal issues presented throughout this text are being reexamined. The rights of copyright, publicity, libel, privacy, and trademark are among the most prominent.

A major concern for the photography profession is computer-enhanced imagery. Digital technology enables a computer to produce vivid images that can

be manipulated and distorted to varying degrees. As a result, many opportunities and risks are surfacing that have not yet been clearly delineated.

A photographer granted a clothing company a license to use his yacht race photographs as "guides, models, and examples, for illustrations to be used on screenprinted T-shirts or other sportswear." The licensee scanned one of the photographs and then digitally modified it, flipping the image and changing the colors, among other things. The photographer sued for copyright infringement, arguing that this use of his photograph was not authorized by the license agreement because the T-shirts bore an altered photograph, not an illustration. Winterland argued that the alteration transformed the image from a photograph to an illustration based on a photograph. In *Mendler v. Winterland Production, Ltd.*, the Ninth Circuit held that the image retained its photographic characteristics, and so this use of the photograph constituted copyright infringement.

While it does not involve photography, *New York Times Co., Inc. v. Tasini* is nonetheless an important case for photographers. Freelance authors of articles that appeared in *The New York Times* and other publications sued over the publishers' reproduction of those articles in electronic databases without permission. The publishers claimed that the use of the articles in such databases constituted a revision of the editions of the publications in which the articles originally appeared. The Supreme Court disagreed and ruled that newspapers and magazines may not republish freelance contributions in electronic databases without the express consent of the writers.

Similar cases have involved photographers. In *Greenberg v. National Geographic Society*, the Eleventh Circuit originally found that *National Geographic* violated the law when it reproduced a photographer's work in a set of CD-ROM magazines containing 108 years of the *National Geographic* magazine. Despite the magazine's argument that the CD-ROMs were similar to copies on microfilm, the court held that the work is not a revision of the prior work but constitutes a new collective work. On rehearing, however, the court agreed with *National Geographic* that the CD-ROMs were, in fact, similar to microfilm because the electronic version presented scans of pages exactly as they appeared in print, even though the electronic version included a search engine. A Second Circuit case, *Faulkner v. National Geographic*, reached the same conclusion.

According to *Bridgeman Art Library, Ltd. v. Corel Corp.*, no one who merely scans a photograph obtains any additional rights in the digital form of the copyright. In this case in the Southern District of New York, the question arose as to whether photographs of approximately seven hundred paintings by European masters (which paintings are in the public domain) would enjoy copyright protection. Here, the objects being photographed were not three-dimensional, and thus the court felt that the photographs were not entitled to copyright protection. Since, said the court, the intention of the photographer was to actually depict the two-dimensional painting, there was no creativity or originality in taking the

photographs. Indeed, said the court, in this case, there was nothing more than "slavish copying," and thus the skilled and artistic input necessary to support a copyright was not present.

It would appear that the court in *Bridgeman* ignored the fact that there is a great deal of skill and creativity involved in photographing even a two-dimensional old master. It appears that the court was concerned about the problems that may occur if photographers are allowed to enjoy copyright protection in photographs of public domain work.

In an earlier case cited by the *Bridgeman* court involving the reproduction of a public domain Uncle Sam bank, the court pointed out that allowing the newly made reproduction to enjoy copyright protection would provide "a weapon for harassment in the hands of mischievous copiers" by improperly reviving copyrights that have expired by virtue of the time limits of protection having run.

Another photographer, Gary Bernstein, sued J. C. Penney, Inc., and others for copyright infringement. J. C. Penney's Web site contained links to sites that included photographs of Elizabeth Taylor taken by Gary Bernstein. He alleged that J. C. Penney should have paid him for use of the photographs rather than providing links to illegally reproduced images. The *Bernstein* case was voluntarily dismissed, but these questions remain.

Digital Millennium Copyright Act. The Digital Millennium Copyright Act (DMCA), enacted in late 1998, was intended in part to implement treaties signed at the World Intellectual Property Organization (WIPO) Geneva Conference in 1996. The Act:

- Criminalizes circumvention of antipiracy measures built into commercial software, except in certain limited circumstances
- Outlaws the manufacture, sale, or distribution of code-cracking devices used to illegally copy software, except in certain limited circumstances
- Prohibits the unauthorized removal or alteration of "copyright management information" (CMI), which includes identifying information about the work, the author, the copyright owner, and the terms and conditions for use of the work
- Prohibits use of false CMI
- Generally limits the copyright infringement liability of Internet service providers (ISPs) for simply transmitting information over the Internet, including nonprofit educational institutions when they serve as ISPs, though ISPs are expected to terminate accounts of repeat offenders
- Requires that Webcasters pay licensing fees to record companies

Kelly v. Arriba Soft Corp. involved the application of this law to a photographer. The plaintiff, Leslie Kelly, was a photographer who maintained two Web

sites containing some of his photographs. The defendant operated a visual search engine, which returned the results as thumbnail images. The user of the search engine could see the full-size version of the image, along with an address for the originating Web site, by clicking on the thumbnail image. No copyright notice was shown, however. The plaintiff sued for copyright infringement and violation of the anticircumvention provisions of the DMCA. The court held that the defendant's use of the images was fair use, that the defendant had not removed any CMI in violation of the law since the court found this to apply to removal from the original work, not from a reproduction, that users of the defendant's search engine were no more likely to infringe than users of the plaintiff's Web site, and that the defendant had no reasonable basis to believe that the users of its search engine would infringe the photographer's copyright. On appeal, the appellate court upheld the ruling that the thumbnail images were not infringing, but sent the question about the full-size images back to the lower court for rehearing. Use of thumbnail images was also addressed by the Ninth Circuit in *Perfect 10, Inc. v. Amazon, Inc.*, which upheld the *Kelly* ruling that thumbnail images are fair use.

In another DMCA case, photographer Lloyd Shugart sued the shoe company Propet USA over use of his images outside the scope of the usage agreement, failure to return his images, as well as removal of CMI. The jury awarded Shugart $12,800 for damages arising from the infringement but awarded $500,000 for removal of CMI and $303,000 for failure to return images.

Trademark Law

As a photographer, you are probably aware that trademark issues may arise in several ways: over the names of your photographs, the name of your business, or, perhaps, your domain name. What you may not be aware of is that your photographs themselves may infringe the trademark rights of others.

The Rock and Roll Hall of Fame Foundation registered the design of its museum as a service mark, and when a professional photographer began to sell a poster featuring a photograph of the museum, the Foundation brought suit for trademark infringement. In *Rock and Roll Hall of Fame and Museum, Inc. v. Gentile Productions*, the Sixth Circuit held that the plaintiff had not shown that the museum building was used as a trademark. The court did not, however, hold that such a scenario could never be deemed trademark infringement, so you should contact an attorney if you are planning to distribute any photographs containing trademarks.

Photographers have attempted to protect their styles using the trademark and trade dress laws, but this attempt has been rejected by the courts. A photograph can, of course, be used as a trademark or service mark for products and services.

The *Barbie* case discussed above also involved a claim for infringement of the Barbie trademark. Again, the court found for the photographer, holding that "the public interest in free and artistic expression greatly outweighs its interest in potential consumer confusion about Mattel's sponsorship of Forsythe's works."

Moral Rights

As an art, photography is a form of property requiring unique consideration, and as a photographer, you have an interest in deciding whether to disclose your work, seeing that your work retains the form you gave it, and ensuring that you are properly credited. While these rights indirectly affect the photographer's economic interests, they more basically affect the photographer's reputation and, therefore, generally are referred to as *moral rights* or *droit moral.*

The artist's moral rights are recognized in some form in most countries, including the United States, and have been included in the Berne Convention, discussed earlier, which covers international copyright protection in addition to many elements of the droit moral. All signatories to the Berne Convention and are obligated to adhere to its moral rights provisions. While moral-rights principles are often considered antagonistic to the property rights of owners in the United States, protection of certain minimal moral rights became mandatory when the United States became a signatory to Berne in 1988.

In 1990, Congress passed the Visual Artists Rights Act (VARA), which amends the Copyright Act by providing to authors of certain works the rights of attribution and integrity. The Act expressly includes photographs produced for exhibition purposes only, in a signed, numbered edition of two hundred or fewer. These rights may be enforced by any applicable remedy, other than criminal penalties, otherwise available for infringement under the Copyright Act. Visual Artists Rights belong solely to the photographer and are not transferable.

Trade Secret Protection

Another form of protection, known as the *trade secret* law, can afford protection to innovations not covered by copyright or trademark laws. All that is necessary for something to be protectable as a trade secret is that:

- It gives the possessor a competitive advantage
- It will, in fact, be treated as a secret by you
- It is not generally known in your industry

The fundamental question of trade secret law is, what is protectable? The way you use knowledge and information, the specific portions of information you have grouped together, even the mere assembly of information itself may be a trade secret, even if everything you consider important for your secret is publicly available information. For example, if there are numerous methods for producing

a particular photographic effect and you have selected one of them, the mere fact that you have selected this particular method may itself be a trade secret. The identity of your suppliers may be a trade secret, even if they are all listed in the yellow pages. The fact that you have done business with these people and found them to be reputable and responsive to you may make the list of their names a trade secret.

Many trade secrets will be embodied in some form of document. One of the first things you should do is to mark any paper, photograph, or the like that you desire to protect as a trade secret, identifying it as confidential. You should also take steps to prevent demonstrations of your trade secret. Taking these steps will not create trade secret protection, but the fact that an effort has been made to identify the materials and methods you consider secret will aid you in establishing that you treated them as a trade secrets should litigation ever occur. In this area, a little thought and cleverness will go a long way toward giving you the protection of the trade secret laws.

You should have some degree of physical security. It has been said that physical security is 90 percent common sense and 10 percent true protection. You should restrict access to the area in which the trade secret is used. Some precaution should be taken to prevent visitors from peering into the area where the secret process, formula, or technique is employed. Employee access to trade secret information should be on a "need-to-know" basis; a procedure should be established for controlled employee access to the documents. It is also a good idea to have employees sign confidentiality and nondisclosure agreements when hired. You should have outsiders sign a similar agreement before you reveal anything to them about the subject of your trade secret. An attorney who deals with intellectual property can prepare form agreements for use within your business.

Trade secret laws may be the only protection available for your business secrets. Care should, therefore, be taken to restrict access to the information and to treat the information as truly secret.

-2-
Defamation and Libel

In the year 400 B.C., the Greek philosopher Socrates was convicted of teaching atheism to the children of Athens and was sentenced to death. Of the four hundred jurors, all but two voted for conviction. In his defense, Socrates claimed that most of the charges were based on lies and that his reputation had been unjustly attacked for years. For example, he argued that in *The Clouds*, a play by Aristophanes that was performed before the entire population of Athens, the bumbling teacher of philosophy was named Socrates. In Athens, however, free speech, as long as it was not heresy, was an absolute right, and Socrates had no protection against statements that today would be considered defamatory.

Despite the First Amendment guarantee that freedom of speech will not be abridged, in contemporary America, that freedom is limited. Defamatory material, including photographs, is prohibited by law in all fifty states. A statement will generally be considered defamatory if it tends to subject a person to hatred, contempt, or ridicule or if it results in injury to that person's reputation while in office, in business, or at work.

The American Law Institute, whose publications are influential to courts, defines libel as publication of defamatory matter "by written or printed words, by its embodiment in physical form, or by any other form of communication which has the potentially harmful qualities characteristic of written or printed words."

Photographs can be defamatory. Generally, a picture by itself cannot be the basis for liability because truth is a defense to libel, and the camera merely records what is there, though it can become defamatory if edited using software such as

Photoshop, Paint Shop Pro, or Paint.NET or is otherwise altered in a way that exposes the subject to ridicule or contempt.

For instance, figure skater Nancy Kerrigan brought a defamation suit after she discovered computer-generated pornographic photographs of herself on a Web site. The case was settled for an undisclosed sum, and the defendant agreed not to publish any more images of Kerrigan.

Usually, liability for defamation arises because of the accompanying text or captions. Online, the defamation could occur because of a link from or to the site containing the photograph at issue. In determining whether or not a photograph is defamatory, the court will consider a publication in its entirety. So, to protect against liability for defamation, a photographer should caption photographs accurately before selling them. Also, the photographer should be careful not to participate in or explicitly approve of false or injurious text accompanying the photographs.

In *Cantrell v. Forest City Publishing Co.*, a reporter wrote a story on the poverty of a family whose father had been killed in a flood. A photographer took fifty pictures of the family's home, some of which were published with the story. The story contained a number of inaccuracies, but when the family sued, the photographer was not held liable because there was no evidence that he was involved in writing the defamatory text.

If defamation is written or otherwise tangible, it is *libel*; if it is oral, it is *slander*. For the most part, the same laws and principles govern all defamatory statements, but since a photographer's liability involves images that appear on transparency, on paper, and in digital form, we will focus here on libel. As a photographer, you must be cautious about any photographs or captions that might be considered defamatory. If the work is published—and, as you will see, "published" has a very broad meaning in the context of libel—you, as the photographer, could be sued along with the publisher under the libel statutes. Note that due to the Telecommunications Act of 1996, unlike traditional publishers, Internet service providers (ISPs) have immunity for defamation claims in some circumstances. The ISP will be liable, however, if it knew or had reason to know the material was defamatory and failed to take any action.

It is not always easy to determine whether a photograph is defamatory. In order to give you some idea of the scope of libel, let us take a closer look at what kinds of photographs the courts have found to be libelous. Then, we will look at who can sue a photographer for libel and various defenses a photographer can use against different types of plaintiffs.

Actionable Libel

Actionable libel is libel that would furnish legal grounds for a lawsuit. In order for a photograph to be libelous, it must, in legal terminology, "convey a defamatory meaning" about an identifiable person or persons and must have been published.

Thus, for example, a photograph of a Jewish leader on which a Nazi armband has been added using Photoshop would be libelous.

Courts have traditionally put libel into two categories: *libel per se* and *libel per quod*. In libel per se, the defamatory meaning is apparent from the statement or thing itself. In libel per quod, the defamatory meaning is conveyed only in conjunction with other material. In libel per quod, the photograph may be susceptible to more than one reasonable interpretation, but as long as any one of the interpretations is defamatory, the picture will be considered libelous.

Libel Per Se

One example of libel per se is an accusation of criminal or morally reprehensible acts. An accusation of criminal conduct is libelous per se, even though it is not explicitly stated. If the photographer has published a photograph and caption that describe a crime or has cast suspicion by innuendo, that is sufficient for libel per se. In *Time, Inc. v. Ragano*, the court found potential defamation liability based on publication of a photograph of seven men seated at a restaurant table accompanied by an article that referred to the men, two of whom were attorneys, as Cosa Nostra hoodlums. Similarly, in *Hagler v. Democrat News, Inc.*, a newspaper ran a photograph of a sign identifying a couple's cabin to illustrate an article on a drug raid. The owners of the cabin sued for defamation and invasion of privacy. As the pictured cabin was in no way implicated in the drug raid, the photograph would indeed have been defamatory had the text of the article not made it clear that the drug raid had occurred in another cabin.

However, it is never libel per se to say that someone is exercising a legal right, even though the person may not want the fact known. For example, it is not libel per se to say or to imply by a photograph that a man killed someone in self-defense, that he brought a divorce suit against his wife, or that he invoked the Fifth Amendment forty times. Although these statements may cast suspicion, they cannot be libelous per se because they merely report the exercise of a legal right.

To state that someone has a loathsome or contagious disease, such as syphilis, is libelous per se. A statement that describes deviant sexual conduct or unchastity, particularly by a woman, is libelous per se. However, changing societal norms result in modifications of what is considered libelous per se. In 2009, a federal court judge in New York ruled in *Stern v. Cosby* that, due to changes in attitude about homosexuality, calling someone (in this case, Howard Stern, Anna Nicole Smith's lawyer) a "homosexual" is no longer defamation "per se," though the plaintiff still has the opportunity to prove that it is defamatory in context.

Similarly, in *Amrak Productions v. Morton*, the court held that a photograph of a gay man (José Guitierez) mistakenly captioned as portraying Jimmy Albright was not defamation, since the caption identified the man as "Madonna's secret lover," and nothing in Guitierez's appearance gave any indication of homosexuality.

In one case, the court found that publication of a woman's nude photograph without her consent in a magazine that promoted the careers of aspiring porn stars was defamatory. The suggestion of unwed pregnancy also undermines a woman's reputation for chastity and can be the basis for defamation action. In *Triangle Publications, Inc. v. Chumley*, a newspaper and magazine published a photograph of a teenage girl embracing a man and a photograph of her alleged diary with an entry stating she was pregnant. These photographs were part of an advertisement for a television series on teen pregnancy. The court held that the photographs were defamatory.

One case was brought by a woman whose photograph was published, along with a fictitious biography and medical history, in brochures used to market Merck's anti-AIDS drug Crixivan to AIDS patients. The brochures described the plaintiff as a nineteen-year-old mother who had AIDS and herpes, though she was actually a woman in her thirties who contracted HIV from her husband. The court found for the plaintiff on summary judgment, holding that Merck and its advertising agency had libeled the plaintiff by causing her to appear promiscuous and by stating that she had herpes when, in fact, she did not.

Actress Florence Henderson, who starred as the mom on *The Brady Bunch*, brought suit against Serial Killer, a company selling T-shirts displaying her picture with the words "Porn Queen" underneath. The company immediately removed the offending merchandise from its Web site.

When the statement involves politics, the determination of libel per se is more difficult. Today, courts generally agree that a statement that a person belongs to a particular political group will be libel per se only if that group advocates the use of violence as a means of achieving political ends. Thus, to say that someone belongs to the Ku Klux Klan would probably be libel per se, but to say that someone is a racist would probably not be since racism is not necessarily intertwined with the use of violence. In some instances, though, a photograph that makes a statement concerning someone's political affiliation may constitute libel per se regardless of the political group's attitude toward violence. For example, to depict someone as a communist may be libel per se because communist affiliation is generally injurious to a person's reputation within significant portions of society today.

It also is usually deemed libel per se to impute to a professional person a breach of professional ethics, general unfitness, or inefficiency. For example, it may be libel per se to indicate that a person's business is bankrupt because the statement implies a general unfitness to do business. However, to indicate that the businessperson did not pay a certain debt is not libel per se because everyone has a legal right to contest a debt. Similarly, it may be libel per se to imply that a doctor is a butcher because it implies general incompetence, but it is not libel per se to imply that the doctor made a mistake, so long as it does not imply general incompetence—everyone makes mistakes.

There is a gray area concerning statements or pictures about certain business practices that may not be illegal but that, nonetheless, could give a business bad publicity. To indicate someone is cutting prices would not be libel per se, but to indicate someone is cutting prices to drive a competitor out of business would be.

It is impossible to describe every situation that could constitute libel per se since any situation can be libel per se if it is likely to produce a reprehensible opinion of someone in the minds of a large number of reasonable people. Remember, the rule of thumb is that a photograph or statement is libelous per se when the defamatory meaning is clear from the situation itself. Thus, a photograph of a person shaking hands with someone wearing a Ku Klux Klan costume and setting fire to a cross would be libel per se if the photographer skillfully imposed the image of a person who would not be involved with the Klan on the photograph.

Libel Per Quod

In libel per quod, since the defamatory meaning is conveyed only in conjunction with other factors, the plaintiff who sues for libel must introduce the context of the situation and demonstrate to the court how the picture and caption, text, or other pictures as a whole result in a defamatory innuendo. For example, *Gomes v. Fried* involved a photograph that showed an officer sitting in his police car with his head tilted to one side, and it was accompanied by a caption reading: "Officer Gomes' car shown in the center of the lightly traveled Bristol Avenue (Sunday afternoon) prowling for traffic violations. His head tilted may suggest something." While the officer admitted that the photograph was accurate, the court observed that the innuendo in the caption made it potentially defamatory, suggesting to ordinary readers that the officer was sleeping on duty. In fact, as many readers stated in later letters to the newspaper, and as the officer himself testified, he was called "Sleepy" and known as the Sleeping Officer. Nevertheless, the codefendants, the editor, and publisher of the newspaper knew that the officer was not sleeping but was writing a traffic citation at the time the photograph was taken. Thus, although the photograph was accurate, the court held that the photograph could be the basis for a lawsuit.

Another example of a case involving libel per quod was characterized as "libel by thank you." In April 1993, a Los Angeles federal judge dismissed an unusual libel suit involving a high-powered Beverly Hills entertainment lawyer, Mickey Rudin, and celebrity author Kitty Kelley. Rudin charged Kelley with defaming him in her 1991 unauthorized biography of Nancy Reagan when Kelley thanked Rudin as one of the people she said had made "the most important contribution to this book." Specifically, Rudin argued that Kelley had maliciously listed him as a source to create the false impression that he revealed confidential information to Kelley about a relationship between Nancy Reagan and Frank Sinatra, a former client of Rudin. Rudin is neither mentioned nor quoted in the book; his name

appears only in the list of 612 sources and in footnotes to one chapter that refer to correspondence with Rudin. He maintained that he never spoke to Kelley or provided any kind of assistance.

The judge dismissed Rudin's case, holding that Rudin failed to prove he had been damaged in the manner necessary under California law to sustain his claims of libel or invasion of privacy. The judge also rejected Rudin's argument that Kelley violated the federal Lanham Act by falsely identifying him as a source, giving the impression Rudin was associated with the book.

Material that is clearly a parody or humor has been held not to be defamatory. Three women whose photographs appeared in a book called *Hot Chicks With Douchebags* sued over photographs of them taken with men described in the book as "douchebags" (defined as men who dress and act ostentatiously). The court found there was no defamation because the photographs and text were used for humorous social commentary, and a reasonable person would realize the book was satirical. Further, the photographs had no captions, and the women were not named in the book.

Defamatory Advertising and Trade Libel

Photographers should be aware that they are potentially liable for a type of defamation known as *trade libel* if they help to create advertisements that impugn the quality of commercial merchandise or products. If an advertisement reflects adversely on a competitor's character, it can constitute *defamation per se*. If the advertisement on its face implies that a competitor is fraudulent or dishonest and if the competitor can prove financial loss, he or she may have an action for *defamation per quod*.

Proof of Damage

The distinction between libel per se and libel per quod is important primarily because it determines whether the plaintiff has to prove damage. Where there is libel per se, damage to reputation will be presumed and the plaintiff need not prove it. If, however, the charge is libel per quod, damage normally must be proved, although there are some exceptions to this general rule. If the innuendo in the libel per quod falls within one of four categories, damage will be presumed, as it is in libel per se. The four categories are innuendoes that:

1. Adversely reflect upon someone's ability to conduct a business, trade, or profession

2. Impute unchastity to an unmarried woman

3. Accuse someone of committing a crime of moral turpitude (a crime of moral turpitude is something that is immoral in itself, irrespective of the fact that it is punished by law; examples are rape and murder)

4. Accuse someone of having a loathsome disease, such as leprosy or a sexually transmitted disease

Publication

As mentioned earlier, a photograph must be published in order to constitute actionable libel. The legal meaning of *publication* in the libel context is very broad. Once a photograph is communicated to a third person who sees and understands it, the photograph, in the eyes of the law, has been published. Thus, if you show a photograph to someone other than the subject, you have published the photograph.

Generally, the person who is defamed can bring a separate lawsuit for each repetition of the defamatory photograph. However, when the photograph is contained in a book, magazine, or newspaper, a majority of courts have adopted what is known as the *single-publication rule*. Under this rule, a person cannot make each copy of the book grounds for a separate suit; rather, the number of copies is taken into account only for purposes of determining the extent of damages. The same rule applies online—and republication will be deemed to occur only if there is substantial modification to the defamatory content.

Who Can Sue for Libel?

In order for someone to sue for libel, the photograph at issue must clearly depict or identify that person or entity. This is easy to prove, of course, when the plaintiff is identified by name in the text or caption or where the plaintiff is clearly visible and identifiable in the photograph. If a plaintiff is not identified by name, the plaintiff can prove that he or she was nonetheless "identified" by showing that a third party could reasonably infer that the photograph was of the plaintiff. For example, if the plaintiff had a very unique and distinctive tattoo and it was visible in the photograph even though the plaintiff's face was not, then the plaintiff would likely be able to establish that he or she was depicted in it.

The courts have uniformly held that groups, corporations, and partnerships can sue for libel, just as an individual can. Although there has been disagreement among the states as to whether nonprofit corporations should be protected, the trend seems to be to allow nonprofit corporations to sue when they are injured in their ability to collect or distribute funds.

If a defamatory picture is published depicting an identified group of people, the possibility of each member of that group having a good cause of action will depend on the size of the group and whether the photograph defames all or only a part of the group.

The individual members of a group might not prevail if the allegedly defamatory statement referred to only a portion of the group. If, for example, someone states that "some members" of a particular trade group shown in a photograph "are communists," the individual members probably cannot prevail in a defamation suit since the statement is not all-inclusive and since those included are not named. Again, the size of the group could affect the court's ruling. If the partially defamed group is small and the people are recognizable, it would be more likely

that the reputation of each member had been damaged, even though the statement was not all-inclusive.

When the group is composed of more than one hundred members, the individuals generally do not have a good cause of action. If, on one hand, someone published a photograph of thousands of people in a ballpark audience and added a caption indicating that all depicted were thieves, it is unlikely that one person's reputation could be damaged as a result of the photograph. On the other hand, if that same caption described a small group of individuals in the photograph, those individuals could probably win a defamation suit since they would be more likely to be subject to contempt, hatred, or ridicule as a result of the defamatory picture.

A photographer confronted with the question of whether or not to publish a work that identifies a person, group, or entity should make a two-step analysis. First, does the picture—with any caption or related material—defame a reputation? If the answer is no, then it may be safely published (assuming no other wrongful act, such as copyright infringement or invasion of privacy, is involved). If the answer is yes, the second step is to determine whether there is a valid defense.

Defenses to Libel

Since photographers often write captions or descriptions to accompany their photographs, you as a photographer need to know the situations in which you can defend your right to publish certain kinds of pictures. Even if a plaintiff proves defamation, publication, and damages (where damages must be proved), the photographer may, nevertheless, prevail in a lawsuit if he or she is able to establish a valid defense.

Disclaimers

In the past, many have relied on use of an appropriately worded disclaimer to prevent potential defamation problems. A 2006 case, however, made reliance on a disclaimer a risky proposition. In *Stanton v. Metro Corporation*, the appellate court found the disclaimer used was insufficient. The case involved an article entitled *Fast Times at Silver Lake High: Teen Sex in the Suburbs*, which featured a photograph of five young people, including the plaintiff, Stacey Stanton. The article discussed sexual promiscuity of teens in the greater Boston area and included interviews with a number of high school students.

The article bore a disclaimer on the first page stating that the photographs were "of individuals unrelated to the people or events described in this story," but the disclaimer's text was of a smaller size than the surrounding text and was located in such a place that the reader was likely to turn the page to read the rest of the article before reaching the disclaimer. Further, the court noted that the disclaimer also stated that the photographs were "from an award-winning five

year project on teen sexuality." It was felt this language suggested that, even if the depicted teens were not related to the story, they were promiscuous.

Truth

Truth is an absolute defense to a charge of defamation, although it may not protect against other charges, such as invasion of privacy. It is not necessary for a potentially defamatory statement to be correct in every respect in order to be considered true. As long as the statement is true in all essential particulars, the defense will be acceptable. For example, if the caption "X robbed Bank A" appeared under a photograph of a bank robbery, it would be considered true and, therefore, not actionable, even though the photograph was, in fact, of a robbery of Bank B. The essential fact is that X was guilty of robbing a bank, so it is irrelevant which bank was robbed.

Opinion

Another possible defense is that the supposedly defamatory material was one of *opinion* rather than fact. The rationale for this defense is that one's opinion can never be false and, therefore, cannot be defamatory. Of course, the line between a statement of fact and an opinion is often hard to draw, particularly in the area of literary or artistic criticism.

Not surprisingly, art, literary, and drama critics have frequently been accused of libel after they have published particularly scathing reviews. When criticizing the work of artists, the critic is free to use rhetorical hyperbole as long as the statements do not reflect on the character of the artist. For example, in the early 1970s, Gore Vidal sued William F. Buckley, Jr., for calling Vidal's book *Myra Breckenridge* pornography. The court held that, in context, the statement did not assail Vidal's character by suggesting that he himself was a pornographer; thus, the statement was not defamatory.

An example of criticism that did assail character is a famous case from the 1890s in which the American artist James Whistler won a defamation suit against John Ruskin, an English art critic. In his assessment of Whistler's painting *Nocturne in Brown and Gold*, Ruskin wrote: "I have seen, and heard, much of Cockney impudence before now, but never expected to hear a coxcomb ask 200 guineas for flinging a pot of paint in the public's face." On the surface, this statement was an expression of opinion of the painting's worth. At the same time, it implied facts about Whistler's motives, suggesting that he was defrauding the public by charging money for something that was not even art. The court found these implied facts to be defamatory since they described Whistler as professionally unfit.

If an opinion assailing character concerns a topic of public interest, it might be allowed since such opinions do have some, if limited, privilege. Such a situation arose in *Lavin v. New York News, Inc.*, when a court declined to find that a

photograph of two policemen captioned "Best Cops Money Can Buy" constituted defamation. The court held that the photograph and the accompanying article on organized crime came within the privilege concerning opinions on subjects of public interest.

Note that it is often required that, in order to take advantage of the opinion defense, the basis for the opinion be given, so that the persons to whom the defamatory content is published can determine how reliable the opinion is. In such a situation, the defense is available only if the stated facts are complete and accurate.

Consent

Someone accused of defamation may also raise the defense of *consent*. It is not libelous to publish a photograph of a person who has consented to its publication. In this situation, the extent of the material that may be legally published is governed by the terms and context of the consent.

An interesting case that turned on consent concerned a student humor magazine that had run a piece for Mother's Day consisting of four pictures. One picture was totally black. Under it was the caption "Father Loves Mother." Another picture showed a little girl with the caption "Daughter Loves Mother (And wants to be one too!)." A third picture showed a boy whose arm was tattooed with a heart enclosing the word *Mother* captioned "Sailor Boy Loves Mother," and the final picture showed a face partly covered by a hood labeled "Midwife Loves Mother." The picture of the little girl happened to be a photograph of the daughter of a local Methodist minister, Mr. Langford, and it was rumored that he was about to sue the school newspaper for libel. Langford maintained that the pictures and captions made innuendoes about the unchastity of his daughter, his wife, and himself. Another student newspaper sent two reporters to interview the minister, and he gladly consented to the interview. When the minister filed suit, the newspaper that had conducted the interview published an article which truthfully set out the facts of the suit and contained material from the interview. It also republished the allegedly libelous material. The minister then sued the second paper, but he lost because the court found that he had consented to republication of the material.

In 1991, in *Miller v. American Sports Co., Inc.*, the Supreme Court of Nebraska found that a model's consent to use her picture in connection with the sale of products shown on a brochure was a defense to her invasion of privacy and libel claims against the issuer of the brochure. The court found that the brochure, used for selling bathtubs and refrigerators, did not libel the model who was shown on the cover wearing only a bathing towel, even though the cover also displayed the word "sex." When the brochure was fully opened, the letters forming the word became part of the phrase, "See us next time you build or buy." The remainder of the brochure did not suggest that the model was promoting or selling herself for another's sexual gratification—she was not identified, and the brochure did not disclose how she might be contacted.

Further, the court held that even if the brochure was libelous, the model's consent to her photograph being used in the brochure was an absolute defense. Although the model did not know exactly what uses might be made of her picture, she admitted that she could have restricted its use but did not.

Reports of Official Proceedings

Another defense to what would otherwise be considered defamation is that the statement or picture was part of a report of *official proceedings* or a *public meeting*. As long as the context is a "fair and accurate" account of those proceedings, there can be no liability, even if the picture in question is both defamatory and false. The requirement that the publication be fair and accurate means that whatever was published must be a fair and balanced rendition. For example, a writer may not quote only one side of an argument made in court if there was also a rebuttal to that argument. The account need not be an exact quote, and it is permissible to include some background material to put an accompanying photograph into proper perspective. However, a photographer or caption writer must be careful not to include extraneous information because these will not be protected by the report-of-official-proceedings defense.

Photographers and lawyers learned long ago that it is not always clear what constitutes an official proceeding or public meeting. Court proceedings from arrest to conviction are definitely official proceedings. On the other hand, photographs taken outside of court are not. A newsletter sent by a legislator to constituents does not generally constitute an official proceeding, whereas a political convention probably does.

Reply

Another defense to an accusation of libel is that of *reply*. If someone is defamed, that person is privileged to reply, even if the first person is defamed in the process. This privilege is limited to the extent that the reply may not exceed the provocation. For example, if A publishes a photograph of B and indicates that B is a communist, B has a right to reply that A is a liar or that A is a right-wing extremist because both of these comments bear some relation to the original defamation. If, later on, A sues B for libel because of the statement about A being a right-wing extremist, B can simply show that the statement was in response to the material published by A (the reply defense), but if B made the mistake of responding to A by calling A a thief—a statement that bears no relation to A's accusation—B cannot have recourse to the reply defense.

Statute of Limitations

Another possible defense is the *statute of limitations*. Basically, statutes of limitations limit the time period within which an injured party can sue. The reason for these

time limits is the difficulty of resolving old claims once the evidence becomes stale and the witnesses forget or disappear.

In the case of libel, the injured party must generally sue within one or two years from the date of first publication, although in some states the period is longer. If suit is brought after this time has elapsed, the statute of limitations will be available as a defense to bar the suit.

The period of time allowed by statutes of limitations for libel begins when a photograph is first published. Since publication means the act of communicating the matter at issue to one or more persons, the first publication of a book, magazine, or newspaper containing the photograph is deemed to occur when the publisher releases the finished product for sale. A second edition is generally not considered a separate publication for calculating time elapsed under the statute of limitations, at least where the single-publication rule is followed.

In some jurisdictions, a demand for retraction may be required to be made. For instance, in Oregon, a plaintiff is not entitled to recover "general damages" (those not measurable by proof of a specific monetary loss) for a defamatory statement published in a newspaper, magazine, other printed periodical, or broadcast by radio, television, or motion pictures, unless a retraction has been demanded but not published.

Absence of Actual Malice

The defense most frequently used in recent libel suits was created by the United States Supreme Court in 1964 in *New York Times Co. v. Sullivan*. The case against the *Times* concerned an advertisement it published that contained some inaccuracies and allegedly defamed L. B. Sullivan, the police chief of Montgomery, Alabama. The Supreme Court held that the *New York Times* was not guilty of libel, stating that the existence of a profound national commitment to the principle that debate on public issues should be uninhibited, robust, and wide open and that such debate may well include vehement, caustic, and sometimes unpleasantly sharp attacks on government and public officials. Thus, the court found that the First Amendment provides some protection to writings that criticize public officials for anything they do that is in any way relevant to their official conduct.

By virtue of privilege or First Amendment protection, when a public official sues for defamation, the official must prove with "convincing clarity" that the defendant published the statement with "actual malice." *Actual malice* is defined as knowledge of the falsity or a reckless disregard for the truth or falsity of the statements published. *Reckless disregard* is further defined as serious doubts about the truth of the statement. Conflicts often arise in suits against newspapers when a public official is the plaintiff and tries to find the source of a paper's information in order to show reckless disregard of the truth, while the newspaper tries to protect its source.

The *Sullivan* case placed a greater burden of proof upon public officials in defamation suits. Prior to *Sullivan*, a preponderance of the evidence was proof of defamation, but now the courts require "convincing clarity," which is somewhere between the "preponderance of the evidence" required in most civil suits and the "proof beyond a reasonable doubt" required in criminal cases. For the photographer, the result of *Sullivan* was the public-official privilege—the privilege to examine public officials with considerable scrutiny.

The standards resulting from *Sullivan* were applied in 1984 in the highly publicized case *Sharon v. Time Inc.*, which arose after the massacre of Palestinian refugees by Lebanese Phalangists in retaliation for the assassination of Lebanon's President Gemayel. At the time, Lebanon was occupied by Israeli forces and Ariel Sharon was Israel's defense minister. *Time* magazine published a story alleging that Sharon had secretly discussed the possibility of such a retaliatory attack with Gemayel's family, who remained politically powerful. Sharon sued *Time*, which steadfastly refused to retract the allegations.

The jury held that *Time's* article was false and that Sharon was defamed by it, but the jury also found that *Time* did not possess actual malice, which meant that the magazine did not have to pay any damages. Both sides claimed victory. Sharon declared himself vindicated of the allegations, while *Time* pointed to the fact that it did not have to pay damages to Sharon. Most commentators, however, did agree that *Time* suffered great damage to its journalistic reputation.

Ariel Sharon went on to file a second lawsuit for libel against *Time* in Israel. According to a legal treaty between the United States and Israel, judgments of Israeli courts are recognized in America and vice versa. The Tel Aviv district court judge ruled that he would accept the American jury's ruling that *Time* had defamed Sharon and printed false material about him. Significantly, it is not necessary to prove malice in a libel suit under Israeli law; it is necessary only to show that a story is false and defamatory. Consequently, *Time's* Israeli lawyer was reported as stating that the magazine had little chance of winning in the Israeli court.

In January of 1986, while the Tel Aviv judge was in the process of deciding the case, the parties announced an out-of-court settlement. In return for Ariel Sharon's dropping his libel action, *Time* stated to the Tel Aviv court that the reference to Sharon's supposed conversation in Beirut was "erroneous." In addition, *Time* agreed to pay part of the Israeli minister's legal fees. The *Time* statement appeared to acknowledge more culpability than had previously been admitted. The difference in the outcomes in the two cases illustrates the importance of requiring a plaintiff to prove actual malice in a libel suit. To some extent, this requirement in American law results in broader protection for the press than exists in other countries.

The American jury's verdict in *Sharon* may have spurred a settlement in another much-publicized case being tried at the same time, *Westmoreland v. CBS*. In *Westmoreland*, the former commander of American troops in Vietnam

challenged allegations of wrongdoing on his part made by CBS in a documentary about the war.

It has been speculated that the parties in *Westmoreland* realized that a verdict similar to that in *Sharon* would be damaging to both of them. Settlement of the case allowed both sides to claim victory without the necessity of submitting the issues to a jury.

The depth of criticism required for a finding of libel under the public-official privilege created in *Sharon* varies from case to case. While the most intimate aspects of private life are fair game when one is discussing an elected official's or a candidate's qualifications for political office, when discussing civil servants, such as police and firefighters, only comments directly related to their function as civil servants are privileged.

The Supreme Court has defined public officials as those "who have, or appear to the public to have, substantial responsibility for or control over the conduct of governmental affairs." This category has been held to include all civil servants from police officers to secretaries. Recently, the court has begun applying the public-official exception to public figures as well, but it has experienced a good deal of difficulty in determining who should be considered a public figure.

A Public Figure. At present, the U.S. Supreme Court recognizes two ways in which people may become public figures. The first is to "occupy positions of such persuasive power and influence that they are deemed public figures for all purposes." This category includes those who are frequently in the news but are not public officials, such as Madonna and Brad Pitt. The fact that they are deemed public figures "for all purposes" means that the scope of privileged comment about them is virtually without limit.

The second way of becoming a public figure is to "thrust [oneself] to the forefront of particular public controversies in order to influence the resolution of the issues involved." This category has two requirements. First, there must be a public controversy. The court in *Time, Inc. v. Firestone* held that not every newsworthy event is a public controversy; nor is an event a public controversy merely because there may be different opinions as to the propriety of an act.

The *Firestone* case is a good example of how narrowly the court applies the term "public controversy." *Time* magazine accidentally published a story stating that Mr. Firestone was divorced from Mrs. Firestone because of "[his] extreme cruelty and [their] adultery." In fact, the divorce was granted because the judge found that neither party to the divorce displayed "the least susceptibility to domestication," a novel ground for divorce under Florida law. *Time* went astray because the judge himself had once commented that there was enough testimony of extramarital adventures on both sides "to make Dr. Freud's hair curl." In its defense against Mrs. Firestone's suit for libel, *Time* insisted that Mrs. Firestone was a public figure. As evidence of this, it showed that the divorce had been covered

in nearly every major newspaper and that Mrs. Firestone herself had held periodic press conferences during the trial, but the court refused to equate a *cause célèbre* with a public controversy. As a result, Mrs. Firestone was required to prove only that *Time* had been negligent in its reading of the court's opinion and that there was actual injury.

The second requirement in this public-figure category is that the person has voluntarily thrust him- or herself into the controversy in order to influence the issues. This requirement would be met if someone's actions were calculated to draw attention to that person or to arouse public sentiment but not if the person were arrested or convicted. A student who makes a speech during a peace demonstration, say, is considered a public figure only with respect to the subject of the demonstration. In matters that have nothing to do with the political controversy, the courts would probably regard the student as a private individual.

To reiterate, the Supreme Court will require only public officials and public figures to prove actual malice in a defamation suit. Yet, even private persons will have to prove negligence if they sue a newspaper for libel that occurred in a piece relating to a matter of public concern. Although the Supreme Court held that the plaintiff in *Firestone* did not have the heavy burden of proof of a public figure, she still had to prove negligence in her suit for libel. This is more difficult than that which is required of the average person who has been defamed with regard to some private, unnewsworthy matter. Generally, the everyday, private person who sues for libel does not need to prove actual malice or any other state of mind. All he or she needs to demonstrate to the court is that a written work or a photograph's caption identifying him or her conveyed a defamatory meaning and was published.

The Supreme Court recently increased the burden of proof for private plaintiffs suing newspapers writing about matters of public concern. In *Philadelphia Newspapers, Inc. v. Hepps*, a 1986 case, a businessman operating a franchise in Philadelphia sued the *Philadelphia Inquirer* for publication of several articles asserting that he had links to organized crime and had used these links to influence local government. The court held that in such a case, the plaintiff, Hepps, not the defendant, bears the burden of proof on the issue of the truth or falsity of the statement. The court found that the Constitution requires that the burden be so shifted in order to ensure that true speech on matters of public concern not be stifled.

How does one determine whether information is of public concern? The distinction may hinge on whether or not the defendant represents the media. The Supreme Court dealt with the media-nonmedia distinction in a case involving a reporting service that published and circulated a grossly inaccurate credit report. The reporting service pleaded First Amendment protection, but the court, by a five-to-four vote, held that since the credit report was not a matter of public concern, it was not entitled to protection by the First Amendment. Thus, the injured business had only to prove defamation and publication.

Unfortunately, the court did not define what kind of speech or photograph is of public concern. Lacking such a definition, photojournalists and other photographers need to be extremely careful about the subjects of their pictures and accompanying text.

A question that has often been raised by legal scholars but has as yet not received an answer from the courts is whether a person who at one time was a public figure can ever effectively return to private life. It is probably better to remain on the safe side and treat anyone who has been out of the limelight for any significant period as a private person.

Despite the tremendous burden of proof placed upon public officials and public figures, they are still able to win in many defamation suits. For example, Barry Goldwater was successful in his suit against Ralph Ginzburg, who had published an article stating that Goldwater was psychotic and, therefore, unfit to be president. Goldwater proved that material in the article was intentionally distorted. In a later case, actress Carol Burnett won a libel suit against the *National Enquirer.* The article said that Burnett had been drunk and boisterous in a Washington restaurant when, in fact, her behavior had been beyond reproach. Burnett was able to show that the article was published with reckless disregard for the truth or falsity of the facts and thus satisfied the malice requirement.

Protection Against Defamation Suits

Since the law on libel is complicated and subject to continual modification by the Supreme Court, any potentially libelous work should be submitted to a lawyer for review before publication is considered. Remember, everyone directly involved in the publication of libelous material can be held liable. Photographers should be aware that publishers may attempt to protect themselves from defamation suits by including a clause in the photographer's contract stating that the photographer guarantees not to have libeled anyone and accepts responsibility for covering costs if the publisher is sued. The risks involved in agreeing to such a clause are obvious. It is also wise to obtain a signed privacy-and-property-release form from anyone whose name or work is being associated with yours. (See appendix 1 for a sample release.)

-3-
The Rights of Privacy and Publicity

The right to be protected from a wrongful invasion of privacy, largely taken for granted today, is a relatively new legal concept. In fact, the right of privacy was not suggested as a legal principle until 1890 when arguments for developing the right appeared in a *Harvard Law Review* article written by the late Justice Louis Brandeis and his law partner, Samuel Warren. This article, written largely because of excessive media attention given to the social affairs of Warren's wife, maintained that the media were persistently "overstepping in every direction the obvious bounds of propriety and of decency" in violation of the individual's right "to be let alone."

From this rather modest beginning, the concept of a right to privacy began to take hold. In many of the early privacy cases, the *Harvard Law Review* article was cited as justification for upholding privacy claims, although courts also found their own justifications. For example, in 1905, a Georgia court suggested that the right of privacy is rooted in natural law. In the words of the court: "The right of privacy has its foundations in the instincts of nature. It is recognized intuitively, consciousness being the witness that can be called to establish its existence." Other courts have upheld right-of-privacy laws on constitutional grounds, both state and federal, arguing that although there is no express recognition of a right to privacy in the U.S. Constitution, it can, nevertheless, be inferred from the combined language of the First, Fourth, Fifth, Ninth, and Fourteenth Amendments.

Although the right of privacy is now generally recognized, the precise nature of the right varies from state to state. Some states have enacted right-of-privacy statutes. Some simply recognize the right as a matter of common law. Others

expressly refuse to recognize a right of privacy, while still others have not yet taken a position. You should, therefore, keep in mind that the situations discussed in this chapter might be handled differently in the state where you live or work. The cases here should not be relied upon to determine a photographer's rights and liabilities. They are included simply to illustrate some of the legal developments in the area of privacy rights so that you can avoid obvious traps, identify problems as they arise, and know when to consult a lawyer. Since most photographers distribute their work throughout the country, it is prudent to comply with the most stringent state requirements.

The four different types of civil invasion of privacy currently recognized by the courts are:

1. Intrusion upon another's seclusion

2. Public disclosure of private facts

3. Portrayal of another in a false light

4. Commercial appropriation of another's name or likeness

Intrusion Upon Another's Seclusion

An intrusion upon another's seclusion will be wrongful if three elements are present. First, there must be an actual intrusion of some sort. Second, the intrusion must be of a type that would be offensive to a reasonable person (courts will not consider the particular sensibilities of the plaintiff). Third, the intruder must have entered that which is considered someone's private domain. Thus, for example, it is generally not unlawful to take pictures of a person in a public place or disclose facts the person has discussed publicly. It is likely, however, that an intrusion would be wrongful if someone goes on someone else's land without permission or opens someone else's private desk and reads materials found there. Publication is not a necessary element in a case for intrusion since the intrusion itself is the invasion of privacy.

The nature of a wrongful intrusion upon another's seclusion is well illustrated by two cases: *Dietemann v. Time, Inc.* and *Galella v. Onassis.* In *Dietemann*, the plaintiff claimed to be a healer. Investigators for *Life* magazine sought to prove that he was a charlatan. In the process of checking out his claim, reporters entered Dietemann's house under false pretenses, and, while in his house, they surreptitiously took pictures and recorded conversations. This information was then written up in an expose appearing in *Life.* The court held that the healer's right of privacy had indeed been violated, since there was no question that his seclusion was invaded unreasonably.

An even more obvious intrusion is illustrated by *Galella v. Onassis.* Ronald Galella, known for his persistence and tenacity, is a freelance photographer specializing in photographs of celebrities. For a number of years Jacqueline Onassis,

Caroline Kennedy, John Kennedy, Jr., and other members of the Kennedy family were among his favorite subjects. Onassis and the others were constantly confronted by Galella, who used highly offensive chase scene techniques, in parks and churches, and at funeral services, theatres, schools, and elsewhere. One of his practices was to shock or startle his subjects in order to photograph them in a state of surprise. While taking these photographs, he would sometimes utter offensive or snide comments. After hearing a wealth of evidence regarding this type of behavior, the court, in a scathing opinion, held that Galella had wrongfully intruded upon the seclusion of his subjects. Finding monetary damages to be an inadequate remedy, the court issued a permanent injunction that prohibited Galella from getting within a certain distance of Onassis and the others. A decade later, the court found that Galella had repeatedly violated this injunction and was thus guilty of civil contempt. In order to avoid a prison sentence of up to six years and a fine of up to $120,000, Galella promised the court he would never again photograph Onassis or her children.

In both *Dietemann* and *Galella*, the defendants maintained that any attempt to restrain their efforts to get information or photographs was constitutionally suspect, since it would infringe upon their First Amendment rights. These arguments are not particularly persuasive. Courts have universally attempted to balance rights in intrusion cases: The right of the press to obtain information is balanced against the equal right of the individual to enjoy privacy and seclusion. Thus, the courts have refused to construe the First Amendment as a license to steal, trespass, harass, or engage in any other conduct that would clearly be wrongful or offensive.

This balancing approach is apparent in *Galella*. The court found that the intrusions were so pervasive and offensive that it did not matter that many of the acts occurred while Onassis and her children were in public rather than private places. Their right to privacy had been significantly infringed. Furthermore, the products of Galella's efforts were trivial, being nothing more than fodder for gossip magazines. Thus, the harmful effect of suppressing Galella's First Amendment freedoms was found to be slight or nonexistent. Significantly, the court did not at first forbid further photographs, but merely regulated the manner in which they could be taken.

For the dedicated photojournalist, the possibility of an intrusion suit should always be weighed against the natural tendency to aggressively pursue the facts, but even photojournalists on important assignments have no right to harass, trespass, use electronic surveillance, or enter a private domain.

Photographers should be aware that even a photograph taken in a public place can result in liability for wrongful intrusion. In *Daily Times Democrat v. Graham*, the court found wrongful intrusion when a photographer took the picture of an obese woman whose skirt was blown upward while she was standing in a fun house. Some states have statutes that make the use of hidden cameras a misdemeanor. For instance, Oregon has a statute covering photographs or videos of nudity or "intimate areas" (e.g., undergarments, genitalia, and female nipples)

without consent where the person has a reasonable expectation of privacy, such as when in restrooms, lockers rooms, and dressing rooms, where the photographs or videos are taken "for the purpose of arousing or gratifying the sexual desire of the defendant."

In general, however, most photographs shot in public places are not problematic. In fact, Google's Street View application has recently been held not to be an invasion of privacy. See, for instance, *Boring v. Google*, a case brought by a couple after a Google Street View camera-car drove past a "private road" sign in their driveway to take pictures of their house. The judge held that although Google had trespassed to take pictures, no evidence was submitted to show that the Street View service caused mental shame, suffering, or humiliation to a person of ordinary sensibilities, and thus there was no invasion of privacy.

Anti-Paparazzi Legislation

In 1998, California enacted a law designed to protect people from offensive news-gathering techniques. This law prohibits trespassing with the intent to capture any type of visual image, sound recording, or other physical impression of another engaging in "personal or familial activity" where the physical invasion occurs in a manner offensive to a reasonable person. It also prohibits the attempt to capture any type of visual image, sound recording, or other physical impression, through the use of a visual- or an auditory-enhancing device, of the person engaging in a personal or familial activity under circumstances in which the plaintiff had a reasonable expectation of privacy, even without physical trespass, if the image, sound recording, or physical impression could not have otherwise been obtained without a trespass. Personal and familial activity is defined to include intimate details of the plaintiff's personal life, interaction with the plaintiff's family or significant others, and other aspects of the plaintiff's private affairs, but does not include criminal activity.

While the law as originally enacted provided immunity for the media publishing such photographs, effective January 1, 2010, the law applies to the media if it knowingly publishes any photograph taken in violation of the law. In addition, it provides for the imposition of civil fines ranging from $5,000 to $50,000 for violations of the law, in addition to the penalties set forth in the original statute, namely, liability for up to three times the amount of actual damages, as well as punitive damages. Further, if the invasion of privacy was committed for a commercial purpose, the defendant may be required to pay proceeds from the commercial use to the plaintiff. The court can also grant a restraining order.

Public Disclosure of Private Facts

The public disclosure of private facts was the aspect of the right of privacy that first prompted Warren and Brandeis to publish their article in the *Harvard Law*

Review (discussed on the first page of this chapter). Plaintiffs are less likely to win in these circumstances, however, because the First Amendment protection that modern courts apply to "newsworthy information," which includes educational or informative material, as well as current events, makes it unlikely that photographers depicting matters of public interest will incur liability for public disclosure. Where the information disclosed is true, the First Amendment freedoms afforded to the press almost invariably outweigh an individual's right of privacy. Only in very limited circumstances will the balance be shifted in favor of the individual.

In order to bring a case for this kind of invasion of privacy, the plaintiff must prove that private facts about him or her were publicly disclosed and that the disclosure would be objectionable to a person of ordinary sensibilities. If the facts are newsworthy, the disclosure must be outrageous in order to be actionable.

The first question, then, is whether a photograph involves private facts. This is basically a matter of common sense; anything that one keeps to oneself and would obviously not wish to be made public is probably a private fact. Thus, private debts, certain diseases, psychological problems, and the like usually involve private facts.

There is some seemingly private information that courts will treat as public. For purposes of defining potential invasion of privacy liability, "official public records" include legislative, judicial, and executive records and records of documents affecting title to property, such as deeds and vehicle title transfers. Information contained in a public record is never considered to be private. This principle was firmly established by the Supreme Court in the mid-1970s in *Cox Broadcasting Corp. v. Cohn.* At issue was the constitutionality of a Georgia statute that made it a misdemeanor to publicly disclose the identity of a rape victim. In violation of this statute, someone at the broadcasting company made known the name of a rape victim, on the basis of information gleaned from a court indictment. The plaintiff, the father of the deceased victim, sued the broadcaster for publicly disclosing private facts, arguing that the statute converted the information into private facts. The highest Georgia court ruled in favor of the father, but when the case reached the Supreme Court, the decision was reversed. In a sweeping opinion, the court declared that no one could be liable for truthfully disclosing information contained in an official court record or, by implication, any other public record. Such disclosures enjoy an "absolute privilege" and are treated as public facts, regardless of how personal the information may be. An absolute privilege also exists for public disclosure of private facts made in the context of judicial, legislative, or executive proceedings.

The second requirement a plaintiff must meet in a case for public disclosure is proving that the public disclosure of private facts would be offensive to a reasonable person of ordinary sensibilities. Although a recluse may place a very high premium on absolute privacy, the law does not give such special rights. If a

disclosure is minimal and, therefore, not offensive to the sensibilities of reasonable persons, the recluse will have no cause of action, even though, from a recluse's personal perspective, the disclosure may seem egregious.

Disclosures of newsworthy information are generally protected by the First Amendment. As long as such disclosure is truthful, the disclosure is privileged, and an individual's right to privacy will outweigh First Amendment freedoms only when the disclosure is outrageous. This privilege regarding newsworthy information significantly insulates media photographers from liability for invasion of privacy.

Photographs with seemingly private subject matter tend to be treated as public if the photographs were taken in public places. For example, in *Anderson v. Fisher Broadcasting Companies, Inc.*, the Oregon Supreme Court refused to recognize an accident victim's claims that his privacy was invaded by a tape shown in an advertisement for a news feature on emergency medical care. The court held that unless the plaintiff could prove fraud or intentional infliction of emotional distress, there was no liability, even though the facts contained on the tape were not newsworthy. Similarly, courts ruled that neither a photograph of a couple embracing in a marketplace nor a photograph of a defendant in a courtroom were actionable.

Because photographers generally have the right to take photographs in public places, the persons being photographed should use care in addressing the perceived intrusion. For instance, a photographer who shot a photograph of Mick Jagger kissing Uma Thurman in a public place was awarded $600,000 after he was wrestled to the ground by Jagger's bodyguard, who confiscated the photographer's camera and destroyed his film.

Generally, truthful disclosures pertaining to public figures or public officials are considered newsworthy, at least to the extent that the disclosure bears some reasonable relationship to the public role. If, however, the disclosure is highly personal, such as sexual habits, and has no bearing upon the individual's public role, the disclosure may not be privileged and thus may be actionable. This is particularly true where the individual does not enjoy a great deal of fame or notoriety. A presidential candidate or a mass murderer, for example, could expect considerably greater intrusions into and disclosure of his or her private affairs than a minor public official or a traffic offender. Similarly, private individuals who are involuntarily thrust into the public light will receive more protection than those who seek fame and notoriety.

A person no longer in the public eye may or may not be considered newsworthy. Some people, of course, remain newsworthy even though they have long since left the public eye, but generally, the newsworthiness of people who once were public officials or public figures tends to decrease with the passage of time. To the extent that these people become less newsworthy, their right to privacy becomes stronger.

Melvin v. Reid, decided in 1931, illustrates the point. The plaintiff in this case was a former prostitute who had been charged with murder but was acquitted after a rather sensational trial. Thereafter, she led a conventional life; she married and made new friends who were unaware of her sordid past. Some years after the trial, a movie of the woman's early life was made, in which she was identified by her maiden name. She sued, alleging public disclosure of private facts, and the court ruled in her favor. The court conceded that the events that initially brought the woman into the public eye remained newsworthy but stated that to identify her by name constituted a "willful and wanton disregard of the charity which should actuate us in our social intercourse." The moviemakers' disclosure was deemed so outrageous that it could not be considered newsworthy, and the disclosure privilege, therefore, did not apply.

The case of *Briscoe v. Reader's Digest Association, Inc.*, provides an interesting contrast. In this 1971 case, the *Reader's Digest* had published an article about truck hijacking. The article related a hijack attempt involving the plaintiff, Briscoe, who was identified by name. During the years between the hijack attempt and the defendant's disclosure, Briscoe had led an exemplary life. He sued for public disclosure of private facts, alleging that as a result of the article he had been shunned and abandoned by his daughter and friends, who previously had not known of the incident.

Although the facts of *Briscoe* were very similar to those of *Melvin*, and although the issue of outrageous disclosure was raised, the information in the *Briscoe* case was considered newsworthy and thus privileged. That this disclosure was considered newsworthy, whereas the disclosure in the *Melvin* case was not, might best be explained by the fact that the *Melvin* disclosure intruded upon the sex life of the plaintiff, revealing that she had once been a prostitute. It would appear that a disclosure is most likely to be considered unconscionable, and thus not newsworthy, if it relates to someone's sexuality, which is perhaps the most private aspect of anyone's life.

Note that today both the *Melvin* and *Briscoe* cases would be decided in view of the holding of *Cox*, discussed above, that all facts disclosed in public records are considered public and absolutely privileged.

One final question that has been the subject of litigation in this area is whether an excerpt taken from a publication and used in an advertisement is privileged to the same extent as it is in the original publication. Although the answer is not altogether clear, it appears to depend on whether the advertisement is used to promote the work from which the excerpt was taken or to promote something else.

In *Friedan v. Friedan*, the defendant, Betty Friedan, the noted feminist, wrote and published an account of her early domestic life. She included several photographs of those early years, one of which was a family portrait of her, her former husband, and their child. This picture was selected for use in a television

commercial promoting the defendant's publication. Carl Friedan, the defendant's former husband, sued her, alleging that the original publication, as well as the advertisements, constituted an invasion of his privacy as a public disclosure of private facts.

The court easily disposed of Carl Friedan's case. Since Betty Friedan was a noted feminist, her life was a matter of public interest. By virtue of being her former spouse, Carl Friedan also became newsworthy, despite the fact that he had persistently sought to avoid publicity. Because he was deemed newsworthy, the public disclosure about his past private life was permissible. As to the commercial, the court held that where an advertisement is used to promote the publication from which the excerpt was taken, the advertisement will enjoy the same protection as the original publication. Therefore, since Betty Friedan's biographical account was permissible, the television commercial was also permissible.

The case of *Rinaldi v. Village Voice, Inc.*, involved a slightly different situation. The plaintiff was a prominent judge. The *Village Voice* published an article critical of his performance on the bench. There was no question as to whether the article was permissible, since the plaintiff was clearly newsworthy and the disclosure pertained to his public role. At issue was the question of whether the *Village Voice* could incorporate excerpts from that article into an advertisement for itself. The court held that the advertisement was not permissible since the excerpts were used for the purpose of increasing subscriptions for subsequent issues of the newspaper. The *Village Voice* was held liable for public disclosure of private facts. Had the advertisement been used to promote the particular issue from which the excerpts were taken, it would, presumably, have been permissible under the reasoning applied in *Friedan*.

Where excerpts or photographs are used for purposes other than advertising, such as the circulation of galley proofs of forthcoming books to newspapers and magazines for review, the excerpts or photographs are more likely to enjoy the same privilege as information published in complete form. In *Estate of Hemingway v. Random House, Inc.*, Ernest Hemingway's widow brought an action against the writer and publisher of the book *Papa Hemingway*. The author had drawn largely on his own recollections of conversations with Ernest Hemingway and included two chapters on the famous novelist's illness and death. The court found that Hemingway was clearly a public figure and rejected the widow's argument that the description of her feelings and conduct during the time of her husband's mental illness was so intimate and unwarranted as to constitute outrageous disclosure. The court also rejected her claim that, even if disclosures in the book were protected by the First Amendment, circulation of galley proofs to book reviewers of sixteen journals and newspapers amounted to unlawful use of private facts for advertising purposes, even if disclosures in the book were protected by the First Amendment. In holding that circulation of proofs to reviewers is not generally advertisement, the court stated:

A publisher, in circulating a book for review, risks unfavorable comment as well as praise; he places the work in the arena of debate. The same reasons which support the author's freedom to write and publish books require a similar freedom for their circulation, before publication, for comment by reviewers.

In summary, a public disclosure of private facts will support a lawsuit if the effect of the disclosure would be objectionable to persons of ordinary sensibilities, unless the disclosure is newsworthy. Whether a disclosure is or is not newsworthy will depend upon the social value of the facts disclosed, the extent to which the plaintiff voluntarily assumed public fame or notoriety, and the extent to which the disclosure related to the plaintiff's public role. Finally, even a disclosure relating to newsworthy persons may be actionable if it would outrage reasonable persons.

Portrayal of Another in a False Light

Portrayal of another in a false light has been actionable as an invasion of privacy for some time. In 1816, in what was probably the first case to address the issue, the poet Lord Byron successfully fought the publication under his name of a rather bad poem that he did not in fact write. Byron was extremely protective of his reputation and apparently felt that the inferior piece would harm his image as an artist.

To bring a suit for false light, a plaintiff must prove that the defendant publicly portrayed the plaintiff in a false light and that the portrayal would be offensive to reasonable people had it been of them. In cases involving the media, the plaintiff must also prove that the portrayal was done with malice.

Thus, false-light cases often involve works that falsely ascribe to the plaintiff particular conduct or action. Usually, photographs do not portray their subjects in a false light, but the accompanying caption or story may, in conjunction with the photograph, create a false impression. For instance, a caption that suggested that two nude models who were photographed together were lesbians was found to be a false-light invasion of privacy in *Douglass v. Hustler Magazine, Inc.*

Leverton v. Curtis Publishing Co. is another example. A young girl who had been struck by an automobile was photographed while a bystander lifted her to her feet, and that photograph appeared in a local newspaper the following day. Nearly two years later the *Saturday Evening Post* published an article entitled *They Ask to Be Killed*, the gist of which was that most pedestrian injuries are the result of carelessness on the part of the pedestrian. The photograph of the girl was used to illustrate the story. The girl sued the *Post* for invasion of privacy, alleging, among other things, that the *Post* had portrayed her in a false light. The court ruled in her favor because the rational inference from the use of the photograph in the article was that the plaintiff had been injured because of her carelessness, when in fact she had been completely without fault.

Another frequent cause of false-light cases involves publications that attribute to someone views or opinions that the person does not actually hold or statements that the person did not make.

An extreme case is *Spahn v. Julian Messner, Inc.*, in which the defendant published a biography of Warren Spahn, a renowned baseball player. This biography was replete with fictionalized events, dramatizations, distorted chronologies, and fictionalized dialogues. Although the biography tended to glorify Spahn, it nevertheless placed him in a false, albeit radiant, light. As a result, the publisher was held liable for invasion of privacy.

Distortions or inaccuracies involving insignificant events, places, and dates are likely to be safe, provided the errors are not pervasive. However, false statements pertaining to significant aspects of someone's life are more likely to result in liability, particularly if they involve highly personal and sensitive matters. The crucial question is whether the false portrayal would be offensive to a reasonable person in the position of the person portrayed. Was the plaintiff, as a result of the publication, humiliated, estranged from friends or family, or embarrassed?

In addition to proving an objectionable portrayal in a false-light case, the plaintiff might also have to prove malice, as is necessary in defamation. Defamation and false-light invasion of privacy have much in common, so that as the law evolves with respect to one, the other is also affected. In 1964, the Supreme Court in *New York Times Co. v. Sullivan* articulated a new requirement for liability in defamation cases: Where the plaintiff is a public figure, public official, or otherwise newsworthy, and where the defendant is a member of the media, the plaintiff must prove that the allegedly defamatory statement was made with malice. Malice is shown if the defendant knew the statement was false or published the statement with reckless disregard for its truth or falsity. The court felt that an unreasonable limitation on First Amendment freedoms would result if liability was imposed for mere negligence or failure to use due care in ascertaining truth or falsity.

The *New York Times* rule was at first limited to defamation cases, making it fairly easy for a newsworthy plaintiff to avoid the more stringent proof-of-malice requirement by couching the complaint in terms of invasion of privacy rather than defamation. If a lawsuit for invasion of privacy could be maintained, the plaintiff could prevail over the media defendant by simply proving negligence.

This rather obvious means of circumventing the *New York Times* rule was done away with three years later in *Time, Inc. v. Hill*. The Supreme Court took the opportunity to extend the rationale of *New York Times* to false-light cases of invasion of privacy. A few years earlier, a family named Hill had been held hostage by escaped convicts, and the incident was subsequently portrayed in a play that differed in many material respects from the actual incident. After the play was written, *Life* magazine published a story on the incident that identified the Hills by name and stated as fact some of the fictionalized and dramatized parts of the play. In the Hills' suit, the court required proof of malice, even though the

action was for invasion of privacy rather than defamation. As a result, newsworthy plaintiffs suing media defendants either for defamation or for invasion of privacy on the basis of public portrayal in a false light must prove that the defendant published with malice.

Although defamation and false-light cases are substantially similar, they do differ in some respects. First, the nature of the injury is different. Defamation is injury to the plaintiff's reputation within the community. False light is more inclusive, extending to injuries to the plaintiff's sensibilities caused by personal embarrassment, humiliation, estrangement of loved ones, and the like. Second, in defamation cases where the plaintiff is a private person who, by circumstances beyond his or her control, is thrust into the public eye, media defendants may be held liable for mere negligence, rather than malice, but in false-light cases, all newsworthy plaintiffs, whether or not they have voluntarily assumed their public role, must prove malice on the part of a media defendant.

Commercial Appropriation of Another's Name or Likeness

Commercial appropriation of someone's name or likeness as an invasion of privacy bears little resemblance to cases based upon wrongful intrusion, public disclosure of private facts, or portrayal in a false light. In all of those situations, the plaintiff must prove that the defendant's words or pictures caused the plaintiff to suffer humiliation, embarrassment, or loss of self-esteem, focusing on the injury to the plaintiff's sensibilities. In contrast, the law against appropriation is designed to protect someone's privately owned or commercial interest in one's own name or likeness. Athletes, movie stars, authors, and other celebrities obviously receive a considerable amount of their income from the controlled exploitation of their names or likenesses. The monetary benefits from such exploitation would be minimal without some legal protection.

In suing for unauthorized commercial appropriation, a person is exercising the *right of publicity*, which is defined as a person's right to exploit his or her name, likeness, or reputation and is commonly applied to entertainers and other famous people. Twenty-five states have some form of protection for the right of publicity—some by statute and some by common law.

In order to bring a suit for this type of invasion of privacy, one need only prove that the defendant wrongfully appropriated the plaintiff's name or likeness for commercial purposes. *Appropriation* in this sense means use. The fact of appropriation is rarely at issue in these cases, since the use will be obvious. However, the purpose of the use must be commercial, or expected to bring profits, either directly or indirectly. A purely private use will not result in liability for wrongful appropriation.

As with the other kinds of invasion of privacy, any use that is considered newsworthy or informative will not be actionable as a commercial appropriation,

even though some commercial gain might result from the use. As you might suspect, it is often difficult to know where to draw the line between "trade and advertising" and "newsworthiness." Each case is looked at in light of its own facts, and often there are gray areas.

In 1990, the New York Court of Appeals concluded that a "real relationship" existed between a magazine article about in vitro fertilization and an accompanying photograph of an unidentified large family. The photograph, therefore, was newsworthy. The family had not given *Omni* magazine permission to use their photograph and sued for invasion of privacy. In *Finger v. Omni Publications Intern., Ltd.*, the court stated that questions of newsworthiness "are better left to reasonable editorial judgment and discretion." Only where there is not any real relationship between a photograph and an article, or where the article is an "advertisement in disguise," should the judiciary intervene.

The California Supreme Court ruled in *Comedy III Productions, Inc. v. Gary Saderup, Inc.*, that California's statutory right of publicity bars commercial exploitation of celebrity images that do not add significant creative elements. Gary Saderup made charcoal drawings of the Three Stooges, which he reproduced on T-shirts and as lithographic prints without the consent of the owner of the rights in the Three Stooges. The court found that the value of his work derived primarily from the fame of the Three Stooges rather than from creative elements of his own. Obviously, this case would likely apply to photographs of celebrities and others.

Another California case, *Michaels v. Internet Entertainment Group, Inc.*, involved a video depicting Pamela Anderson and Bret Michaels having sex. The defendant planned to show the tape on its Internet subscription service, and Michaels and Anderson brought suit seeking an injunction. The court granted the injunction on the basis of copyright infringement, as well as violation of the rights of publicity and privacy.

Namath v. Sports Illustrated involved the use of a celebrity's likeness in an advertisement. *Sports Illustrated* published an article about the 1969 Super Bowl game that included some photographs of Joe Namath. One of those photographs was subsequently used in an advertisement promoting the magazine. Namath sued, alleging that the use of his photograph was a wrongful commercial appropriation. The court held for the magazine, maintaining that its use of Namath's picture was primarily informative because it indicated the general content and nature of the magazine, as well as what subscribers could expect to receive in the future. Commercial benefits were only incidental. However, if *Sports Illustrated* had used Namath's picture in such a way that it appeared that Namath endorsed the magazine, the use would have been actionable, since the commercial purpose could not be said to be incidental to the dissemination of information.

In *Booth v. Curtis Publishing Co.*, *Holiday* magazine shot and published a photograph of actress Shirley Booth as part of a news story about a resort. Miss Booth consented to this use of her photograph but brought suit when *Holiday* republished her photograph six months later as part of an advertisement for

Holiday subscriptions. Here, too, the court denied relief, holding that *Holiday's* use of the photograph fell within the special exemption for incidental advertising of a news medium itself. The court also noted that the actress was properly and fairly presented. The court reasoned that the magazine used the photographs solely to illustrate the quality and content of the magazine and, therefore, the use of the photographs was incidental.

A commercial misappropriation, as well as false-light invasion of privacy, was found in *Douglass v. Hustler Magazine, Inc.*, which concerned photographs published in *Hustler*. The pictures had been taken with the model's consent, but she understood that they would appear in *Playboy*. The court found that model-actress Robin Douglass' right to publicize herself was undermined when *Hustler* deprived her of the choice of publications in which her pictures would appear. However, the court found that *Hustler's* publication of stills from a movie in which Douglass appeared was not misappropriation because the still photographs were in the public domain and, therefore, beyond Douglass' control.

Hoffman v. Capital Cities/ABC, Inc., involved *Los Angeles* magazine's publication of digitally altered photographs in a fashion spread featuring Dustin Hoffman as Tootsie wearing a Richard Tyler gown and Ralph Lauren heels, as well as other actors, including Cary Grant and Marilyn Monroe, wearing contemporary fashions. The Ninth Circuit held that the photograph spread was not an advertisement (despite inclusion of the clothes' prices and a listing of stores where they could be bought) and was protected by the First Amendment.

New York law prohibits use of another's likeness without consent for advertising or trade. A 2006 case, *Nussenzweig v. DiCorcia*, concerned the photograph of an Orthodox Hasidic Jew who believes use of his image for commercial purposes violates the Second Commandment's prohibition on graven images. His image was shot by a professional photographer one day when he was walking through Times Square. This photograph was exhibited at a gallery, along with others, and a catalog of the exhibition was distributed. The photograph was also included in two reviews of the show, and ten editioned prints of the photograph were sold. The court held that although the photograph was sold, the use was artistic rather than commercial and did not violate the New York privacy laws.

In one case, the right of publicity was held to be limited by certain aspects of the federal copyright law. In *Baltimore Orioles v. Major League Baseball Players*, baseball players sued club owners, asserting that their performances during ball games were being telecast without the players' consent and that, under state law, the telecasting constituted a misappropriation of the players' property right of publicity in their performances. The court found that the players' performances were within the scope of their employment, and thus the club owners owned the copyright to the performances. When state and federal law conflict, the federal law takes precedence. In this case, the players' rights of publicity in the game-time performances, as granted by state law, were found to be preempted by federal copyright law.

In *Toney v. L'Oreal USA, Inc.*, however, the Seventh Circuit found that because a model's identity was not and could not be fixed in a tangible medium of expression, the rights protected by the Illinois Right of Publicity Act are not equivalent to the rights protected by copyright and, therefore, the model's right of publicity was not preempted by the copyright laws.

With the advent of people posting snapshots online come new questions. For instance, there are numerous allegations arising out of the use of photographs posted on Web sites such as Flickr. Flickr is an online service that allows anyone with an account to post photographs. Users have the option of granting a Creative Commons license for use of their photographs or of limiting those who are permitted to download their photographs. However, it appears that some unscrupulous individuals download and reproduce photographs without permission, in some cases for commercial purposes.

Appropriation After a Celebrity's Death

A final question is whether a lawsuit based upon commercial appropriation can be brought after the death of the person whose name or likeness was used. In the early 1990s, television commercials featured contemporary entertainers such as Paula Abdul and Elton John singing and dancing with computerized images of deceased entertainers, including Louis Armstrong, Humphrey Bogart, and James Cagney. Does it infringe upon these deceased celebrities' rights of privacy? There is considerable controversy over this issue.

In many states, an entertainer's right of publicity ends when that person dies. Thus, the estates of the deceased stars would have no recourse in many jurisdictions, even though it is highly unlikely that the 1990s advertisers obtained the deceased performers' consents to include them in the commercials. This also raises ethical issues for photographers who provide photographs that could be used to affect a deceased entertainer's reputation.

In a 1984 case in New York, *Southeast Bank, N.A. v. Lawrence*, the court denied the defendants the right to name their Florida theater after playwright Tennessee Williams without his estate's consent. The court held that New York recognizes a common law right of publicity and ruled that the right of publicity survives death and descends to the deceased's heirs. In 1985, it was determined that the law of Florida rather than of New York applied and that Florida recognized only very limited exceptions, not applicable in this case, where the right of publicity survived death.

In a similar case involving the Elvis Presley estate, the plaintiff, Factors Etc., Inc., had acquired the exclusive right to market the name and likeness of Elvis Presley during Presley's lifetime. Factors Etc. sued, after Presley's death, to prevent another company from distributing posters bearing Presley's image. The federal court, sitting in New York and applying New York law, ruled in favor of Factors

in *Factors Etc., Inc. v. Pro Arts, Inc.*, holding that when a party has the right to exploit a name or likeness during the lifetime of the subject, the right survives that person's death.

In another case, *Memphis Development Foundation v. Factors, Etc., Inc.*, involving the same license and essentially the same facts but decided in the State of Tennessee under Tennessee law, the court reached the opposite conclusion. The Memphis Development Foundation had solicited money from the public for purposes of erecting a statue of Presley. A donation of twenty-five dollars or more entitled the contributor to an eight-inch pewter replica of the statue. The foundation sought a court ruling on whether the exclusive license of Factors Etc., Inc., to Presley's likeness was still valid. This time the court held that a suit based upon commercial appropriation under no circumstances survives the death of the person portrayed.

Since then, the Tennessee legislature has passed a statute which explicitly states that the right to publicity *will* survive death and pass to the heir of the person whose name or likeness is commercially appropriated for a period of ten years after the person's death. Several other states, including Florida, Oklahoma, and Virginia, have passed similar laws. California's law had granted such rights only to celebrities who died after December 31, 1984, but on January 1, 2008, a new law took effect, granting the estate or beneficiary of any California celebrity who died within seventy years prior to 1985 the retroactive right to demand payment for commercial use of images of such celebrity. This law was enacted after CMG Worldwide obtained the rights of publicity for Marilyn Monroe from her estate, and two courts—one in New York and one in California—ruled against CMG on the basis that the California law applied only to celebrities who died after 1985, holding that Monroe's right of publicity ceased to exist after her death (see *Shaw Family Archives, Ltd. v. CMG Worldwide, Inc.* and *The Milton H. Greene Archives, Inc. v. CMG Worldwide, Inc.*). Thus, her estate and its licensing agent, CMG, did not own and could not control Monroe's persona. Unfortunately for CMG, after the new law was enacted, a New York court ruled that the California law applies only to people who were domiciled in California as of the date of death, and Marilyn Monroe was not.

Such statutes guarantee the survival of such a right regardless of whether the person's name was commercially exploited during life. However, some states, while recognizing that the right to publicity can survive death, maintain that it will do so only if it was commercially exploited during life.

This raises a difficult question because it gives no rights to the heirs of those famous individuals who chose not to exploit their names and faces while alive. Nevertheless, in *Martin Luther King Jr. Center For Social Change, Inc. v. American Heritage Products, Inc.*, Coretta Scott King persuaded the court to enjoin American Heritage from selling plastic busts of Dr. King even though Dr. King had not commercially exploited his fame during life.

Since the law is unsettled on whether the right to sue for commercial appropriation survives death, it is difficult to make a general statement about the scope of such a right. Perhaps the most that can be said currently is that more and more courts and legislatures are recognizing that death should not automatically extinguish a right as meaningful and valuable as the right to control the use of a person's name or likeness. Many legal commentators approve this trend. Prudent photographers will attempt to comply with the strictest state laws since their work is likely to be distributed throughout the country.

Releases

Use of a photograph without written consent always raises the possibility of a lawsuit based on violation of some aspect of right to privacy. The surest and simplest way to avoid right-to-privacy suits is to obtain a release from the subject of the picture or a release from the owner of any property photographed. (See the sample forms in appendix 1.)

In some states, such as New York, a photographer must obtain written consent for the use of a person's photograph in advertising or promotion. Although an oral release may be legally valid in other circumstances or locales, it may be hard to prove that you received an oral release and difficult to enforce one. Therefore, a release should be in writing.

Generally, contracts require consideration—something that indicates compensation for a service rendered. As a release might be considered a contract, it is probably wise to pay the subject at least a small amount. However, one authority has stated that photographic releases are valid even when the photographer pays the subject nothing in modeling fees or use rights.

Most form releases are designed to protect the photographer. However, if a model has been hired by an advertising agency, the release should also cover the agency and the agency's client. A release should be drafted to include permission for the photographer to take the picture, as well as permission for the photographer to make a certain use of the picture.

Sometimes litigation is threatened or instituted even when a release exists, as was the case with Vanessa Williams. In 1986, the former Miss America dropped a $400 million lawsuit against *Penthouse* magazine and two photographers after concluding that she had signed a model release for the nude pictures that resulted in her relinquishing her crown under pressure.

It is common for a photographer to use a standard release form; however, this form should be used intelligently and modified as needed. Each release should specifically, if briefly, describe the subject matter and the use the photographer plans to make of the picture. A photographer would be wise to stamp the photograph with the same date as the date on the release form; this prevents any confusion or ambiguity as to what is covered when the photograph is released.

A well-drafted model release provides protection for the photographer. In 2005, a New York district court found for defendants in a case brought by tennis player Anastasia Myskina, who had posed nude as Lady Godiva for *GQ's* October 2002 sports issue after signing a standard model release authorizing use of the photographs "for editorial purposes." After the shoot, Myskina posed topless for additional photographs, after the photographer orally agreed not to publish them. Both the Lady Godiva and topless photographs were published in the Russian magazine *Medved*. Myskina argued, among other things, that the release was not binding because she was not fluent in English and that she would not have signed it if she knew the photographs could be used for anything other than the *GQ* cover. The court found that, absent fraud or duress, the release was binding since Myskina signed it and that evidence of the photographer's oral agreement could not be considered because it contradicted the clear terms of the written release.

On the contrary, in *Buller v. Pulitzer Pub. Co.*, the court pointed out that, while a valid release waives the subject's right to sue for invasion of privacy, the burden of proof is upon the photographer to show just what was consented to. In *Russell v. Marboro Books*, a fashion model posed reading in bed, fully clothed, for an advertisement to promote a book club. The model signed a broadly worded waiver that allowed the book club to make unrestricted use of the photograph, although it did not permit the photograph to be altered. However, when the book company sold the photograph to a bed sheet manufacturer who retouched the photograph, putting the title of a well known pornographic book on the book the model held in the picture and running the photograph with sexually suggestive copy, the model sued, alleging that her personal and professional standing were damaged by the bed sheet advertisement. The court awarded her damages on the basis of invasion of privacy and libel, reasoning that the release was ineffective because the content of the photograph was altered so as to make it substantially unlike the original. Thus, a release should include a clause granting the right to alter a photograph and granting the right to add any type of copy or captions.

In the event a photographer has not obtained a release on a particular photograph, he or she may achieve limited protection against a third party's unauthorized use of the photograph by stating on the back of the picture: "This photograph cannot be altered for commercial or advertising use; nor can it be copied, televised, or reproduced in any form without the photographer's permission."

Photographers should be aware that a release signed by the parent of a child subject may not be valid in all instances. Current court decisions uphold the validity of releases signed by parents; however, language in these cases indicates that courts would refuse to find the releases binding in certain circumstances.

In *Faloona by Fredrickson v. Hustler Magazine, Inc.*, the mother of two minor children executed a full release to a photographer for the use of nude photographs of her children. The children and their mother sued the photographer when the children's picture appeared in *Hustler* magazine. While not objecting to the photographs per se, the plaintiffs believed that publication in *Hustler* constituted false-light invasion of privacy, public disclosure of private facts, and commercial misappropriation. The court applied Texas law, which provides that a parent has the authority to consent to matters of substantial legal significance concerning a child, and dismissed the case. New York and California have laws similar to those of Texas on the issue of parental consent; presumably, similar cases would have the same outcome in these jurisdictions. However, in *Faloona*, *Hustler* showed the children's photograph to illustrate a review of a sex education book in which the photograph originally appeared. Had *Hustler* used the photograph in a salacious manner, the court probably would have invalidated the consent.

In *Shields by Shields v. Gross*, the court held that when the parent or guardian of a minor gives unrestricted consent to a photographer to make a commercial use of the minor's photograph, the minor may not later make use of the common law right to break a contract entered into while she was a minor. However, photographers should be aware that this case contains a strong dissent, and the holding was influenced by the fact that Ms. Shields was a professional actress, although a child. The holding has evoked critical commentary, as many believe that a minor's right to privacy should supersede the business community's interest in binding minors to contractual terms. The law may change in the future to reflect this philosophy.

Some states, including California, have legislation, known as Jackie Coogan legislation, requiring photographers to follow strict requirements when using a minor as a model. It is, therefore, advisable to check with an attorney before you use a child model.

Since the legal concepts discussed in this chapter are still evolving, and because their treatment varies from state to state, you as a photographer would be well advised to work closely with a lawyer when a question arises regarding invasion of a right to privacy.

The model release in appendix 1 follows the principles that we have discussed. The form can—and should—be modified to meet any special needs that you may have.

-4-
Censorship and Obscenity

The First Amendment of the United States Constitution states in part, "Congress shall make no law . . . abridging the freedom of speech, or of the press." First Amendment absolutists insist that the words are all encompassing and that no law should ever be enacted that places any restriction whatsoever on the free exercise of speech or press. Although a strict reading of the Constitution may support this opinion, the judiciary has never fully upheld it and has ruled that certain types of speech are not protected by the First Amendment.

Two theories have been used to justify exceptions to First Amendment protection. The first theory maintains that although certain expressions do normally deserve First Amendment protection, such protection will not be forthcoming if another right, either public or private, outweighs the citizen's First Amendment rights. Examples of speech (which has been defined as including photographs) that are not absolutely protected include defamatory remarks, remarks that advocate unlawful conduct, and remarks that invade someone's privacy.

The second theory suggests that certain expressions do not constitute speech for purposes of First Amendment protection because they are without serious social value. Under this theory, courts often maintain that obscene works are not protected.

Prior Restraint

When the First Amendment was being written, the memory of the English licensing system, under which nothing could be published without prior approval, was

still vivid in the minds of the framers of the Constitution. Some historians suggest that the First Amendment was written specifically to prevent such prior restraints. Today, the First Amendment means more than freedom from prepublication censorship, but because of its potential for abuse, censorship before publication is still considered more serious than restrictions imposed after publication. The Supreme Court in *Near v. Minnesota* recognized that "liberty of the press . . . has meant, principally although not exclusively, immunity from previous restraints and censorship."

Prior restraints impose an extreme burden upon the exercise of free speech since they limit open debate and the unfettered dissemination of knowledge. It is not surprising that the Supreme Court has almost universally found that it is unconstitutional to restrain speech prior to a determination of whether the speech is protected by the First Amendment.

Prohibition of Political Speech

A prior-restraint lawsuit generally begins with a request, often by the government, for a court order prohibiting publication of information already in the media's possession. Where controversial political speech is involved, the government may argue that publication will cause substantial and irreparable harm to the United States. In *New York Times Co. v. United States*, for example, the government tried to stop the publication of the Pentagon Papers, which detailed U.S. involvement in Vietnam prior to 1968. The government claimed that publication would prolong the war and embarrass the United States in the conduct of its diplomacy.

The Supreme Court found that the government's claim of potential injury to the United States was insufficient to justify prior restraint. The justices, although believing that publication would probably be harmful, were not persuaded that publication would "surely" cause the harm alleged. Justice Potter Stewart wrote a concurring opinion emphasizing that the government must show that disclosure "will surely result in direct, immediate, and irreparable damage to our Nation or its people."

In a later case, *United States v. The Progressive, Inc.*, the government used a similar argument: national security. In the *Progressive* case, the government sought to prohibit publication of a magazine article that detailed a method for constructing a hydrogen bomb. The government's case was weak for a variety of reasons, not the least of which was the fact that the alleged secrets were not then classified and had in fact been published in books, journals, magazines, and the government's own reports. Any diligent reporter could have uncovered the same information. Perhaps realizing the impossibility of meeting the test of "direct, immediate, and irreparable damage" laid out in the 1971 Pentagon Papers case, the government abandoned the suit, but not until after raising the chilling threat of prior restraint.

Prohibition of Pretrial Publicity

Another kind of suppression of the free flow of information involves the restriction of pretrial publicity. Here the conflict is between the individual's right to a fair trial and the right of the press to its First Amendment guarantee of free speech. This conflict was addressed in *Nebraska Press Association v. Stuart.*

The Nebraska Press Association appealed a court order prohibiting the press from reporting on confessions and other information implicating an accused murderer after the murder of six family members had gained widespread public attention. The trial judge originally issued the order because he felt that pretrial publicity would make it difficult to select a jury that had not been exposed to prejudicial press coverage.

The Supreme Court, nonetheless, struck down the trial judge's order, finding that the impact of publicity on jurors was "speculative, dealing with factors unknown and unknowable." The justices went on to suggest alternatives to restraining all publication, including changing the location of the trial, postponing the trial, asking in-depth questions of prospective jury members during the selection process to determine bias, explicitly instructing the jury to consider only evidence presented at trial, and isolating the jury.

This decision appears to go far in requiring that other methods of pretrial precautions be taken and that an order restricting press coverage be used only as a last resort. While this case involved press coverage, the same rule should apply to a photographer who wishes to publish a photograph of the scene of a crime or one that may be involved in litigation.

Prohibition of Commercial Speech

In other areas, however, the court has been more tolerant of prior restraints. For example, the court held in *Virginia State Board of Pharmacy v. Virginia Consumer Council, Inc.,* that prior restraints are sometimes permissible when purely commercial speech, such as advertisements or other promotional material, is involved. In that case, the court considered the constitutionality of a Virginia statute that prohibited pharmacists from advertising prices of prescription drugs. The court held that the statute was unconstitutional and, thereby, rejected the notion that commercial speech is never entitled to First Amendment protection.

However, the court distinguished commercial speech from ordinary speech in discussing the application of the First Amendment to it. Since many of the dangers associated with prior restraints (such as suppression of political dissent) were not deemed to be present, the court ruled that prior restraints of commercial speech are not always unconstitutional. Here, too, the rule announced by the court should apply to prior restraint imposed on photographs.

Prohibition of Obscene Speech

Prior restraints have also been upheld where the suppressed material was obscene, but the Supreme Court has imposed several procedural safeguards for this type of case. For example:

- The accused must be given a prompt hearing
- The government agency making the accusation carries the burden of showing that the material is, in fact, obscene
- A valid final restraint can be issued only after a judicial proceeding
- Once the government agency has itself made a finding of obscenity, it must take action on its own behalf in a court of law to confirm its own finding

Prior restraints on commercial speech and alleged obscenity are less often condemned by the courts because the immediately topical nature of and public interest in the free flow of political speech are not characteristic of commercial or sexual expressions; therefore, the public interest is not compromised as much by delays in publication of sexual expressions. As Justice John Harlan commented in *Quantity of Copies of Books v. Kansas*, ". . . sex is of constant but rarely particularly topical interest."

The Scope of Permissible Prior Restraints

It should be emphasized that the major presumption the court made in *Near v. Minnesota* is still applicable: The chief purpose of the First Amendment's freedom-of-the-press provision was to prevent prior restraints on publication. In *Near*, the court listed only three situations that *might* justify prior restraint:

1. The need to prevent obstruction of a government's recruiting service or to prevent publication of the sailing dates of transport ships or the number and location of troops
2. Failure to meet the requirements of decency, as in an obscene publication
3. The necessity of avoiding incitement to acts of violence and the overthrow by force of orderly government

These three exceptions, along with the requirements that the government prove with certainty that particular speech is unprotected and is likely to cause irreparable harm, limit the scope of permissible prior restraint.

It is worth noting that the Supreme Court has held that a school could suspend a student because of a speech he made containing numerous sexual metaphors, despite the student's claim of First Amendment protection. The court felt that the school's right to maintain an appropriate educational environment for children outweighed the student's right of free speech.

Obscenity

Obscenity is perhaps the area where most of the censorship in this country has occurred.

A variety of laws are involved in regulating obscene materials. Some state laws prohibit publication, distribution, public display, or sales to minors of obscene material. Some city ordinances prohibit any commercial dealings in pornography whatsoever. Transporting obscene material across a state line or national border is forbidden by federal law, and it is a crime punishable by up to five years in jail to send obscene materials through the U.S. mail.

Since the private possession of obscene material is not unlawful, one who simply photographs material that could be categorized as obscene has not thereby violated obscenity laws.

However, in *Osborne v. Ohio*, the state court upheld a statute making even the private possession of child pornography illegal. The court felt that child pornography was entitled to minimal protection and that the states' interest in destroying the market for child pornography was sufficient to allow Ohio to proscribe the possession and viewing of child pornography. The court also noted that pedophiles use child pornography to seduce other children into sexual activity. In a 2001 criminal case in Ohio, a man was convicted for his fourteen-page journal involving three fictitious children who are depicted as being placed in a cage in a basement, sexually molested, and tortured.

You should be aware that if your work is declared obscene, you may face a lawsuit from your publisher since many photographer-publisher contracts contain a warranty or indemnity clause stating that nothing in the work is obscene. In the event that the photograph is declared obscene, such a clause may entitle the publisher to either sue the photographer directly for breach of warranty or bill the photographer for any losses the publisher incurred in an obscenity suit.

Defining Obscenity

It has been the task of the Supreme Court, as the ultimate interpreter of the Constitution, to devise a definition of obscenity that is specific and, at the same time, flexible. It must be specific if it is to provide useful guidance to photographers and publishers, and it must be flexible to accommodate changes in social mores and ethics.

As the court has attempted to formulate a definition that accomplishes these two objectives, the law of obscenity has undergone rapid changes.

The Roth Definition

In *Roth v. United States*, a New York publisher and distributor of books, photographs, and magazines was convicted in the 1950s of violating a federal obscenity statute by mailing obscene circulars and advertising an obscene book. He appealed to the U.S. Supreme Court, claiming that his conduct was protected by the First Amendment. The court rejected this argument and affirmed the conviction, but in the course of its opinion, it did away with the standard that had

been applied to obscenity cases since 1868, the test devised by a British court in *Regina v. Hicklin.*

The *Regina* court had held that a publication that condemned certain practices of Roman Catholic priests in the confessional was obscene. There, the test for obscenity was "whether the tendency of the matter charged as obscenity is to deprave and corrupt those whose minds are open to such immoral influences and into whose hands a publication of this sort may fall." Because this test dictated that the material be judged according to the effect of an isolated excerpt upon persons of delicate sensibilities, it subjected to threat of censorship any adult treatment of sex, among other things, and endangered the right to publish and distribute many highly acclaimed literary works.

In recognition of these problems, the court, in considering *Roth,* set forth a new standard: A work would be considered obscene if "to the average person, applying contemporary community standards, the dominant theme of the material taken as a whole appeals to prurient interest."

It was hoped that *Roth* would stabilize the law of obscenity, but confusion remained. In *Jacobellis v. Ohio,* the Supreme Court reversed a conviction for violation of an Ohio statute that prohibited the possession and exhibition of obscene films. The Supreme Court held that the lower court had erroneously construed the phrase "contemporary community standards" to mean local rather than national standards. The court thought that allowing local standards to govern would have the effect of denying some areas of the country access to materials that were acceptable in those areas, simply because publishers and distributors would be reluctant to risk prosecution under the laws of more conservative states where the same materials would be unacceptable. By applying a national standard to the case, the court maintained that the film was not obscene.

The question remains, however, of how to define the national standard. In *Roth,* it seems to have been found in the personal tastes and predilections of the majority of the justices, particularly in light of Justice Stewart's statement on the nature of obscenity: "I know it when I see it."

The Memoirs Definition

When the attorney general of Massachusetts requested a court order declaring the book *Fanny Hill* obscene, the Massachusetts courts ruled in his favor. On appeal, the Supreme Court in *Memoirs v. Massachusetts* reversed the Massachusetts courts, holding that the mere risk that a work *might* be exploited by advertisers because of its treatment of sexual matters is not sufficient to make it obscene. Instead, the court held in a plurality opinion that the prosecution must establish three separate elements to prove obscenity:

1. The dominant theme of the material taken as a whole appeals to a prurient interest in sex

2. The material is patently offensive because it affronts contemporary community standards relating to the description or representation of sexual matters

3. The material is utterly without redeeming social value

However, even this three-part test has not brought clarity to the law of obscenity. In 1972, six years after the *Memoirs* decision, the Supreme Court was again confronted with a state court's overly broad definition of obscenity. The case was *Kois v. Wisconsin*.

In *Kois*, the Wisconsin state court convicted the publisher of an underground newspaper of two counts of violating a state obscenity statute that prohibited the dissemination of "lewd, obscene, or indecent written matter, pictures, sound recording, or film." The first count was for publication of an article that reported the arrest of one of the newspaper's photographers on a charge of possession of obscene material. Two relatively small pictures, showing a nude couple embracing in a sitting position, accompanied the article. The second count was for distributing a newspaper containing a poem entitled *Sex Poem*, which was a frank, play-by-play account of the author's recollection of sexual intercourse.

The Supreme Court reversed the obscenity conviction, finding that for the first count, the pictures were rationally related to an article that was clearly entitled to First Amendment protection. As for the second count, the poem had "some of the earmarks of an attempt at serious art."

The Miller Definition

The Supreme Court tried again to provide a workable definition in its 1973 *Miller v. California* decision. In this case, Marvin Miller sent five unsolicited brochures to a restaurant. The brochures advertised four books: *Intercourse*, *Man-Woman*, *Sex Orgies Illustrated*, and *An Illustrated History of Pornography*. Also included was a film entitled *Marital Intercourse*. The brochures contained pictures of men and women in a variety of sexual positions with their genitals displayed.

In reviewing *Roth* and *Memoirs*, the court concluded that one thing had been categorically settled: "Obscene material is unprotected by the First Amendment," but because any limitation on an absolute freedom of expression could lead to undesirable and dangerous censorship, it was deemed essential that state obscenity laws be limited in scope and properly applied. These concerns are manifest in the *Miller* obscenity test, which substantially modified the *Roth-Memoirs* test. The *Miller* test is:

1. Whether "the average person, applying contemporary community standards" would find that the work, taken as a whole, appeals to the prurient interest

2. Whether the work depicts or describes, in a patently offensive way, sexual conduct specifically defined by the applicable state law

3. Whether the work, taken as a whole, lacks serious literary, artistic, political, or scientific values

Thus, the *Roth-Memoirs* requirement that prosecutors prove that the challenged material is "utterly without social value" was replaced by a new standard that required merely the absence of "serious social value." Moreover, the court upheld the right of a state to apply a local rather than a national standard in enforcing its obscenity laws.

The intent of *Miller* was to provide much clearer guidelines for protected speech, both to state legislatures enacting statutes and to prosecutors enforcing that legislation. *Miller* required that state statutes be more specific, so the states attempted to define the *Miller* test for their own communities. However, instead of clarifying the law, the hodgepodge of legislation spurred by *Miller* has only contributed to the vagueness, increased breadth, and chilling effect of obscenity legislation. Inconsistencies in the laws require the photographer to be aware of local statutes and ordinances in each area where distribution of a given photograph is planned.

Defining "Community Standards." One of the greatest difficulties courts have had in applying the *Miller* test has involved defining "community" for the purposes of ascertaining moral standards. The Supreme Court said in 1974 that *Miller's* effect "is to permit the juror in an obscenity case to draw on his own knowledge of the community from which he comes in deciding what conclusion an 'average person' would reach in a given case." The court, however, does not require that the juror be instructed as to how large the relevant community is geographically. Instructions that direct the jury to apply "community standards" without specifying the boundaries of that community are acceptable. In reaffirming the idea that jurors are to draw on their own knowledge, the court has emphasized that community standards are not to be defined legislatively.

Defining "Patently Offensive." The Supreme Court in *Miller* provided some guidance as to the meaning of "patently offensive," indicating that the phrase refers to "hard-core" materials, which, among other things, include "patently offensive representations or descriptions of ultimate sexual acts, normal or perverted, actual or simulated," and "patently offensive representations or descriptions of masturbation, excretory functions, and lewd exhibitions of the genitals." These examples indicate that materials less than "patently offensive" may well be entitled to First Amendment protection and thus serve as a limitation on the states' powers to arbitrarily define obscenity.

In *Jenkins v. Georgia*, the Supreme Court applied this standard to the Academy Award–winning film *Carnal Knowledge*. A Georgia court had convicted the defendant after a jury determined that the film was obscene. Although the court recognized that the issue of obscenity was primarily a question of fact to be determined by the jury, it was not willing to grant the jury unlimited license in making that determination. Because the court decided that the film was not sufficiently hardcore to be considered patently offensive, it reversed the jury's decision and the resulting conviction.

Defining the "Prurient Interest" of the "Average Person." According to the ruling in *Miller*, to be judged obscene, a work must appeal to the "prurient interest" of the "average person." "Prurient interest" is an elusive concept, but that did not stop the Supreme Court from attempting to define it in *Roth* as that which "beckons to a shameful, morbid, degrading, unhealthy, or unwholesome interest in sex." Some states have attempted to write their own definition of "prurient interest" into their obscenity statutes. One such attempt that was challenged as overly broad led to yet another Supreme Court decision on obscenity in *Brockett v. Spokane Arcades, Inc.*

The statute challenged in *Brockett* defined obscene matter as that appealing to the prurient interest, which was further defined as "that which incites lasciviousness or lust." The Supreme Court held that by including "lust" in its definition of prurient, the statute extended to material that merely stimulated normal sexual responses. Thus, the statute was overly broad and unconstitutional. The court indicated that material said to appeal to prurient interests is to be judged by its impact on the normal person, not by its effect on those who are easily influenced or unusually sensitive. Thus, a jury is not to consider the effect the material in question would have on those under eighteen.

These statements by the court raise the possibility of a defense argument that if a work obviously appeals to a bizarre or deviant sexual appetite, acquittal is required because the "average person" is not affected. A widely recognized exception to the average-person standard has been established by the court, however, where it can be shown that a given book, magazine, or film was designed for and distributed only to a well-defined deviant group.

The issue of whether material appeals primarily to the prurient interest may be influenced by the manner in which it is advertised. Evidence of an advertising practice known legally as *pandering* may contribute to the likelihood that a work will be declared obscene. Pandering occurs when materials are marketed by emphasizing their sexually provocative nature.

The relevance of pandering was first determined by the Supreme Court in 1966 in *Ginzburg v. United States*. In *Ginzburg*, the Supreme Court reviewed a conviction under a federal obscenity statute for distribution of several publications containing erotic materials that, because they were of some value to psychiatrists and other professionals, were not in and of themselves obscene. However, since the defendants had portrayed the materials as salacious and lewd in their marketing and had indiscriminately distributed those works to the general public, the trial court had found the materials to be obscene. The Supreme Court affirmed, stating that evidence of pandering is relevant to the question of obscenity.

The Supreme Court again upheld the relevance of pandering in *Hamling v. United States*. In that case, the court made it clear that when the obscenity question is a close one, evidence of pandering may be considered. Such evidence is but one factor in determining whether a work is obscene, however, and does not replace the *Miller* test.

Thematic Obscenity. Obscenity that is more or less the central theme of a work and thus relevant to the ideas the work intends to express is known as *thematic obscenity.* Such material is not completely beyond the reach of the states if it is, in fact, obscene. At the same time, the Supreme Court is extremely suspicious of state obscenity statutes that appear to prohibit sexually explicit materials that convey certain ideas rather than sexually explicit and patently offensive materials in and of themselves.

The Supreme Court addressed thematic obscenity in *Kingsley International Pictures Corp. v. Regents of the University of New York.* In this case, the court reviewed a New York statute that forbade licenses for the exhibition of motion pictures that portrayed "acts of sexual immorality . . . as desirable, acceptable, or as a proper pattern of behavior." Application of the statute had resulted in denial of a license for *Lady Chatterley's Lover,* a film that portrayed an adulterous relationship.

The court found that the New York statute went beyond regulating the depiction of patently offensive sexual acts and, in effect, prevented the expression of an idea—namely, that an adulterous relationship could under some circumstances be condoned. Because the right to express ideas is expressly protected by the First Amendment and because the statute denied that right, the statute was deemed unconstitutional.

Another attempt to suppress thematic obscenity was overturned by the court in 1962 in *Manual Enterprises, Inc. v. Day.* This time the court held that a magazine for homosexuals was not obscene. Obscenity, it said, requires proof of two elements: (1) patent offensiveness and (2) appeal to prurient interest. Because pictures in the magazine under attack were found to be no more objectionable than the pictures of female nudes that society tolerates in other magazines, they could not be prohibited simply because they conveyed the idea of homosexuality.

Federal Statutes

Although obscenity laws are often state and local, in some situations, the federal government has passed legislation dealing with specific issues.

Pandering. Under the anti-pandering law, people who receive any pandering advertisements, which those people find erotically arousing or sexually provocative, can notify the Postal Service that they wish to receive no further mailings from the sender. The Postal Service is then required to issue an order directing the sender of such advertisements to refrain from further mailings to those recipients. The U.S. Supreme Court upheld the validity of the anti-pandering law in *Rowan v. U.S. Post Office Dept.* In that case, the Supreme Court said that a "mailer's right to communicate must stop at the mail box of an unreceptive addressee."

The Postal Reorganization Act of 1970 contains a provision that prohibits the mailing of sexually oriented advertisements to any person who has requested that

his name be placed on the Postal Service list of persons desiring not to receive sexually oriented advertising. This law is popularly known as the Goldwater Amendment and was enacted in an effort to prevent the flow of vulgar or pornographic material into the home of anyone not wishing to be subjected to such mail, while preserving the rights of those who want to receive such material through the mail. The notice authorized under the Goldwater Amendment affects all mailers and not just a particular mailer. A person's name and address are kept on the list for five years unless a revocation or renewal is filed.

A year's subscription to a copy of the list of those who do not wish to receive sexually oriented advertisements can be obtained from the Postal Service by payment of an annual service fee, which is determined by dividing the number of buyers for the previous calendar year into the total cost to the U.S. Post Office of compiling, processing, printing, and distributing the list. A sexually oriented advertisement is defined as:

> . . . any advertisement that depicts, in actual or simulated form, or explicitly describes, in a predominantly sexual context, human genitalia, any act of natural or unnatural sexual intercourse, any act of sadism or masochism, or any other erotic subject directly related to the foregoing. [However,] material otherwise within the definition of this subsection shall be deemed not to constitute a sexually oriented advertisement if it constitutes only a small and insignificant part of the whole of a single catalog, book, periodical or other work the remainder of which is not primarily devoted to sexual matters.

Child Pornography Legislation. Attempts to regulate pornography have also been made by legislators enacting child pornography laws. This legislation is designed to curb sexual abuse of children by making it unlawful to use children in explicit sexual performances or pornographic pictures. The Supreme Court has been relatively supportive of state efforts to outlaw pornography dealing with children. In the 1982 case of *New York v. Ferber*, the court held that a state may ban the distribution of materials showing children engaged in sexual conduct even though the material is not legally obscene. State child pornography laws vary widely. It would be a good idea for a photographer who plans to sell or display any pictures depicting children in sexual poses to consult with a lawyer.

As noted above, in 1990, the U.S. Supreme Court upheld a pornography statute in Ohio criminalizing the private possession of child pornography despite a strong dissent by Justice Brennan on the vagueness of the statute. A short time later in Ohio, the Cincinnati Contemporary Arts Center and its director faced criminal prosecution for possession of child pornography when the Center displayed Robert Mapplethorpe's homoerotic photographs, some of which were photographs of naked children. Both were later found not guilty.

Also in 1990, Federal Bureau of Investigation agents raided the studio of San Francisco photographer Jock Sturges. Sturges, who is known for his black-and-white portraits of families in the nude, had asked his film processor to make negatives from color slides he had taken of some of the children he had photographed. The pictures had been taken with the permission of all of the children's parents, and the negatives were to be used to make color prints that Sturges intended to give as gifts to the families.

The police were notified by the San Francisco branch. Sturges' film processor had taken the negatives to Newell Colour, a photo processing laboratory based in London, to be printed. State law requires such commercial processing laboratories to report photographs that may violate child pornography statutes. Failing to do so may subject them to loss of business licenses. Sturges' film processor was arrested, which led to the raid of Sturges' studio and the confiscation of much of his work. Duke Diedrich, a spokesman for the FBI, said it was the Bureau's policy to investigate when it seemed "the focus of the photos is directed toward the genitalia." The charges were eventually dropped and the confiscated materials returned.

In 1988, Congress passed the Child Protection and Obscenity Act. This law prohibits the use of computers to advertise, distribute, or receive child pornography and the sale, or possession with intent to sell, of child pornography on federal lands. Producers of sexually explicit materials are required to keep records of the age and identity of each performer participating in sexually explicit conduct.

The Child Pornography Prevention Act of 1996 expands the definition of child pornography to include that which not only actually depicts the sexual conduct of real children, but also that which appears to be a depiction of a minor engaging in sexual conduct. This includes digitally altered images, as well as images of adults who appear underage. In *Ashcroft v. Free Speech Coalition*, the U.S. Supreme Court ruled that the portions of the law dealing with pandering and virtual pornography were overboard and unconstitutional. Congress then passed the Prosecutorial Remedies and Other Tools to End the Exploitation of Children Today Act of 2003 (PROTECT Act), redrafting the pandering provision. The PROTECT Act was also challenged on constitutional grounds but was upheld in *United States v. Williams.*

More recently, there have been numerous cases where teens have been charged with child pornography for *sexting*, that is, sending explicit messages or photographs via cell phone. In response to public outcry, some jurisdictions have reduced sexting from a felony to a misdemeanor, do not require the offender to be placed on sex offender lists, and otherwise reduced penalties for sexting by minors. Similar issues have arisen in connection with postings on MySpace.com.

Forfeiture or Closure Legislation

Photographers should be aware that some states have statutes that make it a crime or a public nuisance to disseminate or exhibit obscene material. Usually, these

statutes allow the authorities to close or even cause the owner to forfeit the use of the premises from which the obscene materials were disseminated. Under some of these statutes, authorities may enforce closure or forfeiture of premises even though the material disseminated was "lewd" or "indecent" rather than actually obscene. Some courts have found these statutes to be unconstitutional prior restraints of nonobscene material. However, other courts have upheld forfeiture statutes, reasoning that no closure or forfeiture takes place until there has been a judicial determination of whether the disseminated material was actually obscene.

Informal Censorship

Formal censorship occurs when a law actually prohibits certain activities. Informal censorship, which may occur indirectly through government action or through the actions of private parties, can be just as damaging to freedom of speech.

Government Funding

There is the possibility that government funding could be distributed in such a way as to constitute informal censorship. Controversy surrounded National Endowment for the Arts (NEA) funding when it was discovered that the NEA had given $30,000 to Robert Mapplethorpe and $15,000 to Andres Serrano, two artists whose works were deemed obscene. In response, Congress mandated that the NEA no longer fund obscene art. All artists seeking NEA funding would be required to sign a pledge that their work was not obscene. Numerous artists turned down substantial grants rather than sign. Others filed suits, such as *Bella Lewitzky Dance Foundation v. Frohnmayer (Newport Harbor Art Museum v. NEA)*, contending that the pledge requirement was unconstitutional.

In 1991, Congress deleted the obscenity language and replaced it with a watered-down version. The Act directed the NEA chairperson to ensure that "artistic excellence and artistic merit are the criteria by which applications are judged, taking into consideration general standards and respect for the diverse beliefs of the American public." The artist no longer had to sign a nonobscenity pledge, and, while the artist still had to comport with standards of decency, these standards were to be judged by the courts, not the NEA.

The "decency clause" was held void for vagueness in *Finley v. National Endowment for the Arts*, a suit brought by four artists whose grant applications were denied. The court held that because the decency clause reached a substantial amount of protected speech, confining NEA funding only to what was decent, it was overbroad as well as vague. This decision was overturned by the U.S. Supreme Court in 1998. In *National Endowment for the Arts v. Finley*, the court held that the government has the right to withhold funding from art it considers obscene. "If the NEA were to leverage its power to award subsidies on the basis of subjective criteria into a penalty on disfavored new viewpoints, then we would confront a different case."

The problem is further illustrated by the case of *Advocates for the Arts v. Thompson*. In that case, the plaintiff, Granite Publications, was to receive a grant from the New Hampshire Commission on the Arts, which was funded largely by the National Endowment for the Arts. The commission withdrew its pledge of funding upon discovering that a poem previously published by Granite was, in the commission's opinion, obscene. Granite sued, alleging that its First Amendment rights had been violated. The federal court ruled in favor of the arts commission.

Although the court was not willing to rule that the poem was obscene under the *Miller* test, neither was it willing to intrude upon the discretion of the arts commission to determine which projects would or would not receive government funds. As long as it could be argued that the commission's selections were based on the issue of artistic or literary merit, the First Amendment was not violated. The court did intimate that the commission might not have exercised the best judgment with respect to the poem. Nevertheless, the court refused to place itself in a position of being the final arbiter of questions of literary merit. Moreover, the court refused to require the commission to draw up narrow standards and guidelines by which artistic merit could be judged since these qualities are by their very nature subjective.

The court concluded that refusal of the government to provide funds for the arts will not normally constitute censorship because such refusal does not prohibit the publication of a given work, although inability to publish may be the practical result. Photographers may, therefore, find that their work is unacceptable to publishers who are concerned about this informal type of censorship.

Once a work has received some form of government funding, the withdrawal of the government sponsorship may be a First Amendment violation. Thus, in *American Council of the Blind v. The Librarian of Congress*, it was held that Congress' refusal to continue funding for the purpose of putting into Braille and recording *Playboy* magazine infringed the constitutional rights of the plaintiff, the American Council of the Blind.

"Censorship" by Film Processors

Courts have upheld the right of a film processor to refuse to process or return film that the processor deemed obscene. Processors have been allowed to retain allegedly obscene film on three theories: First, that return of the film might make the processor liable under a state obscenity statute; second, that the owner has no right to film that constitutes obscene contraband; and, third, existence of an implied or express contract term that the developer is not required to process or return films of obscene subject matter. In *Penthouse Inter., Ltd. v. Eastman Kodak Co.*, the court held that a film processor had the right to decide what it would refuse to process so long as its policies were applied uniformly; no First Amendment rights were violated since no state action was involved, and the film processor did not censor or restrict what the magazine could publish.

Predicting Liability

As we have indicated here, whether or not a photograph is likely to be deemed obscene under the *Miller* test is extremely difficult to predict. Courts have experienced numerous problems in applying the *Miller* test, and there is no indication that these problems are likely to be resolved in the near future.

Perhaps the most significant barrier to predictability in obscenity cases is that obscenity is a factual question to be determined by a jury. Presumably, juries are composed of reasonable persons, but it has long been recognized that reasonable persons may disagree. Consequently, it is not particularly surprising that different juries have come up with different results in obscenity cases involving essentially the same facts and issues.

How, then, is the photographer to predict whether a particular jury might reasonably find a photograph to be obscene? You probably cannot make this prediction, at least not without the assistance of a lawyer familiar with the relevant decisions. By analyzing the various obscenity cases in which the defendant was convicted and contrasting them with those in which the defendant was acquitted and by staying on top of any new obscenity laws which may be enacted in the future, an attorney should be able to provide a fairly accurate prediction as to whether the work in question will or will not be considered obscene. Unfortunately, graphic material, such as photographs and films, is much more often found to be obscene than written material.

Other Censorship Problems

Censorship of obscene material is only one limitation the government places on photographers' First Amendment rights. For instance, the government forbids the photographing of money or postage stamps unless certain requirements are met. (See chapter 5 for more information about these types of restrictions.)

Also, the federal government and most of the states have enacted flag-desecration statutes that impose civil or criminal liability on persons who deface or mutilate a flag. These statutes were enacted in response to the flag burnings by protestors against the Vietnam War and against civil rights abuses. Generally, flag-desecration statutes are designed to prevent breaches of the peace that might result from improper use of and disrespect to the flag. Thus, *People v. Von Rosen* held that magazine publication of photographs of a nude girl covered by an American flag, though disrespectful, did not violate a state flag-desecration statute because the photographs were not likely to bring about a breach of the peace. However, some courts have recognized other purposes to be served by flag-desecration statutes. In *People v. Keough*, the court found that publication of photographs of a female clothed only in an American flag and a pair of boots, posing with a soldier, was sufficient to be a violation of a state flag-desecration statute because the photographs cast contempt upon the American flag.

Many flag-desecration statutes require that the disrespectful display of the flag be a public one. Under these statutes, a photographer could not be liable for any disrespectful flag photograph until it was published.

In the District of Columbia, it is an offense to use the United States flag or any representation thereof for advertising or commercial purposes. Some courts have found that commercial use of flags violates flag-desecration statutes even though those statutes contain no specific provisions against commercial use.

In 1989, the Supreme Court in *Texas v. Johnson* determined that desecrating the American flag is political free speech. This case involved a defendant who had burned the flag as part of a protest demonstration during the Republican National Convention. The court held that a state may not foster its own view of the flag by prohibiting expressive conduct relating to it. In effect, the flag-desecration statute forbids the expression, rather than the conduct, as Texas allows the ceremonious burning of a dirty flag as an expression of respect. Thus, Texas is saying that one may burn the flag to convey one's attitude toward it only if one does not endanger the flag's representation of nationhood and national unity. However, the Supreme Court concluded that the government may not ensure that a symbol be used to express only one view of a symbol of its referents.

Soon after the *Johnson* decision, the federal government passed the Flag Protection Act of 1989, which was held unconstitutional in 1990 in *United States v. Eichman*, concluding that "punishing desecration of the flag dilutes the very freedom that makes this emblem so revered, and worth revering."

-5-

Governmental Licenses and Restrictions on Photographing Public Places and Private Property

S tates usually regulate professions that could present a threat to the general public, such as healthcare professionals and building contractors. Whether or not it is appropriate for a state to require a photographer to be licensed has been a matter of some controversy. Generally, such licensing statutes have been held unconstitutional as interfering with an individual's First Amendment rights.

Licensing

The purpose of state and local licensing statutes is threefold:

1. To generate revenue
2. To regulate entry into certain trades and professions
3. To regulate the standards to which those in a particular trade or profession are held

As photography poses no threat to the general public, it has been concluded that a state does not have the authority to regulate the profession.

There was a brief period when the licensing of photographers was held to be constitutional by the North Carolina Supreme Court. That same court later, in 1949, reversed its 1938 position and struck down the licensing scheme. Subsequently, there have been a number of other state supreme courts that have similarly ruled licensing requirements for photographers as unconstitutional.

In 1970, the South Dakota Supreme Court held unconstitutional a city ordinance requiring all itinerant or transient photographers to be licensed and bonded. In this case, the court concluded the ordinance was invalid because there was no similarly imposed burden on local photographers. Thus, the ordinance was overburdening to non local photographers involved in interstate commerce.

Restrictions on Photographing Governmental Items and Personnel

There are also certain restrictions on photographing governmental items. The U.S. presidential seal, for example, may not be reproduced in any form without the proper authorization. U.S. currency and stamps may be reproduced only in black and white and only if the reproduction is at least 150 percent larger or 75 percent smaller than the currency's actual size.

Regulations also prohibit the use in promotional or advertising materials of identifiable personnel employed by federal entities and official insignias, as well as other identifying symbols used by federal entities, and authentic uniforms, markings, or other designations used by Department of Defense entities.

It is a federal offense to "reproduce, manufacture, or use" the characters "Smokey Bear" and "Woodsy Owl." Those characters were created by the United States Forest Service, a division of the Department of Agriculture.

In 1993, however, a federal district court held that the U.S. Forest Service was not justified in relying on this statute to prevent the use of a chain-saw-wielding Smokey Bear by an environmental organization. The court stated that this depiction of Smokey Bear was purely expressive, noncommercial speech protected under the First Amendment. Further, the court stated that such a use was unlikely to cause confusion or to dilute the value of Smokey Bear to help prevent forest fires and that the statute was unconstitutionally applied to the satirical poster.

The Department of Homeland Security has identified certain agency intellectual property on its Web site that should not be used without its prior authorization. This list can be accessed by going to the Department of Homeland Security Web site (*www.dhs.gov*), and, via the site map, clicking onto the Important Notices page and then to the Department of Homeland Security Intellectual Property Policy.

Restrictions on Photographing Public Places

There is a federal prohibition against photographing post offices and military installations. The federal government also prohibits the commercial exploitation of photographs of federal land without express permission. The photographing of prisons may also be restricted. In one case, the governor of Florida initially upheld the position of the director of prisons on the denial of an already issued permit to film an anti-capital-punishment movie in a state prison. After the matter received some adverse publicity, he reversed his position and allowed the film to be made.

Photojournalists tend to have somewhat more legal protection of their right of access to subjects if those subjects are newsworthy. The United States Supreme Court has recognized that the First Amendment protects the media's right to publish news. However, news media have no constitutional right of access to scenes of crime or disaster when the general public is excluded. The United States Supreme Court has held that as long as restrictions treat the media and the public equally, they are constitutional. However, some cases indicate that news professionals may have more rights than the general public. This is particularly true for photographers of courtroom proceedings.

After the tragic events of September 11, 2001, restrictions have become significantly broader. Contrary to what security guards or police officers may advise you, neither the Patriot Act nor the Homeland Security Act prohibits or restricts photography. Still, there remain reports of "unofficial bans" across the country, where photographers are harassed, detained, and/or ordered to stop taking photographs. Photographers, whether professionals or tourists shooting snapshots, have been told by security guards, as well as police officers, that they should not take photographs of bridges, industrial plants, trains, bus stations, federal buildings, and the like. Cameras have even been confiscated. Similar problems have arisen in the United Kingdom.

New York's Metropolitan Transportation Authority (MTA) and New Jersey Transit proposed bans on photography on their buses and subways, though the idea was abandoned after criticism by photographers and journalists. In April 2009, the New York Police Department issued an Operations Order reminding officers that most photography in the city is unrelated to terrorism and that photographers should not be detained without reasonable suspicion of illegal activity. MTA has also issued reminders to its staff, because of the harassment of photographers. See the MTA Web site (*www.mta.info/nyct/rules/rules.htm*) for the rule expressly permitting photography.

Courtroom Proceedings

Rule 53 of the Federal Rules of Criminal Procedure prohibits "taking of photographs in the courtroom during the progress of judicial proceedings." Cameras are also prohibited in civil proceedings in federal court.

Generally speaking, the propriety of granting or denying permission to the media to broadcast, record, or photograph court proceedings involves weighing the constitutional guarantees of freedom of the press and the right to a public trial on the one hand and, on the other hand, the due process rights of the defendant and the power of the courts to control their proceedings in order to permit the fair and impartial administration of justice.

It is also generally agreed that, on the basis of the right of freedom of the press, representatives of the media have a constitutional right to broadcast, record, or photograph court proceedings. In cases in which media representatives have

claimed that court rules and orders prohibiting broadcast or photographic coverage of judicial proceedings infringed upon the freedom of the press, however, the prohibitions have been upheld as reasonable and proper attempts to preserve courtroom decorum and to protect the rights of defendants. The courts have also rejected claims by press representatives that such prohibitions deprived them of rights protected by federal civil rights laws.

It is also generally agreed that the constitutional right to a public trial does not give the press the right to broadcast, record, or photograph court proceedings because the right to a public trial is for the benefit of the defendant and because the requirement of a public trial is satisfied when members of the press and public are permitted to attend a trial and to report what transpires. In a number of cases, the courts have held that court orders prohibiting broadcast or photographic coverage of criminal trials were proper attempts to protect the rights of defendants and that the orders, therefore, did not deny the defendants their right to a public trial.

The Supreme Court ruled in *Chandler v. Florida* that the due process rights of an accused are not inherently denied by television coverage and that no constitutional rule specifically prohibits the states from permitting broadcast or photographic coverage of criminal trial proceedings. The court pointed out, however, that, depending upon the circumstances under which such coverage takes place, a due process violation might result.

A number of states have permitted such coverage on either a permanent or experimental basis. Therefore, photographers are advised to consult the applicable rules in order to determine the specific types of equipment that may be permitted, the location of the equipment in the courtroom, and the number of media representatives who may be permitted access to the courtroom to operate such equipment.

There is abundant information available via the Internet regarding photographing courtroom proceedings, although it would be most prudent to consult only sources you know to be authoritative. For instance, at the time of this writing, California provides a general guide of its rules and regulations in an online publication, *Photographing, Recording, and Broadcasting in the Courtroom* (*http://www.courtinfo. ca.gov/reference/cameras-toc.htm*). If you desire more specific information related to your field, numerous books are available for forensic photographers, videographic reporters, and general observers who wish to carry a camera into a courtroom.

Public Places

Newsworthy events often occur in public places such as streets, sidewalks, or parks. These places are public forums because they are open to the public and few restrictions are placed on the activities that may take place in them. Reporters can be barred from covering activities in public forums only if newsgathering restrictions are reasonable.

Photographs of so-called "perp walks" (alleged perpetrators being purposely walked through a public area by police for access by the media) have generated

some controversy. A New York politician charged with tax evasion sued to prevent the media from running photographs of him in handcuffs, but the court denied his motion for injunctive relief, noting that there was no evidence that his right to a fair trial would be impaired by the media coverage.

As a general rule, photographers are allowed to shoot photographs in national parks, just as are tourists. However, permits may be required when the photography involves advertisement of products or services, or the use of models, sets, and props, or when such photography could result in damage to the resources or significant disruption of normal visitor uses. Permits are also required for photographers to shoot in areas normally closed to the visiting public, though oral approval may suffice for a photographer engaged in bona fide newsgathering activities.

In New York City, there are several sections of the administrative code that require permits in order to take motion pictures, to telecast, or to photograph in public places. Other sections of New York City's code forbid the use of tripods in public parks.

Restrictions on Photographing Private Property

As important as the photographic subject's right of privacy is the photographer's right to take pictures. Neither of these rights is absolute; rather, the subject's right of privacy and the photographer's right to take pictures are the mirror image of one another, and one right ends where the other begins.

Generally, photographers have a right to take pictures so long as they do not invade their subjects' privacy or make a public nuisance of themselves, but there are some limits.

Photographers should be aware that owners of buildings, locations, or objects may have a protected interest in exploiting images of those properties. The exclusive right to exploit the likenesses of one's buildings, land, or other possessions is technically a property right rather than a right of privacy, but the legal repercussions of photographing a building may be equivalent to the legal consequences of photographing a person. In *New York World's Fair 1964-65 Corp. v. Colourpicture Pub. Inc.*, the court held that the defendant's photograph of a unique building had invaded a property right of the plaintiff when the photographer commercially exploited the photograph. For this reason, a photographer should obtain a property release from the owner of unique buildings, landmarks, automobiles, and other forms of property when they are to be photographed. However, if a piece of property is not unique, photographing it should not present a problem. When in doubt, you should err on the conservative side and obtain a proper release. As discussed in chapter 1, trademark laws may also be implicated in the photography of private property.

A freelance commercial journalist brought suit against a public civic center and concert promoters who refused to allow him to take photographs of rock

concerts at the civic center. The court in *D'Amario v. Providence Civic Center Authority* held that the photographer's freedom-of-speech and freedom-of-press rights were not violated.

Many newsworthy events occur on private property. Property owners may restrict access to their homes, businesses, shopping centers, and privately owned housing developments. Even when property owners have not barred access, they have been able to obtain damages for trespass or invasion of privacy when they did not consent to the journalist's entry. A key issue in such cases is whether the owner's silence was the effective equivalent of consent. In a Florida case, an invasion-of-privacy lawsuit was brought against a newspaper for publishing a photograph of the silhouette of the body of a seventeen-year-old girl killed in a house fire. The fire marshal and a police sergeant investigating the fire invited the news media into the burned-out home to cover the story. In court, they testified that their invitation was standard practice. The property owner, who was the victim's mother, was out of town at the time of the fire, so she was not present to be asked for permission. Clearly, the fire was of great public interest because of the damage done to the house, because a person had died, and because arson was suspected. The court found implied consent and ruled in favor of the media, with the qualification that if the owner had been present and objected to the reporter's presence, the reporter might have been liable for damages.

Photojournalists should be aware that state constitutions may provide greater protection for the media than does the United States Constitution. In California, the state constitution guarantees access to news on private business property.

However, if the police order you not to enter an area in pursuit of news, you are risking arrest, prosecution, and liability by disregarding the order, whether or not the property in question is publicly or privately owned. In *Stahl v. Oklahoma*, several reporters were arrested for following antinuclear power demonstrators onto a privately owned power plant site. The owner of the land, the Public Service Co. of Oklahoma, had denied both the public and the media access to the plant. The court treated the plant as a government entity because the power company's activities were heavily regulated by the state and federal government. Nonetheless, the judge fined the reporters for criminal trespass, ruling that the First Amendment does not guarantee access to property simply because it is owned or controlled by the government; nor does the First Amendment protect reporters from arrest and prosecution if they have broken the law while gathering news.

In 1991, the Connecticut Appellate Court affirmed a newspaper photographer's conviction for interfering with a police officer's performance of duty. The photographer refused to move from the immediate vicinity of a fatal car accident, despite numerous police requests, insisting it was his constitutional right to remain.

Police departments across the country are under pressure to develop guidelines governing their relationship with the media. If a police department provides guidelines governing access to crime or accident scenes and issues press

credentials, the guidelines must not result in the arbitrary denial of access to certain journalists. In *Sherrill v. Knight*, the court held that if an agency establishes a policy of admitting the media, even though the public is barred, media access cannot later be denied arbitrarily or for less-than-compelling reasons. It also ruled that agencies must publish the standards that will be used in deciding whether an applicant is eligible to receive a press pass and that journalists who are denied press passes must be provided with reasons for the denial and given an opportunity to appeal.

When in doubt about the item to be photographed, prudence would dictate that you should err on the side of caution and obtain a release. A well-drafted document will grant you the right to photograph the item in question and commercially exploit it. (See the sample release in appendix 1.)

-6-
Organizing as a Business

One of the reasons—perhaps the primary reason—why photographers like their work is that they feel they have escaped the stultifying atmosphere of the dress-for-success business world—but they have not escaped it entirely. Most of the same laws, although not the same culture, that govern the billion-dollar auto industry govern the photographer. This being the case, you might as well learn how you can use some of those laws to your advantage.

Any professional person knows that survival requires careful financial planning. Yet, few photographers realize the importance of selecting the optimal form of their business. Most photographers have little need for the sophisticated organizational structures utilized in industry, but since photographers must pay taxes, obtain loans, and expose themselves to potential liability every time they take photographs and sell their work, it only makes sense to structure the business to minimize these concerns.

Every business has an organizational form best suited to it. When we counsel photographers on organizing their businesses, we usually adopt a two-step approach. First, we discuss various aspects of taxes and liability in order to decide which of the basic forms is best. There are only a handful of basic forms: the sole proprietorship, the partnership, the corporation, the limited liability company, and a few hybrids. Once we have decided which of these is appropriate, we go into the organizational details, such as partnership agreements or corporate papers. These documents define the day-to-day operations of a business and, therefore, must be tailored to individual situations.

What we offer in this chapter is an explanation of features of these various business organizations, including their advantages and disadvantages. Chapter 7 discusses the tax aspects of each structure. These two chapters should give you some idea of which form might be best for you.

We will discuss potential problems, but since we cannot go into a full discussion of the more intricate details, you should consult an attorney, and perhaps an accountant, before deciding to adopt any particular structure. Our purpose here is to facilitate your communication with your lawyer and to enable you to better understand the choices available.

The American Dream: Sole Proprietorship

The technical name *sole proprietorship* may be unfamiliar to you, but you may be operating under this form now. A sole proprietorship is an unincorporated business owned by one person. Although not peculiar to the United States, it was, and still is, the backbone of the American dream to the extent that personal freedom follows economic freedom. Legal requirements are few and simple. In some localities, professionals such as photographers are not required to have a business license, but if you wish to operate the business under a name other than your own, the name must be registered with the state or, in some cases, the county in which you are doing business. With these details taken care of, you are in business.

There are many financial risks involved in operating your business as a sole proprietor. If you recognize any of these dangers as a real threat, you probably should consider an alternative form of organization.

If you are the sole proprietor of a business, the property you personally own is at stake. In other words, if for any reason you owe more than the dollar value of your business, your creditors can force a sale of most of your personal property to satisfy the debt. Thus, if one of your employees produces a photograph that is defamatory, is an invasion of someone's privacy, or infringes someone else's copyright, you could find that you are personally responsible for paying the judgment.

You can purchase insurance to shift the loss from you to an insurance company, but insurance is not always available or affordable. In any case, insurance policies do have monetary limits. Furthermore, insurance premiums can be quite high, and there is no way to accurately predict or plan for future increases in premiums. (For further discussion on insurance, see chapter 10.) These hazards, as well as many other uncertain economic factors, could force you into personal bankruptcy if you are the sole proprietor of a business.

Partnership

A partnership is defined by most state laws as an association of two or more persons to conduct, as co-owners, a business for profit. Two photographers can form

a partnership. This arrangement can be very attractive to beginning photographers because it allows them to pool their money, equipment, and contacts.

When a photographer and writer get together and agree to produce a manuscript accompanied by photographs, this also constitutes a partnership. No formalities are required. In fact, in some cases, people have been held to be partners even though they never had any intention of forming a partnership. For example, if you lend a friend some money to start a business and the friend agrees to pay you a certain percentage of whatever profit is made, you may be your friend's partner in the eyes of the law even though you take no part in running the business; or, if you have no formal arrangements, you may find that your collaborator is held to be entitled to one-half of the income you receive, even though his or her contribution was minimal. You can avoid this by making an outright purchase of the other person's work or by paying that person a percentage of what you are paid.

Whichever arrangement you choose, you will be well advised to have a detailed, written agreement prepared by an experienced business lawyer. This is important because each partner is subject to unlimited personal liability for the debts of the partnership. Also, each partner is liable for the negligence of another partner and for the partnership's employees when a negligent act occurs in the course of business.

This means that if you are getting involved in a partnership, you should be careful in at least three areas. First, since the involvement of a partner increases your potential liability, you should choose a responsible partner. Second, the partnership should be adequately insured to protect both the assets of the partnership and the personal assets of each partner. Finally, it is a good idea for you to draw up a written agreement between you and your partner in order to avoid any misunderstandings or confusion in the future.

As previously mentioned, no formalities are required to create a partnership. If the partners do not have a formal agreement defining the terms of the partnership, such as control of the partnership or the distribution of profits, state law will determine the terms. State laws are based on the fundamental characteristics of the typical partnership as it has existed through the ages. The most important of these legally-presumed characteristics are:

- No one can become a member of a partnership without the unanimous consent of all partners
- All partners have an equal vote in the management of the partnership, regardless of the size of their interest in it
- All partners share equally in the profits and losses of the partnership, no matter how much capital they have contributed
- A simple majority vote is required for decisions in the ordinary course of business, and a unanimous vote is required to change the fundamental character of the business

• A partnership is terminable at will by any partner; a partner can withdraw from the partnership at any time, and this withdrawal causes a dissolution of the partnership

Most state laws contain a provision that allows the partners to vary these presumptions and make their own agreements regarding the management structure and division of profits that best suit the needs of the individual partners.

The Limited Partnership

The limited partnership is a hybrid containing elements of both the partnership and the corporation. A limited partnership may be formed by parties who wish to invest in a business and, in return, to share in its profits but who seek to limit their risk to the amount of their investment. The law provides for such limited risk but only so long as the limited partner plays no active role in the day-to-day management and operation of the business. In effect, the limited partner is very much like an investor who buys a few shares of stock in a corporation but has no significant role in running the corporation. In order to establish a limited partnership, it is necessary to have one or more general partners who run the business and who have full personal liability and one or more limited partners who play a passive role.

To form a limited partnership, a document must be filed with the proper state office. If the document is not filed or is improperly filed, the limited partner could be treated as a general partner and, thus, lose the protection of limited liability.

Limited partnership is a convenient business form for securing needed economic backers who wish to share in the profits of an enterprise without undue exposure to personal liability when a corporation may not be the appropriate form for the business to take or when the business does not meet all the requirements to become an S corporation (discussed later in this chapter). A limited partnership can be used to attract investment when credit is hard to get or too expensive. In return for investing, the limited partner may receive a designated share of the profits. From the entrepreneur's point of view, this may be an attractive way to fund a business because the limited partner receives nothing if there are no profits; whereas, had the entrepreneur borrowed money from a creditor, he or she would be at risk to repay the loan regardless of the success or failure of the business.

Another use of the limited partnership is to facilitate reorganization of a general partnership after the death or retirement of a general partner. A partnership, remember, can be terminated upon the request of any partner. Although the original partnership is thus technically dissolved when one partner retires, it is not uncommon for the remaining partners to agree to buy out the retiring partner's share, that is, to return that person's capital contribution and keep the business going. Raising enough cash to buy out the retiring partner, however, could jeopardize the business by forcing the remaining partners to liquidate certain partnership assets. A convenient way to avoid such a detrimental liquidation

is for the retiree or heirs to step into a limited-partner status. Thus, he or she can continue to share in the profits, which, to some extent, flow from that partner's past labor, while removing personal assets from the risk of partnership liabilities. In the meantime, the remaining partners are afforded the opportunity to restructure the partnership funding under more favorable conditions.

Limited Liability Partnerships

For businesses that have been conducted in the partnership form and desire a liability shield, the limited liability partnership, or LLP, is available. This business form is created by converting a partnership into an LLP. It is often available for professionals who, in many states, are prohibited from conducting business through a limited liability company.

The Corporation

The word corporation may bring to mind a vision of a large company with hundreds or thousands of employees—an impersonal monster wholly alien to the world of the photographer. In fact, there is nothing in the nature of a corporation itself that requires it to be large or impersonal. In most states, even one person can incorporate a business. There are advantages and disadvantages to incorporating. If it appears advantageous to incorporate, you will find it can be done with surprising ease and little expense. However, you may need a lawyer's assistance to ensure compliance with state formalities as well as to obtain advice on corporate mechanics and to taxation.

Differences Between a Corporation and Partnership

In describing the corporate form, it is useful to compare it to a partnership. There are several differences between these two forms of business, including the extent of power of the owners and the fundraising capabilities of the business.

Liability. Like limited partners, the owners of the corporation—commonly known as shareholders or stockholders—are not personally liable for the corporation's debts. They stand to lose only their investment.

The corporate shield also offers protection in situations where an employee of the photographer has committed a wrongful act while working for the photographer's corporation. If, for example, an assistant negligently injures a pedestrian while driving to the store to buy a new memory card for the photographer, the assistant will be liable for the wrongful act and the corporation may be liable, but the photographer who owns the corporation probably will not be personally liable.

For the small corporation, however, limited liability may be something of an illusion because, very often, creditors will require that the owners either personally cosign or guarantee any credit extended. In addition, individuals remain responsible for their wrongful acts; thus, a photographer who infringes a copyright

or creates a defamatory work will remain personally liable, even if incorporated. However, the corporate liability shield does protect a photographer in situations where a contract is breached if the other contracting party has agreed to look only to the corporation for responsibility. For example, publishing contracts frequently require photographers to make certain guarantees and statements of fact. If the publisher will contract with the photographer's corporation rather than with the photographer as an individual, then the corporation alone will be liable if there is a breach of their agreement.

Continuity of Existence. The many events that can cause the dissolution of a partnership do not have the same effect on a corporation. In fact, it is common for perpetual existence to be established in the articles of incorporation. Unlike partners, shareholders cannot decide to withdraw and demand a return of capital from the corporation; all they may do is sell their stock. Therefore, a corporation may have both legal and economic continuity, but this can also be a disadvantage to shareholders or their heirs if they want to sell their stock when there are no buyers for it. However, there are agreements that may be used to guarantee a return of capital should the shareholder die or wish to withdraw.

Transferability of Ownership. In a partnership, no one can become a partner without unanimous consent of the other partners unless otherwise agreed in the partnership agreement. In a corporation, however, shareholders can generally sell some or all of their shares to whomever they wish. If the owners of a small corporation do not want to be open to outside ownership, transferability can be restricted.

Management and Control. Unlike a limited partner, a shareholder is allowed full participation in the control of the corporation through the shareholder's voting privileges; the higher the percentage of outstanding shares owned, the more significant the control. Other kinds of stock can be created with or without voting rights. A voting shareholder uses the vote to elect a board of directors and to create rules under which the board will operate.

The basic rules of the corporation are stated in the articles of incorporation, which are filed with the state. These can be amended by shareholder vote. More detailed operational rules—bylaws—must also be prepared. Shareholders and, in many states, directors may have the power to create or amend bylaws. This varies from state to state and may be determined by the shareholders themselves. The board of directors then makes operational decisions for the corporation and might delegate day-to-day control to a president.

A shareholder, even one who owns all of the stock, may not preempt a decision of the board of directors. If the board has exceeded the powers granted it by the articles or bylaws, any shareholder may sue for a court order remedying the situation, but if the board is acting within its powers, the shareholders have no recourse except to formally remove the board or any board member. In a few more progressive states, a small corporation may entirely forego having a board of

directors. In such cases, the corporation is authorized to allow the shareholders to vote on business decisions, just as in a partnership.

Raising Capital. Partnerships are quite restricted in the variety of means available to them for raising additional capital. They can borrow money or, if all the partners agree, can take on additional partners. A corporation, on the other hand, may issue more stock, and this stock can be of many different varieties—recallable at a set price, for example, or convertible into another kind of stock.

A means frequently used to attract a new investor is the issuance of preferred stock. The corporation agrees to pay the preferred shareholder some predetermined amount, known as a dividend preference, before it pays any dividends to other shareholders. It also means that, if the corporation should go bankrupt, the preferred shareholder will generally be paid out of the proceeds of liquidation before the other shareholders, known as common shareholders, although after the corporation's creditors are paid.

The issuance of new stock, in most cases, merely requires approval by a majority of the existing shareholders. In addition, corporations can borrow money on a short-term basis by issuing notes or, for a longer period, by using long-term debt instruments known as issuing debentures or bonds. In fact, a corporation's ability to raise additional capital is limited only by its lawyer's creativity and the economics of the marketplace.

Precautions for Minority Shareholders

Dissolving a corporation is almost always impossible without the consent of the majority of the shareholders. If you are involved in the formation of a corporation and will become a minority shareholder, you must realize that the majority will have ultimate and absolute control unless minority shareholders take certain precautions from the start. There are numerous horror stories of what some majority shareholders have done to minority shareholders. Avoiding these problems is no more difficult than drafting an agreement among the shareholders. We recommend that you retain your own attorney to represent you during the corporation's formation rather than waiting until it is too late.

The S Corporation

Congress has created a hybrid organizational form that allows the owners of a small corporation to take advantage of many of the features described above to avoid the double-taxation problem of a regular, or C corporation, as discussed in chapter 7. This form of organization is called an S corporation. If the corporation meets certain requirements, which many small businesses do, the owners can elect to be taxed in a manner similar to a partnership.

In order for a corporation to qualify as an S corporation, it may not have more than one hundred owners, who must be human beings, S corporations,

nonprofit corporations, or certain kinds of trusts. They must not be nonresident aliens, and there cannot be more than one class of stock.

Limited Liability Companies

The limited liability company, or LLC, which is available in all fifty states, combines the limited liability features of a corporation with all of the tax advantages available to the sole proprietor or partnership. In 1997, the Internal Revenue Code was amended to permit LLCs, at the business' option, to be taxed like corporations or like sole proprietors and partnerships.

A photographer conducting business through an LLC can shield his or her personal assets from the risks of the business for all situations except the individual's own wrongful acts. This liability shield is identical to the one offered by the corporate form. The owners of an LLC can also enjoy all of the tax features accorded to corporations, sole proprietors, or partners in a partnership.

LLCs do not have the same restrictions imposed on S corporations regarding the number of owners, their citizenship/residence, and whether or not they must be individuals or particular entities. In fact, corporations, partnerships, and other business forms can own interests in LLCs. LLCs also may have more than one class of ownership. If, however, an LLC elects to be taxed as an S corporation, then it will be subject to the same restrictions as are imposed on S corporations.

-7-
The Tax Consequences of Business Organization

Prior to the 1986 Tax Reform Act, beneficial tax treatment was the primary impetus behind the choice of many photographers to incorporate rather than create partnerships or remain sole proprietors. Individual tax rates were as high as 70 percent, whereas the top corporate rate was around 34 percent—a major tax savings for those who were able to incorporate. The 1986 Act reduced individual rates to levels equal to or below corporate rates.

Four years earlier, the Tax Equity and Fiscal Responsibility Act (TEFRA) took away one of the other primary advantages of incorporation. Prior to the Act, corporate shareholders benefited from the ability to invest a greater amount of income in tax-deferred retirement plans than persons in partnerships or sole proprietorships. TEFRA, in effect, leveled the playing field so that the choice of business form would not be influenced by variations in tax treatment of retirement plans.

Although the tax benefits among the various business organizations have been roughly equalized, there are still some differences with respect to the tax treatment of the various entities.

Sole Proprietorships

As with an S corporation and a partnership, a sole proprietorship's income and deductions pass through to the sole proprietor and are reported on his or her individual income tax return. Even though the business form is labeled "sole

proprietorship," the practitioner may employ several other practitioners on a salaried basis without affecting his or her own personal tax treatment.

Partnerships

Partnerships are taxed in much the same way as sole proprietorships and S corporations—business income (and deductions) pass directly through to the individual partners. Each partner pays tax on his or her share of the profits, whether distributed or retained, and each is entitled to the same proportion of the partnership deductions and credits. The partnership must prepare an annual information return known as Schedule K-1, Form 1065, which details each partner's share of income, credits, and deductions. With certain exceptions, each partner's distributable share is taxed at his or her individual income tax rate.

There are, however, more technical rules that apply to different situations. Because partnership tax is a very complicated body of law, if you choose this business form, it is recommended that you consult with an accountant.

Corporations

As was discussed in chapter 6, there are two types of corporations for tax purposes: the C corporation and the S corporation. The designation "professional corporation" does not impact the tax characterization.

The C corporation is regarded as a separate legal entity. It is, therefore, taxed as a separate entity. All corporate income is taxed at the corporate rate and then again at the shareholder level when it is distributed as dividends. One might think that this shareholder-level tax could be avoided, or at least postponed, by causing the corporation to retain its earnings instead of paying them out, but Congress has dealt with this situation through the imposition of an "accumulated earnings tax."

The accumulated earnings tax is a penalty tax that is imposed on all accumulated earnings—earnings the IRS treats as dividends that should have been distributed. Accumulated earnings are defined as earnings in excess of reasonable business needs. If the accumulation can be justified (for example, to allow for an anticipated and legitimate expansion of your business), then the tax probably will not be imposed. There are additional ways to avoid this tax, which should be discussed with your tax advisor if you perceive the possibility of liability.

It is the two-tier tax—once at the corporate level and again at the shareholder level—that dissuades many small businesses from opting for C corporation status, even though there are methods of reducing the shareholder tax, using the maximum allowable deductions (as will be discussed later in this chapter). Most small businesses elect to be treated as an S corporation, eliminating the double tax because the shareholders are taxed much like partners in a partnership. In order to be taxed as an S corporation, a special election must be made and filed with the IRS. In addition, certain requirements must be met, as discussed in chapter 6.

S corporations avoid double taxation because corporate income passes through directly to the shareholders. There is no taxation of corporate earnings at the corporate level. Each shareholder must recognize a proportionate amount of corporate income directly on his or her individual income tax return, which is taxed at individual income tax rates. Most of the standard business deductions that are applicable to the C corporation are also applicable to the S corporation. The shareholders apply the business deductions in proportion to their ownership.

Limited Liability Companies

Limited Liability Companies (LLCs) have the option to be taxed as corporations or as partnerships. Check with your accountant to determine the best time for making the election.

Employee Compensation and Benefits

Use of employee benefit plans, as well as the wages paid to owner-employees, can maximize returns to shareholders.

Employee Compensation

For photographers who have chosen to do business as C corporations, payment of employee compensation is actually one of the most effective ways to minimize or eliminate double taxation. Rather than paying out corporate earnings to shareholder-employees as nondeductible dividends, the corporation can pay out salaries and then receive a business expense deduction for the wages paid.

It should be apparent that this deduction provides a potentially large loophole in the tax law. Congress and the courts have all but closed this loophole by placing a limit upon the amount that may be deducted as a business expense—only that which is "reasonable compensation" may be deducted.

A corporation, therefore, cannot avoid income tax by paying excessive salaries to the stockholder-employees. The IRS frequently audits closely held corporations for this type of abuse. Although most challenges are to salaries and benefits for stockholders, excessive compensation paid to a non-stockholder-employee also has been successfully challenged by the IRS.

Reasonability, as always, depends on all the circumstances of the particular case. Factors that the courts have considered include the nature of the job, the size and complexity of the business, prevailing rates of compensation, the company's profitability, the uniqueness of the employee's skills or experience, the number of hours worked, the employee's salary as compared with the salaries of coworkers, general economic conditions, and the presence, absence, and amount of dividends paid.

If a salary is found excessive, no deduction will be allowed for the part of the payment that is excessive. Even though the employer cannot deduct the full amount paid, the employee must report and pay tax on the full amount received.

Usually, a new business is more concerned with underpayment than over-compensation. Employees may work long, hard hours with little compensation in the hope of a brighter future. The IRS realizes this. In later years, when the business is profitable, employees can be compensated for the underpayment of former years by additions to their salaries. The base salaries must be reasonable, and the additional amounts also must be reasonable in light of the past services performed and the compensation already received.

Compensation also may be fixed as a percentage of profits or earnings. Contingent plans of this nature may result in low salaries in lean years and above-average salaries in good years. The IRS accepts this too, as long as, on the average, the salaries are not unreasonable. Of course, some premium is reasonable because of the risk assumed by the employee who accepts such a plan.

Contingent plans are suspect, however, when used for owner-employees, since they can be used to avoid dividends in good years. A stockholder-employee's reward for an increase in business should be a reasonable salary and increased dividends.

Statutory Benefit Plans

Statutory, tax-exempt benefit plans—that is, plans that are specified in the Internal Revenue Code—are available for accident and health coverage, group term life insurance, profit-sharing, pension, and contributory savings plans, to name a few. These plans are not limited to corporate employers. The requirements for benefit plans are extremely complex from a tax standpoint, and retirement plans must also comply with ERISA, the federal Employee Retirement Income Security Act.

Even though the myriad rules and regulations are tedious, the plans are worth considering. If a plan conforms to the rules, employer contributions are immediately deductible as business expenses but are not taxable to the employees as income. Employees are taxed only when they receive payments from the pension plan. Even more importantly, in the case of retirement plans, no tax is imposed on the investment growth of funds deposited in the plan.

Statutory benefit plans can provide accident, medical, or group term life insurance, educational assistance, legal services, or childcare. Each is covered by separate rules and requirements, but all plans must meet a common set of rules to be tax exempt.

Generally, structuring plans to favor highly compensated employees will subject the employees to tax liability on those benefits. This is a complex area, and you should consult with your tax adviser or accountant before adopting any of these plans.

A statutory plan also must meet certain requirements so that the average benefit received by non-highly compensated employees must equal or exceed a set percentage of the average benefits received by highly compensated employees or key employees under the same or similar plans.

Following is a brief overview of some statutory plans:

- An employer may provide up to $50,000 of tax-free, group term life insurance for each employee. Premiums on coverage exceeding $50,000 in face amount are taxable to employees, unless the employee contributes to the plan with his or her own taxable income.

- An employee may receive up to $5,250 in tax-free educational assistance per year from a funded educational-assistance program (after 2001, graduate courses will qualify).

In addition, contributions by employers to health and accident plans are generally tax exempt only if they provide continuing extensions of coverage for various specified time periods after termination of employment.

When an employee receives payment for medical expenses, the amount received is not taxable income unless the employee is already receiving compensation from another source or takes an income tax deduction for the medical expenses.

The employee is also not taxed on amounts received to compensate for injury due to permanent loss of use of a body part or function or permanent disfigurement.

Amounts received to compensate an employee for loss of income due to illness or injury are taxable as income.

A plan can provide assistance for child or other dependent care. The aggregate amount excluded from the employee's income cannot exceed $5,000 in the case of a single parent or marital unit. If an employee receives $2,500 of tax-free child-care assistance, the spouse is eligible to receive only an additional $2,500 in tax-free assistance.

Qualified Plans. Retirement benefits may be provided under "Qualified Plans." The rules for qualified pension, profit-sharing, and stock bonus plans are too numerous to summarize.

Eligibility and benefit rules exist to ensure nondiscrimination. Since it is reasonable to allow for different employer contribution amounts to various plans based upon an employee's value and years of service, there are special rules to prevent and remedy top-heavy plans where accumulated contributions on behalf of highly compensated employees exceed those for other employees.

These plans must be separately funded and administered under rules designed to guarantee, to the extent possible, that retirement funds cannot be reached, tampered with, squandered, or mismanaged by the employer.

There are also vesting requirements so that employees can rely on the plans without worrying about forfeiture due to excessively long employment-period requirements. Maintenance of a qualified plan is impossible without specialized professional help.

Cafeteria Plans. Under a cafeteria plan, an employer may set up a menu whereby an employee is allotted a certain amount of benefit credit and allowed to choose

among various amounts and combinations of plans or the receipt of additional taxable income. Amounts allocable to elected benefit plans are not taxable to the employee. In this way, an employee can tailor a benefits program to best meet his or her individual circumstances. Fringe benefits and educational-assistance plans may not be included in cafeteria plans.

Fringe Benefits. Certain fringe benefits may be provided tax free to employees. Such benefits might include employee discounts, subsidized cafeterias, parking facilities, onsite athletic facilities, and so on. Generally, these benefits must be of no additional cost to the employer or be worth so little that the administrative cost of keeping track of them exceeds the value of the benefit.

Shareholder employees of C corporations can take advantage of all of the above fringe benefits as employees. S corporation shareholders generally cannot avail themselves of certain fringe benefits, such as cafeteria plans, fully deductible health insurance at the corporate level, dependent-care plans, or group term life plans.

Keeping Taxes Low

Photographers rarely think of themselves as being engaged in a business. Many, in fact, go to great lengths to avoid feeling involved in the world of commerce. The IRS, however, treats the professional photographer like anyone else in business; thus, the photographer has many of the same tax concerns as any other business-person. In addition, most photographers have some special tax problems.

First, most professional photographers do not work for a fixed wage or salary. As a result, a photographer's income can fluctuate radically from one tax year to the next. (This is true too, of course, for the photographer who works for some-one else but who also freelances.) Second, many tax rules designed to facilitate investment are not useful to photographers. Photographers can, however, benefit from certain provisions of the Internal Revenue Code to reduce their income tax liability.

Record-keeping

In order to take advantage of all the tax laws that are favorable to you, it is imperative that you keep good business records. The Internal Revenue Service does not require that you keep any particular type of records. It will be satisfied so long as your record-keeping clearly reflects your income and is consistent over time so that it can make accurate comparisons from year to year when evaluating your income.

The first step in keeping business records that will allow you to maximize your deductions is to open a checking account for your business. Try to pay all your business expenses by check. Be sure to fill in the amount, date, and reason for each check on the stub. If the check was written for an expense related to a particular client or job, be sure to put the client's name or a job number on both the check and the stub. Finally, keep all of your canceled checks.

Second, file for a taxpayer identification number.

Third, keep an expense diary that is similar in form to a date book. You should use your expense diary on a daily basis, noting all cash outlays, such as business-related cab fares, tolls, tips, and emergency supplies, as they occur. This will satisfy the IRS requirement that you have good evidence of the business purpose for any expenses.

Qualifying for Business Deductions

There are two principal ways of reducing tax liability. First, there are significant deductions available to photographers. Second, as will be discussed later in this chapter, photographers can spread their taxable income (and thus reduce their tax liability) by using different provisions in the tax code.

Professional photographers may deduct their business expenses and, thereby, significantly reduce their taxable income. However, as with other artists and craftspeople, photographers must be able to establish that they are engaged in a trade or business and not merely a personal hobby. You must keep full and accurate records. Receipts are a necessity. Furthermore, it would be best if you had, in addition to a separate checking account, a complete set of books for all of the activities of your trade or business. A dilettante is not entitled to trade or business deductions.

Tax laws presume that a photographer is engaged in a business or trade, as opposed to a hobby, if a net profit results from the photography during three out of the five consecutive years ending with the taxable year in question. If the photographer has not had three profitable years in the last five, the IRS may contend that the photographer is merely indulging in a hobby, in which case the photographer will have to prove *profit motive* in order to claim business expenses. Proof of profit motive does not require the photographer to prove that there was some chance a profit would actually be made; it requires proof only that the photographer intended to make a profit.

The treasury regulations call for an objective standard on the profit-motive issue, so statements of the photographer as to intent will not suffice as proof. The regulations list nine factors to be used in determining profit motive:

1. The manner in which the taxpayer carries on the activity (i.e., effective business routines and bookkeeping procedures)

2. The expertise of the taxpayer or the taxpayer's advisors (i.e., taking courses in appropriate subjects, awards, prior sales or exhibitions, critical recognition, membership in professional organizations, etc.)

3. The time and effort expended in carrying on the activity (i.e., at least several hours a day, preferably on a regular basis)

4. Expectation that business assets will increase in value (a factor that is generally of little relevance to the photographer)

5. The success of the taxpayer in similar or related activities (i.e., past successes, either financial or critical, even if prior to the relevant five-year period)

6. History of income or losses with respect to the activity (i.e., increases in receipts from year to year, unless losses vastly exceed receipts over a long period of time)

7. The amount of profits, if any, that are earned

8. Financial status (wealth sufficient to support a hobby would weigh against the profit motive)

9. Elements of personal pleasure or recreation (i.e., if significant traveling is involved and few photographs produced, the court may be suspicious of profit motive)

No single factor will determine the results. The case of *Young v. United States* provides an example of how the factors are used. Young was a psychoanalyst who also had a photography business. Although Young was not a commercial photographer and she had experienced large, serious losses, the court held that she had a genuine profit motive in pursuing photography. The court was influenced by the fact that Young did not appear to be pursuing the occupation of photography for mere pleasure or social prestige and that she was organized as a business and kept conventional business records.

Deductible Expenses

Once you have established yourself as engaged in photography as a business, many of your ordinary and necessary expenditures for professional photography are deductible business expenses. This would include photographic equipment and supplies, office equipment, research or professional books and magazines, travel for business purposes, certain conference fees, agent commissions, postage, legal fees, accounting fees, and workspace. Workspace as a deductible expense—particularly space in one's home, which is a matter of concern to numerous businesspeople, including photographers—is covered in the next chapter.

Many of a photographer's expenses are classified as *current expenses*—items with a useful life of less than one year. For example, postage, modeling fees, and telephone bills would be current expenses. These expenses are fully deductible in the year incurred.

There are some business expenses, however, that cannot be fully deducted in the year of purchase but must be depreciated or amortized. These costs are *capital expenditures.* For example, the cost of professional equipment (such as cameras, tripods, memory cards, and lighting equipment) that has a useful life of more than one year is a capital expenditure and cannot be fully deducted in the year of purchase. Instead, the taxpayer has to depreciate, or allocate, the cost of the item over the estimated useful life of the asset. This is sometimes referred to as *capitalizing*

or amortizing the cost. Although the actual useful life of professional equipment will vary, fixed periods have been established in the Internal Revenue Code over which depreciation may be deducted.

In some cases, it may be difficult to decide whether an expense is a capital expenditure or a current expense. Repairs to equipment are one example. If you spend $200 servicing a camera, this expense may or may not constitute a capital expenditure. The general test is whether the amount spent restoring the equipment has added to its value or substantially prolonged its useful life. Since the cost of replacing short-lived parts of equipment to keep it in efficient working condition does not substantially add to the useful life of equipment, such a cost would be a current cost and would be deductible. The cost of reconditioning equipment, on the other hand, significantly extends its useful life. Thus, such a cost is a capital expenditure and would be depreciated.

For many small businesses, an immediate deduction can be taken when equipment is purchased instead of depreciating the expense. This is called the "election to depreciate certain business assets." In order to take advantage of the provision, you must have net income of at least the amount of the deduction. The Economic Stimulus Act of 2008 and the American Recovery and Reinvestment Act of 2009 increased the deduction limit from $125,000 to $250,000 for the years 2008 and 2009, but the limit is slated to return to $125,000 in 2010.

Commissions paid to agents, as well as fees paid to lawyers or accountants for business purposes, are generally deductible as current expenses. The same is true of salaries paid to assistants and others whose services are necessary for the photography business. If you need to hire help, it is a good idea to hire people on an individual, project basis as independent contractors rather than as regular employees. This way, you do not have to pay for Social Security, disability, and withholding tax. You should specify the job-by-job basis of the assignments, detail when each project is to be completed, and, if possible, allow the person you are hiring to choose the place to do the work. There may be other restrictions when attempting to characterize an individual as an independent contractor; you should discuss this with your attorney or tax adviser.

Business Use of an Automobile. If you or your employees use personal vehicles for business, an amount proportionate to the business use may qualify for depreciation, maintenance, and operating expense deductions. You must keep accurate records of the number of "business miles" driven and of the time, place, and purpose of the travel. If records are not kept, no deduction will be allowed. The records must establish total annual mileage, commuting mileage, business mileage, percentage of business use, and the date the vehicle was placed in service. This information must be reported on the tax return. You will also be asked to indicate whether there is written evidence to support the claimed use of the vehicle for business. If the vehicle is a "luxury" vehicle, there are special rules that apply for depreciation purposes.

If an automobile is used solely for business, records separating business from personal use are not necessary if certain conditions are met:

- The vehicle is leased or owned by the employer and provided to one or more employees for use in connection with the business

- The vehicle is kept at the employer's premises when not in use, and no employee using the vehicle lives at the employer's address

- A written policy of the employer forbids personal use of the vehicle, and the vehicle is not used personally, except for minor deviations such as lunch stops, while on the road for business purposes

Travel, Entertainment, and Conventions. Many photographers travel abroad in order to shoot certain subjects. Even more commonly, a photographer might travel within the United States.

On a business trip, whether within the United States or abroad, ordinary and necessary expenses, including travel and lodging, may be 100 percent deductible if your travel is solely for business purposes, except for luxury water travel. Note, however, only 50 percent of the costs of business meals and meals consumed while on a business trip are deductible. If the trip involves primarily a personal vacation, you can deduct business-related expenses at the destination, but you may not deduct the transportation costs.

If the trip is primarily for business but part of the time is given to a personal vacation, you must indicate which expenses are for business and which for pleasure. This is *not* true in the case of foreign trips if one of the following exceptions applies:

- You had no control over arranging the trip, and you are not a managing executive or shareholder of the company that employed you

- Less than 25 percent of the time was spent in non-business activities

- The trip outside of the United States was for a week or less

- A personal vacation was not a major consideration in making the trip

If you are claiming one of these exceptions, you should be careful to have supporting documentation. If you cannot take advantage of one of the exceptions, then you must allocate expenses for the trip abroad according to the percentage of the trip devoted to business (as opposed to vacation).

Whether inside or outside of the United States, the definition of what constitutes a business day can be very helpful to the taxpayer in determining a trip's deductibility. Travel days, including the day of departure and the day of return, count as business days if business activities occurred on such days. If travel is outside the United States, the same rules apply if the foreign trip is for more than seven days. Any day that the taxpayer spends on business counts as a business day even if only a part of the day is spent on business. A day in which business

is canceled through no fault of the taxpayer counts as a business day. Saturdays, Sundays, and holidays count as business days even though no business is conducted, provided that business is conducted on the Friday before and the Monday after the weekend or on one day on either side of the holiday.

Entertainment expenses incurred for the purpose of developing an existing business are also deductible—in the amount of 50 percent of the actual cost. However, you must be especially careful about recording entertainment expenses. You should record in your logbook the amount, date, place, type of entertainment, business purpose, substance of the discussion, the participants in the discussion, and the business relationship of the parties who are being entertained. The IRS requires you to keep receipts for any expenses over $75, though it is strongly recommended that you keep all of your receipts. You should also keep in mind the stipulation in the tax code that disallows deductibility for expenses that are "lavish or extravagant under the circumstances." If tickets to a sporting, cultural, or other event are purchased, only the face value of the ticket is allowed as a deduction. If a skybox or other luxury box seat is purchased or leased and is used for business entertaining, the maximum deduction now allowed is the cost of a non-luxury box seat.

The above rules cover business travel and entertainment expenses both inside and outside of the United States. The rules are more stringent for deducting expenses incurred while attending conventions and conferences outside the United States. Also, the IRS tends to review very carefully any deductions for attendance at business seminars that also involve a family vacation, whether inside the United States or abroad. In order to deduct the business expense, the taxpayer must be able to show, with documents, that the reason for attending the meeting was to promote production of income.

Normally, for a spouse's expenses to be deductible, the spouse's presence must be required by the photographer's employer. In the case of an independent photographer, if the spouse will also be going on business trips, it is wise to make the spouse a partner, employee, or member of the board of the company, assigning the spouse duties that would justify attendance at the convention or conference.

As a general rule, business deductions are allowed for conventions and seminars held in North America. The IRS is taking a closer look at cruise ship seminars and is now requiring that two statements be attached to the tax return when such seminars are involved. The first statement substantiates the number of days on the ship, the number of hours spent each day on business, and the activities in the program. The second statement must come from the sponsor of the convention to verify the first information. In addition, the ship must be registered in the United States, and all ports of call must be located in the United States or its possessions. Again, the key for the taxpayer taking this sort of deduction is careful documentation and substantiation.

Keeping a logbook or expense diary is probably the best line of defense for the photographer with respect to business expenses incurred while traveling. If you are on the road, keep these things in mind. With respect to travel expenses:

• Keep proof of the costs

• Record the time of departure

• Record the number of days spent on business

• List the places visited and the business purposes of your activities

With respect to the transportation costs:

• Keep copies of all receipts (at a minimum, of those in excess of $75)

• If traveling by car, keep track of mileage

• Log all other expenses in your diary

Similarly, with meals, tips, and lodging, keep receipts for all items over $75, and make sure to record all less expensive items in your logbook.

Photographers may also take tax deductions for their attendance at workshops, seminars, retreats, and the like, provided that they are careful to document the business nature of the trip. Accurate record-keeping is the first line of defense for tax preparation. Note that it is no longer possible to deduct for investment seminars or conventions (as opposed to business conventions).

Charitable Deductions. The law provides that an individual or business can donate either money or property to qualified charities and take a tax deduction for the donation. Individuals are afforded more favorable deductions for donations of money or property they own than are photographers donating their own work or business people who donate property out of their inventory. Since this area can be quite technical, you should consult with your tax adviser before making any charitable donations. In addition, there have been some abuses on the part of charities that resulted in misappropriation of donated funds. If you have any question about the validity of a particular charity, you should contact your state Attorney General's Office or the local governmental agency that polices charitable solicitations in your area.

Charitable donations of work by the creator, such as a photographer's donation of his or her own prints, will entitle the taxpayer to deduct for federal income tax purposes only the cost of the materials donated, i.e., photographic paper and ink or the amount actually paid to the lab, rather than the fair market value of the donation. Some states, such as Arkansas, Kansas, Maine, Maryland, Michigan, and Oregon, have enacted laws that allow the taxpayer to deduct more from state income taxes when charitable donations are made to qualified charities.

Grants, Prizes, and Awards. Those photographers who receive income from grants or fellowships should be aware that this income can be excluded from gross income and thus represents considerable tax savings. In qualifying for this exclusion, the grant must be for the purpose of furthering the photographer's education and

training. Amounts received under a grant or fellowship that are specifically designated to cover related expenses for the purpose of the grant are no longer fully deductible. Furthermore, if the grant is given as compensation for services or is primarily for the benefit of the grant-giving organization, it cannot be excluded.

For scholarships and fellowships granted after August 16, 1986, the above deductions are allowed only if the recipient is a degree candidate. The amount of the exclusion from income is limited to the amounts used for tuition, fees, books, supplies, and equipment. Amounts designated for room, board, and other incidental expenses are considered to be income. No exclusions from income are allowed for recipients who are not degree candidates.

The above rules apply to income from grants and fellowships. Unfortunately, the Tax Reform Act of 1986 also put tighter restrictions on money, goods, or services received as prizes or awards. Previously, the amounts received for certain awards were excluded from income in certain cases where the recipient was rewarded for past achievements and had not applied for the award. Examples of this type of award are the Pulitzer Prize or the Nobel Prize. Under the present law, any prizes or awards for religious, charitable, scientific, or artistic achievements are included as income to the recipient, unless the prize is assigned to charity. If you do not know whether a particular activity is deductible, you should consult with a competent CPA or tax adviser before embarking on such activity.

Spreading Income Among Family Members

Another strategy for photographers is to divert some of their income directly to members of their immediate family who are in lower tax brackets by hiring them as employees. Putting dependent children on the payroll can result in a substantial tax savings for professional photographers because you can deduct the salaries as a business expense, and, at the same time, you may not be required to withhold Social Security from the children's wages.

You, as the taxpayer, can still claim a personal dependency exemption for your child if (1) the child is a U.S. citizen, resident, or national or is a resident of Canada or Mexico; (2) the child has the same principal residence as you for more than one half of the year; (3) the child does not provide over one-half of his or her own support; and (4) the child does not file a joint return. This is true if the child is under nineteen years of age at the end of the tax year or if the child is between the ages of nineteen and twenty-four and is a full-time student. The child may not claim a personal exemption if he or she can be claimed by the parents on their tax return.

The following are other restrictions on such an arrangement:

- The salary must be reasonable in relation to the child's age and the work performed
- The work performed must be a necessary service to the business
- The work must actually be performed by the child

A second method of transferring income to members of your family is the creation of a family partnership. Each partner is entitled to receive an equal share of the overall income, unless the partnership agreement provides otherwise. Because the income is taxed once as individual income to each partner, the photographer with a family partnership can break up and divert income to the family members. That income will be taxed to each of them according to their respective tax brackets. The income received by children may be taxed at significantly lower rates, resulting in more income reaching the family than if it had all been received by the photographer, who is presumably in a higher tax bracket than the children.

Although the IRS allows family partnerships, it may subject them to close scrutiny to ensure that the partnership is not a sham. Unless the partnership capital is a substantial income-producing factor and unless partners are reasonably compensated for services performed on the partnership's behalf, the IRS may, in applying the section of the Internal Revenue Code that deals with distribution of partners' shares and family partnerships, decide to forbid the shift in income. This section provides that a person owning a capital interest in a family partnership will be considered a partner for tax purposes even if he or she received the capital interest as a gift; but the gift must be genuine, and it should not be revocable.

Incorporating a Family. In the past, some families incorporated in order to take advantage of the then-more-favorable corporate tax rates. If the IRS questioned the motivation for such an incorporation, the courts examined the intent of the family members, and if the sole purpose of incorporating was tax avoidance, the scheme was disallowed.

There may, however, be other reasons for incorporating, such as to obtain limited liability as discussed in chapter 5. Similarly, for anyone who teaches photography, taking photographs may be an occupational requirement. A photographer may, therefore, wish to incorporate and elect to be taxed as an S corporation. This will enable the corporation to insulate the photographer from personal liability while permitting the business to be taxed as if it were individually owned. If the photographer employs a spouse and children, salaries paid to them will be considered business deductions and thus reduce the photographer's taxable income. When the spouse and children are made owners of the corporation by being provided with shares of stock in it, all of the benefits discussed in the preceding section will generally be available. (Related-party rules could apply, so caution is advised whenever you are dealing with family members in a business; check with your tax adviser or certified public accountant.) Note, however, that losses derived from passive investment, such as stock ownership, may be used only to offset earnings from passive investments and may not be deducted against ordinary income.

Capital Gains Tax

Until just recently, the capital gains tax was nothing more than a relic of the past. The capital gains preference has been and still is a hot topic for partisan debate. Under the Tax Increase Prevention and Reconciliation Act of 2005, taxpayers in the two lowest brackets (10 percent and 15 percent) pay no capital gains tax on long-term investments sold in 2008, 2009, and 2010, and those in the 25 percent bracket or higher pay 15 percent, though different rates apply for real estate, collectibles, and small business stock. In 2011, rates are scheduled to revert to the 2002 rates of 10 percent for taxpayers in the lower brackets and 20 percent for taxpayers in the higher brackets.

The key to a working understanding of the capital gains tax is the definition of a *capital asset*. Capital assets are items of property held by the taxpayer, often for investment purposes. The law does not clearly define a capital asset, but it does identify items that are not capital assets. Among other things, capital assets do not include property used in a trade or business that are subject to the rules for depreciation, inventory held for sale, or real property used in the trade or business. All other properties held by the taxpayer are capital assets—for example, the stock held in the incorporated practice (or any other business in which the taxpayer holds stock).

When a capital asset is sold, the net amount realized minus the adjusted *basis* of the asset (the acquisition price minus such things as the amount of any depreciation taken against it) and minus selling expenses is a capital gain or loss. Capital gains or losses also result from the sale of other property besides capital assets. These exceptions will be discussed later.

Other Property Subject to Capital Gain or Loss Rules

The sale or exchange of property other than capital assets can result in a capital gain or loss. Any property that can have basis can produce capital gain or loss on disposition in the right set of circumstances.

The sale of inventory does not result in a capital gain or loss even if the inventory is sold in bulk. There may be a different result if the entire practice is sold and then liquidated, but, if the inventory is sold at an advertised liquidation, the taxpayer has a good argument that the inventory was sold as goods to customers, resulting in ordinary loss.

Except for like-kind exchanges, the sale of real estate owned and used by a business, including long-term leaseholds, or the sale of depreciable business property, such as furniture or equipment, can result in capital gain or loss.

These are Section 1231 gains and losses. If all the sales of Section 1231 property result in a net Section 1231 gain for the year, the net gain is treated as capital gain; but if Section 1231 losses for the year exceed Section 1231 gains, the resulting net loss is treated as ordinary loss and may be used to offset ordinary

income without limit. The rule is fairly simple for the first year in which Section 1231 loss occurs. The taxpayer must keep track of his or her Section 1231 losses, however, for the next five years following their occurrence. Each time the taxpayer uses a net 1231 loss to offset ordinary income, the amount must be dated and posted to a hypothetical "recapture account." Any Section 1231 net gain occurring over the next five years must be reported as ordinary income to the extent of the amount in the recapture account. The idea is that the tax benefit gained by treating capital losses as ordinary will be erased over time by treating capital gains as ordinary income.

Section 1231 does not apply to property held for one year or less. Sale of short-term property of this type yields ordinary income or ordinary loss.

The technicality of the capital gains tax serves to illustrate the immense complexity of the Internal Revenue Code. The Code is full of pitfalls for the unwary; however, with the aid of a competent tax advisor, one can avoid these pitfalls and hopefully reduce the pinch of this taxing situation.

Sales Tax

There are several state and local taxes that a photographer might be subject to, such as sales taxes, unincorporated business taxes, commercial occupancy taxes, personal property taxes, and inventory taxes. In most states and in some cities, photography is a business subject to sales tax. You should contact your state and city sales tax bureaus, if any, to ascertain their requirements. Usually, the tax bureau will issue you a taxpayer identification number after you fill out some forms. This will allow you to buy certain equipment and supplies without paying the sales tax. However, you will later have to act as an agent of the state, collecting sales tax from your clients and paying it to the state. You should be aware that even if you do not collect the sales tax from your customers, you will be liable for paying it.

Sales taxes do vary from state to state; therefore, be sure to find out what the taxes are in your city and state. Intangible property sales, such as reproduction rights, usually do not have a sales tax associated with them. Also, sales taxes customarily are levied on the last sale when the merchandise reaches the consumer; the manufacturer, distributor, and others earlier in the production chain generally do not pay sales tax. Other states require the out-of-state seller to collect tax for the state in which the goods are delivered. When selling your work across state lines, it is important to know the sales tax regulations in both states. Also, some states impose a sales tax when transporting goods outside of the state, whereas other states do not.

As a photographer, you are probably quite often selling a service (intangible goods), as well as your work (tangible goods). This can present some complicated sales tax issues, especially in light of the fact that sales tax regulations differ from state to state. When a photographer sells the reproduction rights to his or her

work, usually there is no sales tax levied because reproduction rights are intangible. However, in some states, if a tangible item is also sold with the intangible rights, the entire amount of the transaction will be taxed. The New York Sales Tax Bureau, for example, stipulates that when you bill a client for both a service and a tangible item, sales tax must be paid on the entire transaction, even though, had the services been billed separately, they would not have been subject to tax.

Certain organizations such as charities and museums are customarily tax-exempt. They frequently have a tax-exempt resale certificate proving their tax-exempt status. If a client claims to be tax exempt, you should insist on verification because you, the photographer, as well as your client, will be liable for any unpaid sales tax.

If you sell your work via the Internet, you will need to collect and pay any sales tax charged by your state from customers in your state. Currently, unless you have a physical presence in a state, you are not required to collect or pay sales tax, but because there are frequent attempts to pass legislation changing this rule, this could change.

-8-
Tax Deductions for the Office at Home

I t is quite common for photographers to have offices or studios at home for a variety of reasons. The most common reason, though, is probably economic. The cost of renting a separate space is such that many photographers prefer to work at home. Others, of course, choose to work at home because it enables them to juggle work and family obligations.

Before 1976, you could deduct the portion of your household expenses that could reasonably be allocated to professional work. However, in 1976, Congress added Section 280A to the Internal Revenue Code. This law generally disallows any deduction for the use of your personal residence in any business. It applies not only to the building in which you the taxpayer live, but also to any structure attached to the house or on the property. There are, however, limited exceptions to the law.

Exclusive and Regular Use

You may be able to satisfy one or more of the exceptions to this rule. The first exception applies to any portion of the residence used *exclusively* and *on a regular basis* as the photographer's *principal place of business.*

Regularly means that the space is consistently used for business purposes only, meaning that occasional use does not qualify. *Exclusively* means that the area is used only for the business purpose. (There is an exception for the storage of inventory or by the use of a day care facility. Under these two circumstances, the

area does not have to be exclusive.) Generally, an area is considered as being used for business for tax purposes if it meets the above tests and is:

- The principal place of business (this includes administrative use). A home office will generally qualify as a business use for administrative work if the area is used exclusively and regularly and there is no other location available for the taxpayer to conduct these activities
- Used as a place to meet clients
- Used for business purposes and is a separate structure from the taxpayers' personal residence

When the office is in a structure separate from the principal residence, the requirements for deductibility have always been less stringent. The structure must be used exclusively and on a regular basis, just as an office in the home. However, when the office is in a separate structure, it need only be used "in connection with" the business, not as the principal place of business.

The requirement regarding regular use means that the use of the room may not be merely incidental or occasional. Obviously, there is a gray area between regular and occasional. Perhaps some photographers can use this rule as an inducement to overcome temporary bouts of laziness or *ennui*. If you as a photographer are planning on deducting any expenses for your office, you must keep working to satisfy the regularity test.

Like the regularity requirement, the rule regarding the principal place of business has been vague and interpreted differently at different times. In *Meiers v. Commissioner*, the plaintiff owned a self-service laundromat. Mrs. Meiers managed the business, supervised the five part-time employees, and performed other managerial and bookkeeping functions. She spent only about an hour a day at the laundromat and two hours a day in her office at home. The office was used exclusively for activities related to business. The tax court ruled that since the laundromat was the "focal point" of the business, any deduction for an office in the home should be disallowed.

The Court of Appeals for the Seventh Circuit reversed that decision, holding that rather than using the focal point of the business as the basis of its decision, the tax court should have looked to the principal place of the taxpayer's activities. Managerial decisions were made from the office, and a conscious decision was made not to create an office at the laundromat itself. For these reasons, the office-at-home deduction was allowed.

In 1993, however, the Supreme Court held in *Soliman v. Commissioner* that home-office deductions were not available where the taxpayer performed the services or delivered goods outside of the home and income was not directly generated at home.

The Taxpayer Relief Act of 1997 expanded the definition of a taxpayer's principal place of business to include the place where administrative and management activities are conducted if there is no other fixed location for the accomplishment

of such tasks. For instance, a photographer who rents studio space could take the home-office deduction if the administrative aspects of the business, such as preparing invoices, ordering supplies, and the like, were conducted from only the home office.

In another case, the tax court disallowed a claim for an office-at-home deduction despite a unique argument. In *Baie v. Commissioner*, the taxpayers operated a hot dog stand some distance from their home. Because the stand measured only ten feet by ten feet, some of the food preparation and storage was done at home. The taxpayers argued that they were actually engaged in a manufacturing operation at home, and, therefore, the office-at-home section of the Internal Revenue Code did not apply. The court disallowed the deduction, on the basis of the fact that the kitchen and storage areas were not used exclusively for business purposes.

Another decision denying the office-at-home deduction was *Moller v. United States*. The taxpayers were a husband and wife who claimed a deduction for the area of their home used to manage their investments. The court held that in order to qualify as a trade or business, the business must consist of the active buying and selling of securities, with income derived therefrom. The Mollers, however, derived their income from the dividends and interest resulting from holding securities for a long time. This, the court held, did not rise to the level of carrying on a trade or business.

When taxpayers use a portion of their homes for storage of business materials, the requirements for deductibility of the storage area are also more relaxed than other rules in the recent past. The dwelling must be the sole, fixed location of the business, and the storage area must be used on a regular basis for the storage of the business equipment or products. The room used for storage need not be used entirely or exclusively for business, but there must be a "separately identifiable space suitable for storage" of the business-related materials.

Note that no home office deductions are allowed when employees rent their homes to their employers in their capacity as employees.

Is the Home Office Deduction Worthwhile?

If a taxpayer meets one of the tests outlined above, the next question is what tax benefits can result. The answer after close analysis is frequently, "Not very many." A taxpayer who lives in a rented house and otherwise qualifies for the office-at-home deductions may deduct a portion of the rent that would not otherwise be tax deductible. For homeowners, an allocable portion of mortgage interest and property taxes can be deducted against the business. These would be deductible anyway as itemized deductions. The advantage of deducting them against the business is that this reduces the profit that is subject to the business' taxes. The primary tax advantage comes from a deduction for an allocable portion of repairs, utility bills, and depreciation. Otherwise, these would not be deductible at all.

To arrive at the allocable portion, take the square footage of the space used for the business and divide that by the total square footage of the house. Multiply this fraction by your mortgage interest, property taxes, etc., for the amount to be deducted. How to determine the amount of allowable depreciation is too complex to discuss here, and you should discuss this with your accountant or tax advisor.

The total amount that can be deducted for an office or storage place in the home is artificially limited. To determine the amount that can be deducted, take the total amount of money earned in the business and subtract the allocable portion of mortgage interest, property taxes, and other deductions allocable to the business. The remainder is the maximum amount that you can deduct for the allocable portion of repairs, utilities, and depreciation. In other words, your total business deductions in this situation cannot be greater than your total business income minus all other business expenses. The office-at-home deduction, therefore, cannot be used to create a net loss, but disallowed losses can be carried forward indefinitely and deducted in future years against profits from the business.

Besides the obvious complexity of the rules and the mathematics, there are several other factors that limit the benefit of taking a deduction for a studio or office in the home. One of these is the partial loss of the *nonrecognition of gain* (tax-deferred) treatment that is otherwise allowed when a taxpayer sells a personal residence. The Taxpayer Relief Act of 1997 allows homeowners to exclude up to $250,000 of gain ($500,000 for joint filers) from income with some restrictions.

This deferral of gain, however, is not allowed for the portion of the house that was used for business purposes. The taxpayer must pay tax on that portion of the gain from the sale.

For example, if you have been claiming 20 percent of your home as a business deduction, when you sell the home, you will enjoy a tax deferral on only 80 percent of the profit. The other 20 percent will be subject to tax because that 20 percent represents the sale of a business asset. In essence, for the price of a current deduction, you may be converting what is essentially a nonrecognition, or tax-deferred, asset into trade or business property.

Another concern is that by deducting for an office in the home, the taxpayer effectively puts a red flag on the tax return. Obviously, when the tax return expressly asks whether expenses are being deducted for an office in the home, the question is not being asked for purely academic reasons. Although only the IRS knows how much the answer to this question affects someone's chances of being audited, there is no doubt that a "yes" answer does increase the likelihood of an audit.

Given this increased possibility of audit, it does not pay to deduct for an office in the home in doubtful situations. Taxpayers who lose the deduction must pay back taxes plus interest or fight in court. If you believe that your studio or office at home could qualify for the business deduction, you would be well advised to consult with a competent tax expert who can assist in calculating the deduction.

-9-
What to Know About Leases

Photographers may work out of their homes, own the office buildings they use, or rent commercial space. The home-office deduction has been discussed elsewhere in this text (see chapter 8). Purchasing commercial real estate is quite complex and beyond the scope of this book; before embarking on this course, you should retain an experienced real estate lawyer for assistance. In this chapter, we will consider leases.

At some time in your professional life as a photographer, you may be in a position where you will have to evaluate the terms and conditions of a commercial lease. You may also have to examine a residential lease, although these are customarily more tightly regulated by state law than are commercial leases. The relationship between a landlord and a tenant varies from state to state, and it is important for you to consult with an attorney who has some expertise in dealing with this body of law before signing such a lease. As a photographer, however, you may wish to call your attorney's attention to some specific items in a commercial lease that could be of great concern to you.

Description of Property

One of the most important terms in any lease is the description of the property to be rented. Be sure that the document specifies, in some detail, the area that you are entitled to occupy. If you will be renting a studio in a building with common areas, you should have the responsibilities for those common areas spelled out.

Will you be responsible for cleaning and maintaining them, or will the landlord? If you are not responsible for physically maintaining them, will the cost or a pro rata share of the cost of doing so (CAM charges) be passed on to you? When will the common areas be open or closed? What other facilities are available to you, such as restrooms, storage, and the like?

Cost

Another important item is the cost of the leased space. Will you be paying a flat monthly rental fee or one that will change based on your earnings at the location (percentage rent)? Will you be responsible for paying a pro rata share of property taxes and insurance in addition to the rent? In order to evaluate the cost of the space, you should compare it with other similar spaces in the same locale. Do not be afraid to negotiate for more favorable terms.

Care should be taken not to sign a lease that will restrict you from opening another facility close to the one being rented. A clause such as this is often included in a lease with percentage rent. In addition, find out if there is an escalator clause that will automatically increase your rent on the basis of some external standard, such as the Consumer Price Index.

Length of the Lease

It is also important to consider the period of the lease. If you intend to rent a studio for a year or two, it is a good idea to try to get an *option* to extend. This gives you the right—but not the obligation—to extend the term of the lease for one or more set periods, usually on the same terms, other than an increase in rent. It is likely you will want to advertise and promote your business, and if you move on an annual basis, customers may feel that you are unstable. In addition, occasional customers who return on an irregular basis may not know where to find you after the lease period ends. Besides, moving can result in real headaches in regard to mail.

Long-term leases are recordable in some states. Recording, where permitted, is generally accomplished by having the lease filed in the same office where a deed to the property would be filed, usually the county clerk's office. (Check with a local title company or attorney for the particulars in your state.) If you are in a position to record your lease, it is probably a good idea to do so, since recording the lease will then entitle you to receive legal and other notices related to the property. If receiving such notices is important to you and your landlord does not want the lease recorded, discuss the option of recording a memorandum of lease (a summary of the lease) with your landlord.

If you enter into a long-term lease, you should attempt to obtain the right to assign or sublet the space so that you are not locked in if your situation should change. Landlords often impose restrictions on these rights, which range from preapproving the assignee or subtenant to paying the landlord a fee for exercising the right.

Restrictions To Watch Out For

It is essential for you to determine whether there are any restrictions on the particular activity you wish to perform at the leased premises. For example, the area may be zoned so that you are prohibited from discharging developing chemicals into the sewer system. It is a good idea to insist on a provision that puts the burden of obtaining any permit or variances on the landlord or, if you are responsible for them, allowing you to terminate the lease without penalty if you cannot get those permits or variances.

It is also quite common for zoning laws to prohibit certain forms of commercial activities in dwellings when the area is zoned residential and vice versa. You can seek to have a clause inserted in the lease whereby the landlord represents that the premises are zoned for your particular use. If the place you wish to rent will be used as both your personal dwelling and studio, some special problems may arise.

Some states have enacted legislation that permits individuals to live in certain industrially zoned buildings, such as warehouses and the like. This type of legislation began in New York City's Soho district in the late 1960s and has spread throughout the country. Some states also permit limited commercial activity to occur in residentially-zoned areas. These activities are customarily restricted to light manufacturing, such as photographers' and artists' studios, and professional services, such as lawyers, doctors, and accountants. Rarely will these zoning exceptions permit ongoing retail activities. You should consult with your attorney before attempting to operate out of your home or living in your commercial space.

Many leases prohibit the use or storage of hazardous materials. If you still use photography chemicals, you will need to make sure that there is an express exception for those.

Be sure that the lease permits you to display any signage or advertising used in connection with your business. It is not uncommon, for example, for historic landmark laws to regulate signs put on old buildings. Can you put a sign in your window or in front of your building? Some zoning laws prohibit this.

Remodeling and Utilities

Photographers should also be aware that extensive remodeling may be necessary for certain spaces to become useful studios. This remodeling will probably be called "tenant improvements" or "TIs" in the lease document. If this is the case, it is important for you to determine who will be responsible for the costs of remodeling. This should be expressly stated in the lease; otherwise, you may find that you are responsible for a lot more renovating than you anticipated. In addition, it is essential to find out whether it will be necessary for you to restore the premises to their original condition when the lease ends. This can be extraordinarily expensive and, in some instances, impossible to accomplish.

The Americans With Disabilities Act (ADA) of 1990 requires places of public accommodation to be reasonably accessible. The law is broadly interpreted and includes virtually every form of business. The term *reasonable accommodation* is not precise, and thus it is important to determine what must be done in order to fulfill the requirements of this federal statute. Typically, approximately 25 percent of the cost of any covered remodel must be allocated to items that aid accessibility. These would include, among other things, levered door openers, Braille signs, larger bathroom stalls, wheelchair ramps, approved disability-accessible doors, elevators, and the like. You should determine whether the cost of complying with the ADA will be imposed on the landlord, the tenant, or divided.

If you need special hookups, such as water or electrical lines, find out whether the landlord will provide them or whether you have to bear the cost of having them brought in. If the leased premises already have the necessary facilities, question the landlord regarding the cost of these utilities. Are they included in the rent, or are they to be paid separately?

Most commercial leases require the tenant to pay and be responsible for all utilities. You should make these arrangements directly with the utility companies. The landlord should not be involved. Because public utilities are tightly regulated, it is highly unlikely that any negotiation between you and the public utility will be fruitful regarding deposits, rates, fees, or contractual arrangements.

In some locations, garbage pickup is not a problem because it is one of the services provided by the municipality. However, it is not uncommon for renters to be responsible for their own trash disposal. In commercial spaces, this can be quite expensive and should be addressed in the lease.

You should also inquire about the availability of high-speed Internet access.

Security

A good lease will also contain a provision dealing with security. If you are renting an internal space in a shopping center, it is likely that the landlord will be responsible for external security. This is not universally the case, though, so you should ask. If you are renting an entire building, it is customarily your responsibility to provide whatever security you deem important. Does the lease permit you to install locks or alarm systems? If this is something in which you are going to be interested, you should get an answer to that question.

Deliveries

Many photographers have materials delivered to their studios at off hours so as to avoid disturbing potential customers. Does the lease have any restrictions regarding time or location of deliveries? If you are dealing with large bulky items and are accepting deliveries or making them, put a provision in your lease that will give you the flexibility you desire.

Insurance Coverage in the Lease

Customarily, the landlord will be responsible for the exterior of the building. It will be the landlord's obligation to make sure that the building does not leak during rainstorms and that it is properly ventilated. Nevertheless, it is important that the lease deal with the question of responsibility if, for example, the building is damaged and some of your photographs are injured or destroyed. Will you have to take out insurance for the building as well as its contents, or will the landlord assume responsibility for such building insurance?

Similarly, find out whether you will have to obtain liability insurance for injuries that are caused in portions of the building not under your control, such as common hallways and the like. In any case, you should, of course, have your own liability policy for accidental injuries or accidents that occur on your premises, as well as coverage for your own belongings. It is a good idea to have your insurance agent review all of the lease requirements relating to insurance before you sign the lease. (See chapter 10 for more information about insurance.)

Security Deposits

When the lease is first executed, landlords will often require new tenants to pay the first month's rent, the last month's rent, and a security deposit. Some state laws require landlords to keep security deposits in a special trust account during the term of the lease. These funds are available to the landlord if the tenant causes an injury to the property during the lease or fails to leave the premises in proper condition. Tenants who fulfill all of their obligations under the lease should be entitled to refunds of their deposits when their leases expire.

Late Rent

Most leases require the tenant to pay rent at the beginning of each month. Customarily, a lease will impose a penalty on the tenants for a late rent payment. You should try to negotiate for a fairly long grace period—ten or fifteen business days—before your rent is deemed late and a requirement that the grace period start running only after you are notified by the landlord. Generally, the late charges are called *service charges* or something similar to avoid their being characterized as penalties or interest, either of which is subject to specific rules regarding disclosure and amount.

Get It in Writing

Finally, it is essential to make sure that every item agreed upon between you and the landlord is reduced to writing. This is particularly important when dealing with leases since many state laws provide that a long-term lease is an interest in land and can be enforced only if it is in writing.

The writing may consist of several documents. For example, some shopping malls use a *master lease*, which governs the rights and responsibilities of all tenants, as well as an individual lease, which deals only with the issues unique to the specific rental space. In addition to leases, landlords may also add rules and regulations to the lease that are binding on all tenants regarding, for example, parking, waste disposal, rules for common areas, and the like.

-10-
What to Know About Insurance

The insurance business originated in a London coffeehouse called Lloyd's some-time in the late seventeenth century. Lloyd's was a popular gathering place for seamen and merchants engaged in foreign trade. As Shakespeare pointed out in *The Merchant of Venice*, great profit can come from a successful sea voyage, but financial disaster can follow just as surely from a loss of ships at sea. From past experience, these merchants knew that despite their greatest precautions, such disaster could strike any one of them.

Through their dealings with the Italians, who already had a system of insurance, the merchants had become familiar with the notion of insurance, but there was no organized insurance company in England at that time. When these merchants were together at Lloyd's, it became a custom to arrange for mutual insurance contracts. Before a ship embarked, the ship's owner passed around a slip of paper that described the ship, its captain and crew, its destination, and the nature of the cargo. Those merchants who wished to be insurers of that particular ship would initial this slip and indicate the extent to which they could be held liable. The slip was circulated until the entire value of the ship and cargo was covered. This method of creating insurance contracts was called *underwriting*.

Today, the term underwriting describes the formation of any insurance contract, regardless of the means employed in consummating it. Lloyd's of London still uses a method similar to the one that originated in the coffeehouse, but most other insurance companies secure against loss out of their own financial holdings.

The risks covered by insurance have also changed. The original Lloyd's insurers dealt in maritime insurance only. Now, almost anything can be insured—from a pianist's hands to an old master painting.

Although your business may not be as perilous as that of the seventeenth-century merchant, it is not altogether free of risks. Even in rural areas, you may become the victim of burglary, and the forces of nature—fire, flood, earthquake—are undiscriminating in their targets. If you operate out of your home, you may already have homeowner's insurance, but your homeowner's insurance probably will not cover your professional activities.

As a photographer, you probably will need several types of insurance. While it is theoretically possible to insure virtually everything, in fact, as a practical matter, there are some risks that are not worth insuring. This section discusses some of the more common forms of insurance and identifies issues that should be considered when obtaining insurance. Insurance is very closely regulated by state officials; thus our discussion will, of necessity, be general. For specific information about insurance, you should contact your state insurance commissioner and retain an experienced attorney.

What Is Insurance?

All insurance is based on a contract between the insurer and the insured, whereby the insurer assumes a specified risk for a fee, which is called a *premium*. The insurance contract, or *policy*, must contain at least the following:

- A description of whatever is being insured (the subject matter)
- The nature of the risks insured against
- The maximum possible recovery
- The duration of the insurance
- The due date and amount of the premiums

When the amount of recovery has been predetermined in the insurance contract, it is called a *valued* policy. An *unvalued* or *open* insurance policy covers the full value of property up to a specified policy limit.

Insurance companies spread the risk among those subject to that risk through the amount of premium paid by each insured. First, the insurance company obtains data on the actual loss sustained by a defined class within a given period of time. State law regulates how the company defines the class. An insurance company may, for example, separate drivers with many accidents from drivers with few.

Next, the company divides the risk equally among the members of the class. Then, the company adds a state-regulated fee for administrative costs and profits. Finally, the premium is set for each individual in proportion to the likelihood that a loss will occur to him or her.

Besides the method of determining premiums, state insurance laws usually specify the training necessary for agents and brokers, the maximum amount of commission payable to them, and the kind of investments the insurance company may make with the premiums.

The Contract

Even the documents that a company uses to make insurance contracts are regulated. Sometimes the state requires a standard form from which the company may not deviate, especially for fire insurance. A growing number of states stipulate that all forms must be in "plain English"—that is, there must be a specific average number of syllables per word and average number of words per sentence. Because of a federal ruling that insurance contracts are fraudulent if they exceed certain maximum averages, insurance companies have been forced to write contracts that an average person can understand.

One frequent result of the language in which most insurance contracts are written is that the signed contract may differ in some respect from what the agent may have led the insured person to expect. If you can prove that an agent actually lied, the agent will be personally liable to you for the amount of promised coverage. Every state has an agency responsible for regulating insurance carriers operating within the state.

Most often, the agent will not lie but will accidentally neglect to inform the insured of some detail. For instance, if you want insurance for transporting work being returned to the artist, the agent may sell you a policy that covers transport only in public carriers—although you intended to rent a vehicle and transport the work yourself. In most states, the courts hold that it is the duty of the insured to read the policy before signing. If you neglected to read the clause that limits coverage to a public carrier, you would be out of luck. Failure to read the policy is considered no excuse.

In other, more progressive states, this doctrine has been considered too harsh. These states will allow an insured to challenge specific provisions in the signed contract to the extent that they do not conform to reasonable expectations resulting from promises that the agent made. In the preceding example, it might be considered reasonable to expect that you would be insured when transporting photographs in the gallery's custody. If the agent did not specifically bring your attention to this limitation in the contract, odds are that you would have a good chance of not having that limitation apply to you in the event of a loss. One reason is that it is common for the insured to receive the policy only after the premium is paid.

Other states follow a different approach for contract interpretation and attempt to ascertain the intention of the parties. The first step in interpreting an insurance policy is to examine the text and context of the policy as a whole.

If, after that examination, two or more conflicting interpretations remain reasonable, the ambiguity is resolved against the insurer. A court in these states will assume that parties to an insurance contract do not create meaningless provisions and will favor the interpretation that lets all provisions have meaning.

Of course, you should not wait for an agent to point out unexpected variations, even in the most liberal state. You should read the contract with the agent. If it is unintelligible, ask the agent to list on a separate sheet all the important aspects before signing, and then keep that sheet with the contract.

Underinsuring and Overinsuring

Let us consider the case of a woman who inherited a pearl necklace. An appraiser misled her and told her the pearls were genuine and, therefore, worth $60,000. Before having them shipped, the woman obtained insurance on them in the amount of $60,000 and paid a premium of $2,450. The description of the subject matter stated that the pearls were genuine. When the pearls were ruined after they arrived at the delivery terminal but before the woman received them, she tried to collect the $60,000.

In the course of the investigation of the accident, it was discovered that the pearls were not genuine but cultured pearls and worth only $61.50. Of course the insured could not collect $60,000 because no genuine pearls were lost or damaged. The worst of it was that she could not collect even $61.50 because the policy did not cover cultured pearls.

You might think that, in this case, the insured would at least get back her premium. She argued this but lost again. The court reasoned that had the pearls been lost in transit instead of being destroyed, the actual value of the pearls would never have come to light. Therefore, the insurance company had indeed assumed the risk of paying out $60,000 and thus was entitled to the premium.

The outcome of this case does not mean that if an insured accidentally overvalues goods, he or she will lose coverage. Had the pearls been genuine but worth only $20,000, the woman would have recovered $20,000. Overinsurance does not entitle one to a recovery beyond the actual value of the goods; the actual value is the amount of insurable interest.

Because you can at best only break even with insurance, you might think it would be profitable to underinsure your goods, pay lower premiums, and lose only if the damage exceeds the policy maximum. This has been tried without success.

An insured stated the value of his property as $9,950 and obtained insurance on that amount. A fire occurred that caused at least $9,950 worth of damage. The insurance company investigated the claim and determined that the insured owned at least $36,500 in property. The company refused to pay on grounds that the insured obtained the insurance fraudulently. The court agreed with the insurance

company, stating that the intentional failure to communicate the full value of the property rendered the entire contract void. Therefore, the insured could not even collect the policy maximum. All he could hope for at best would simply be to get his premiums back.

Although at first glance this decision may seem harsh, its ultimate fairness becomes apparent with a little analysis. The chance of losing $9,950 out of $36,500 is greater than the chance of losing $9,950 out of $9,950 simply because most accidents or thefts do not result in total losses.

The courts have various criteria for determining whether or not an omission or misstatement by the insured renders a policy void. In all cases, however, the omission or misstatement must be intentional or obviously reckless and must be material to the contract. *Materiality* is determined by the degree of importance that the insurance company ascribes to the omitted or misstated fact. If stating the fact correctly would have significantly affected the conditions or premiums that the company would demand, then the fact is material. In the preceding case, had the full value of the unscheduled property been stated, the insurance company would either have required that the full value be insured or that a higher premium be paid for the limited coverage. Thus, the misstatement was clearly material.

Many insurance contracts allow some undervaluation where it is not material and not intentional. This provision is designed to protect the insured from inflation, which causes property to increase in replacement value before the policy's renewal date. Considering the inflation rate, it is wise to reexamine your coverage each year.

A *co-insurance* clause generally provides that the insured may recover 100 percent of any loss up to the face value of the policy, provided that the property is insured for at least 80 percent of its full value. For example, if a photography studio worth $100,000 was insured for $80,000 and suffered a $79,000 loss from a covered casualty, the insured would recover the full amount of the loss, or $79,000. If the studio was insured for only $50,000, a formula would be used to determine the amount of recovery: divide the amount of insurance coverage by the total value of the property and multiply the resulting fraction by the loss.

For example:

$$\frac{\$50,000(\text{insurance})}{\$100,000(\text{value of business})} \times \$79,000(\text{loss}) = \$39,500(\text{recovery})$$

Scheduling Property

All insurance policies are limited to certain defined subject matter and to losses caused to that subject matter by certain defined risks. The typical insurance policy will include various exclusions and exemptions. For example, most homeowner and auto insurance policies cover personal property but exclude business property.

If a photographer keeps some of his photographs at home for personal enjoyment, are those pieces personal or business property? The answer depends on whether the photographer ever sells or commercially displays any of these items. If so, they may be considered business property.

In order to avoid a potentially tragic loss because of a technicality, the photographer may simply *schedule* the photographs that are held for personal enjoyment. Scheduling is a form of inventorying in which the insured submits a list and description of all pieces to be insured with an appraisal of their value. The insurer assumes the risk of loss of all scheduled works without concern as to whether they pertain to the business or not. Insurance on scheduled property is slightly more expensive than that of unscheduled property.

Many battles occur between the insurer and the insured over the value of objects stolen, destroyed, or lost. In anticipation of such battles, maintain records of sales to establish the market price of your work and keep an inventory of all works on hand. The value of the photographs must be determined by an expert in the field—both when the policy is obtained and after a loss—but this will not always prevent the insurance company from contesting the scheduled value.

What and When to Insure

Four factors should be weighed to determine whether or not to obtain insurance. First, you must set a value on that which is to be insured. Material goods are valued according to the cost of replacement. If you keep a large inventory of prints or if you own expensive equipment, as most photographers do, it should probably all be insured. The most elementary way to determine whether the value is sufficiently high to necessitate insurance is to rely on the pain factor: If it would hurt to lose it, insure it. You should also consider whether it is appropriate for you to obtain *business-interruption insurance* or *business-overhead-expense insurance*. Business-interruption insurance is designed to provide the business owner with lost earnings resulting from business interruption caused by specified risks, such as fire, storms, and the like. Business-overhead-expense insurance provides coverage for the loss or injury of an identified *key person*. Customarily, there is a thirty-day waiting period after the loss or injury before payments begin and then a period of approximately two years within which overhead, such as salaries, rent, utilities, and the like, are reimbursed.

Second, you must estimate the chances that a given calamity will occur. An insurance broker can tell you what risks are prevalent in the photography business or in your neighborhood. You should supplement this information with your personal knowledge. For example, you may know that your studio is virtually fireproof or that only a massive flood would cause any real damage. Although these facts should be weighed in your decision, you should not be guilty of audaciously tempting fate, for, as the great tragedians have recounted, to scoff at disaster is to

invite it. If the odds are truly slim but some risk is still present, the premium will be correspondingly smaller in most cases.

The third factor is the cost of the insurance. Bear in mind that insurance purchased to cover your business is tax deductible. That means if you pay tax at a rate of 30.5 percent, Uncle Sam is theoretically paying for 30.5 percent of your premium.

Fourth, you must determine whether you are legally obligated to obtain certain insurance. For example, commercial leases customarily require the tenant to maintain liability insurance in specific amounts, with the landlord as an identified insured party. There may be a comparable provision in your mortgage.

Hazard Insurance

To protect your studio and darkroom, look into a commercial policy that insures against fire, theft, and other hazards. The policy should be carefully worded to include all locations. For your equipment, a *camera floater*, which is written to cover loss or damage to equipment, is a necessity. The camera floater is usually attached to the package policy. The camera floater can include worldwide coverage for loss and damage to all parts of your equipment. Floaters only cover the equipment specifically listed, so be sure to periodically update your policy. Also, it is common for most floater policies to cover the amount of your cost, less depreciation; therefore, consider getting a *stated value floater*, which will reimburse you for the current replacement cost.

Liability Insurance

A general liability provision covers you for claims of injury to others resulting from your negligence. Coverage includes bodily injury at or away from the studio. If you do fashion work and have models in your studio on a regular basis, it is important that you carry enough liability insurance to cover them in the event they are injured and become unable to work. You should check your automobile coverage to see if it covers models if they become injured while you transport them to and from work.

Liability coverage can be extended to include legal injury, such as invasion of privacy, copyright infringement, and libel. If this type of coverage is important to you, check with your insurance broker. Advertising insurance may cover claims for copyright, trademark, and patent infringement, but, depending on the specific language used in your policy and the law of your state, you may need to obtain a rider for this coverage.

Intentional acts are virtually always excluded from coverage. In *American Guarantee & Liability Co. v. 1906 Co.*, Visual Arts Studio, which concentrated on photographing and videotaping young women for modeling portfolios and advertisements, as well as "glamour photography," was sued when it came to light

that women were videotaped dressing and undressing in the studio's dressing rooms. The court found that there was no coverage for the offending parties.

A similar case, *American Family Mut. Ins. Co. v. M. B.*, involved a photographer who sexually harassed and assaulted models. The photographer's employer was found not to have coverage for the photographer's conduct because the employer was aware of and tolerated the situation, and, therefore, such actions were excluded from coverage.

In *Andy Warhol Foundation v. Federal Insurance Co.*, it was held that the insurance company must defend Andy Warhol's estate and foundation in a copyright infringement lawsuit filed by *Time* over a photograph taken of Jackie Kennedy at President John Kennedy's funeral, which Warhol incorporated into several works. Whether appropriate notice of the claim had been provided to the insurance carrier was an issue in this case.

The most appropriate thing for you to do when you are served with a complaint in a lawsuit is to immediately contact an experienced attorney. The case should then be promptly *tendered* (submitted) to your insurance carrier for coverage. If your policy covers the claims in the complaint, the insurance will probably fund the defense and will probably be responsible for any recovery against you.

In addition to providing coverage for covered claims, most insurance policies also cover situations where a counterclaim is filed. This means that if, for example, you sue someone in order to recover your fees for work performed and they file a counterclaim against you alleging that you defamed them, the counterclaim may also be covered, and the insurance company will probably be required to fund the cost of the defense, as well as pay any possible recovery.

A possible trap for photographers is that most of the standard business insurance policies exempt liability arising from contractual obligations from coverage. It would, therefore, be wise for those who enter into contracts containing indemnification provisions to add the party being indemnified as an additional insured. Most often, this additional coverage will cost nothing or, at most, only a nominal amount. If this practice is adopted, then the party who is contractually indemnified will also be covered by the insurance policy in the event of a claim.

When a lawsuit or a counterclaim is tendered to an insurance company for coverage, the company may either accept responsibility without more ado, decline coverage and reject the claim, or assume responsibility for defending the claim but reserve the right to decline to pay any adverse award or even to reconsider the situation when the case is ultimately resolved. In the unusual situation when an insurance company assumes full responsibility for the case, then it will pay the full cost of defending the case, as well as any settlement or adverse judgment.

Most companies do not provide this type of blanket defense, particularly if any of the items being sued for are not clearly within the scope of the policy coverage. The most common situation is for the company to accept responsibility for defending the case, paying the attorneys and other litigation costs, but reserving

the right to refuse to pay any adverse judgment or settlement. This is known as a *reservation of rights.*

In this situation, some courts have found that there is a conflict between the insurance company and the business or individual who purchased that insurance. A leading California case held that in order to protect the insured when a reservation-of-rights situation arises, the insurance company must hire a second lawyer to represent the insured party in monitoring the case and advising the insured party. The insurance company, thus, would have to pay for two lawyers if it reserved its rights with respect to coverage of any claim.

If the insurance company denies coverage, then you should determine whether the denial is correct. In many situations, the insurance companies accept years of premiums, and then, when a claim is made, coverage is denied. The courts frequently have agreed with the insured and imposed liability on the insurance company. In fact, many jurisdictions provide that if the insurance company loses in a case where it is alleged that the insurance company was acting in bad faith, then the insurance company must reimburse the complainant for attorney's fees incurred, but if the insurance company wins, no attorney's fees will be recoverable by the insurance company.

Other Types of Insurance

As a photographer, it is likely you may employ models, assistants, and the like on a temporary or part-time permanent basis; and you may be required to provide income for these employees who are unable to work because of illness or injury. Also, if you have a large permanent staff, you may want to consider medical and retirement benefits for your employees. You may be required by law to purchase Workers' Compensation insurance as well.

Transit insurance covers your photographs when they are shipped to a gallery, agency, or the like. In addition, you might consider professional malpractice coverage, which would cover any liability you would incur in a situation where your client sues you because his or her pictures did not turn out as anticipated. For instance, if you accidentally reformat the memory card containing wedding photographs that have not yet been uploaded to your computer, malpractice insurance will enable you to compensate your customer and will protect you from what might be a disastrous financial liability.

Also available is bailee coverage, which you might consider if you often photograph the property of others and that property remains under your control for a period of time. If you are photographing priceless art objects, one of which becomes broken or lost, bailee coverage could be a godsend.

Keeping Costs Down

As we have already explained, the premiums charged by an insurance company are regulated by state law. Nonetheless, it still pays to shop around.

If you are going to purchase any insurance, purchase all of it at the same time and at the same place, if possible. With one broad policy, it is more likely you will be able to include the more unusual risks associated with the photography business, and at a lower rate, than if you have several separate policies.

Seeking a policy with a higher-than-average deductible may save you a considerable amount on your premium as it eliminates the costs associated with small claims for the insurance company. Also, you should attempt to obtain coverage of up to $1 million with unlimited risk, as in a general liability policy.

Individuals applying for medical insurance are generally charged extremely high rates. If you join an organization like the American Society of Media Photographers (ASMP), you may be able to take advantage of group rates available to members.

• • •

Because a photographer's insurance needs tend to be complicated and tend to vary with the type of photography done, do try to find an insurance broker experienced in serving photographers before signing onto any policy.

The best insurance agent to deal with is one that already has clients who are in business for themselves. That agent is more likely to be able to predict and incorporate your particular needs into your policy. If you are unable to locate such a qualified agent in your area, try consulting with one of the professional organizations, such as the American Society of Media Photographers (ASMP) or the Professional Photographers of America (PPA). These organizations should be able to give you information on local organizations in your area and may even be able to provide you with specific referrals.

-11-
Contracts and Remedies

In the normal course of business, photographers enter into contracts with magazines, agents, other photographers, customers, and photo labs. The contractual terms may vary with the kind of service or image contracted for, but in every case, the nature of legally binding agreements is the same.

The word "contract" commonly brings to mind a long, complicated document replete with legal jargon designed to provide hours of work for lawyers, but this need not be the case. A simple, straightforward contract can be just as valid and enforceable as a complicated one, though, depending on the issues to be covered, it may still be a long document.

What is a Contract?

A contract is defined as a legally binding promise or set of promises. The law requires the participants in a contract to perform the promises they have made to each other. In the event of *nonperformance*—usually called a breach—the law provides remedies to the injured party. For the purposes of this discussion, we will assume that the contract is between two people; however, contracts may have any number of parties.

The three basic elements of every contract are:

1. The offer

2. The acceptance

3. The consideration

Suppose, for example, you show a potential customer a variety of family portraits taken in your studio and suggest what you think would be the best arrangement for photographing her family (the offer). The customer says she likes the way you have photographed other families and wants you to do it the same way for her (the acceptance). You agree on a price (the consideration).

That is the basic framework, but a great many variations can be played on that theme.

Types of Contracts

A contract need not be a formal, written document. Contracts can be express or implied, oral or written, formal or informal.

Express or Implied

Contracts may be *express* or *implied*. An express contract is one in which all the details are spelled out. Suppose, for example, you make a contract with a sculptor to deliver twenty photographs of his work, on or before October 1st, at an agreed-upon price, which will be paid thirty days after the photographs are delivered.

That is fairly straightforward. If either party fails to live up to any material part of the contract, a breach has occurred, and the other party may withhold performance of his or her obligation until receiving assurance that the breaching party will perform. In the event no such assurance is forthcoming, the aggrieved party may have reason to sue for breach of contract.

If the photographs are delivered on October 15th and the sculptor had needed to get them to the judges for a juried exhibit by October 10th, time was an important consideration, and the sculptor would not be required to accept the late delivery, but if time is not a material consideration, then the tardy delivery would probably be considered *substantial performance*, and the sculptor would have to accept the delivery in spite of the delay.

Note that a small minority of jurisdictions would require strict performance despite the fact that the contract did not provide that time was of the essence. In these states, the sculptor may consider any late delivery to be a breach.

Express contracts can be either oral or written, although if you are going to the trouble of expressing contractual terms, you should put your understanding in writing.

Implied contracts are usually not in writing. Suppose you call a printer to order 1,000 sheets of letterhead without making an express statement that you will pay for the printing. The promise to pay is implied in the order and is enforceable when the stationery is picked up.

However, with implied contracts, things can often become a lot stickier. Suppose an acquaintance asks you, a well-known wildlife photographer, to bring over one of your recent large prints of a nesting eagle to see how it will look in her living room. She asks if you will leave it there for a few days. Two months

later, she still has it, and you overhear her raving to others about how marvelous it looks over the fireplace.

Is there an implied contract to purchase in this arrangement? That may depend on whether you are normally in the business of selling your work or whether you usually loan your work for approval.

Another kind of implied contract will arise when somebody requests you to send him your work. When, for example, Nike Corporation requested sports-action photographer Don Johnson to send his portfolio to the corporation, there was an implied agreement that Nike would take reasonable care of the portfolio and return it in due course. When the portfolio was lost at Nike, Johnson sued and recovered for his lost work.

Possible Contract Scenarios

Let us examine the principles of offer, acceptance, and consideration in the context of several potential situations for a hypothetical freelance photographer, Pat Smith.

Smith has had works accepted in local and regional exhibitions, has won several prizes, and is getting assignments from large national corporations. In a word, Smith is developing quite a reputation. With this brief background, we will look at the following situations and see whether an enforceable contract comes into existence.

Situation A. At a cocktail party, Jones expresses an interest in hiring Smith to photograph Jones' family. "It looks like your work will go up in price pretty soon," Jones tells Smith. "I'm going to hire you while I can still afford you."

Is this a contract? If so, what are the terms of the offer—the particular work, the specific price? No, this is not really an offer that Smith can accept. It is nothing more than an opinion or a vague expression of intent.

Situation B. Brown offers to pay $800 for one of Smith's photographs that she saw in a show several months ago. At the show it was listed at $900, but Smith agrees to accept the lower price.

Is this an enforceable contract? Yes. Brown has offered, in unambiguous terms, to pay a specific amount for a specific work, and Smith has accepted the offer. A binding contract exists.

Situation C. One day, Gray shows up at Smith's studio and sees a photograph that she would like to use in her book. She offers $200 for the exclusive publication rights in the photograph. Smith accepts and promises to deliver the photograph to Gray's publisher next week, at which time Gray will pay for the rights. An hour later, Brown shows up. She likes the same photograph and offers Smith $300 for the exclusive publishing rights in it. Can Smith accept the later offer?

No. A contract exists with Gray. An offer was made and accepted. The fact that the rights have not yet been exercised or paid for does not make the contract any less binding.

Situation D. Green agrees that Smith will photograph Green's wedding and present Green with an acceptable wedding album for $2,000. It is understood that Smith will take a variety of shots throughout the festivities. After Smith presents Green with the proofs, Green indicates that he is disappointed and will not accept any of them.

Green is making the offer in this case, but the offer is conditional upon his satisfaction with the completed work. Smith can accept the offer only by producing something that meets Green's subjective standards—a risky business. There is no enforceable contract for payment until such time as Green indicates that the completed album is satisfactory.

Now, suppose Green came to Smith's studio and said that the completed album was satisfactory but then, when Smith delivers it, says it does not look right when Green reexamines it at home.

It is too late for Green to change his mind. The contract became binding at the moment he indicated that the album was satisfactory. If he then refuses to accept it, he will be breaching his contract.

Oral or Written Contracts?

Contracts are enforceable only if they can be proven. The hypothetical examples mentioned above could have been oral contracts, but a great deal of detail is often lost in the course of remembering a conversation. The best practice, of course, is to get it in writing. A written contract not only provides proof but also makes very clear the understanding of both parties regarding the agreement and its terms.

Some people are adamant about doing business strictly on a handshake, particularly where photography is concerned. The assumption seems to be that the best business relations are those based upon mutual trust, and some business people believe that any agreement other than a gentlemen's agreement belies this trust.

Although there may be some validity to these assumptions, people who own small businesses, such as photographers, would nevertheless be well advised to put all of their oral agreements into writing. Far too many people have suffered adverse consequences because of their reliance upon the sanctity of oral contracts.

Even in the best of business relationships, it is still possible that one or both parties might forget the terms of an oral agreement, or both parties might have quite different perceptions about the precise terms of the agreement reached. When, however, the agreement is put into writing, there is much less doubt as to the terms of the arrangement. Thus, a written contract generally functions as a safeguard against subsequent misunderstanding or forgetful minds. In addition, a written contract avoids what is perhaps the principal problem with oral contracts: the fact that they cannot always be proven or enforced.

Even if there is no question that an oral contract was made, it may not always be enforceable. There are some agreements that the law requires to be in writing.

An early law that was designed to prevent fraud and perjury, known as the Statute of Frauds, provides that any contract which, by its terms, cannot be fully performed within one year must be in writing. This rule is narrowly interpreted, so if there is any possibility, no matter how remote, that the contract could be fully performed within one year, the contract need not be reduced to writing.

Assume that a customer and a photographer have entered into a contract in which the photographer has agreed to produce five pictures. Assume further that the agreement requires that the photographer submit one set of proofs per year for five years. In this situation, the terms of the agreement make it impossible for the photographer to complete performance within one year. If, however, the photographer agrees to submit five sets of proofs within a five-year period, it is possible that the photographer could submit all five sets in the first year; therefore, the Statute of Frauds would not apply, and the agreement need not be in writing to be enforceable. The fact that the photographer might not actually complete performance within one year is immaterial. So long as complete performance within one year is possible, the agreement may be oral.

The Statute of Frauds further provides that certain agreements relating to the sale of goods must be in writing to be enforceable. This provision has been incorporated into the Uniform Commercial Code. The UCC provides that a contract for the sale of goods costing over $500 is not enforceable unless it is in writing and is signed by the party against whom enforcement is sought. There is no such monetary restriction on service contracts, however. Regardless of the amount of payment, a contract for the sale of services that can be completed within one year need not be in writing.

Distinguishing Sale of Goods from Sale of Services. Obviously, it is important to know whether a particular contract is regarded as involving the sale of goods or the sale of services. The UCC defines *goods* as being all things that are movable at the time the contract is made, with the exception of the money (or investment securities or certain other types of documents) used as payment for the goods. This definition is sufficiently broad to enable most courts to find that the transactions between a photographer and a supplier of such items as film, paper, cameras, and tripods involve goods. Unfortunately, the distinction is not so clear in the case of agreements between a photographer and a customer.

At least one court, in *Carpel v. Saget Studios, Inc.*, has ruled that the photographer-customer contract is a contract for the sale of goods, i.e., completed works. In this case, a contract to take wedding pictures was held to be a contract for

the sale of goods and thus enforceable. It is possible, however, that a commission to produce a work could be held to be a personal service contract and thus not covered by the UCC.

Determining the Contract Price of Goods. Assuming for the moment that the various agreements entered into by the photographer involve a sale of goods, a second matter to be determined is whether the price of the goods exceeds $500. In most cases, the answer will be clear—but not always.

A photographer, for example, might contract to purchase several camera accessories from a wholesaler. The price for the total purchase exceeds $500, but the price for the individual accessories does not. Which price determines whether or not the statute applies?

Or suppose a photographer sells pictures to a gallery. The gallery will offer the pictures at a price that exceeds $500, but the price the photographer gets is less than $500. Again, which price is used to determine whether the statute applies?

Obviously, a photographer will not in every case be able to ascertain whether the financial terms of a given contract exceed $500, any more than one can always be certain whether a given agreement involves the sale of goods or of services. Given the differences in interpretation by various courts, the best way to ensure that a contract will be enforceable is to put it in an unambiguous writing.

No-Cost Written Agreements

At this point, you might claim, with reason, that your profession is taking photographs, not writing legal documents. Where are you going to find the extra time, energy, or patience to draft contracts?

Fortunately, you as a photographer will not always need to do this since the suppliers or customers you deal with may be willing to draft satisfactory contracts. However, be wary of someone else's all-purpose contracts—they will almost invariably be one-sided, with all terms drafted in favor of whoever paid to have them prepared.

As a second alternative, you could employ an attorney to draft your contracts, but this may be worthwhile only where the contract involves a substantial transaction or where you will use the contract in numerous transactions. With smaller transactions, the legal fees may be larger than any benefits you would receive.

The book entitled *Business and Legal Forms for Photographers*, published by Allworth Press, is an excellent resource and contains many useful forms and documents. There are also some form contracts in appendix 1 of this book.

The Uniform Commercial Code, a compilation of commercial laws enacted in every state (though Louisiana has not enacted the sections discussed in this chapter), provides a third alternative. You need not draft a contract at all or rely on a supplier, customer, or attorney to do so.

The UCC provides that where both parties are merchants and one party sends to the other a written confirmation of an oral contract within a reasonable time after that contract was made—and the recipient does not object to the confirming memorandum within ten days of its receipt—the contract will be deemed enforceable.

A merchant is defined as any person who normally deals in goods of the kind sold or who, by occupation, represents himself as having knowledge or skill peculiar to the practices or goods involved in the transaction. Thus, professional photographers and their suppliers will be deemed merchants. Even an amateur photographer may be considered a merchant, since adopting the designation "photographer" may be deemed as a representation of oneself as having special knowledge or skill in the field. The rule will, therefore, apply to many oral contracts you might make. Consumers, such as individuals who wish to have family portraits taken, are probably not merchants within the meaning of the statute.

It should be emphasized that the sole effect of the confirming memorandum is that neither party can use the Statute of Frauds as a defense, assuming that the recipient fails to object within ten days after receipt. The party sending the confirming memorandum must still prove that an oral contract was, in fact, made prior to or at the same time as the written confirmation, but once such proof is offered, neither party can raise the Statute of Frauds to avoid enforcement of the agreement.

The advantage of the confirming memorandum over a written contract is that the confirming memorandum can be used without the active participation of the other contracting party. It would suffice, for example, to simply state: "This memorandum is to confirm our oral agreement."

However, since the writer would still have to prove the terms of that agreement, it would be useful to provide a bit more detail in the confirming memorandum, such as the subject of the contract, the date it was made, and the price or other consideration to be paid. Thus, you might draft something like the following:

> *This memorandum is to confirm our oral agreement made on July 3, 2010, pursuant to which [Photographer] agreed to deliver to [Magazine Editor] on or before September 19, 2010, five photographs and the right to use each of them one time only in the October issue of [Magazine] for the price of $200.*

The advantages of providing some detail to the confirming memorandum are twofold. First, in the event of a dispute, the photographer could introduce the memorandum as proof of the terms of the oral agreement. Second, the recipient of the memorandum will be precluded from offering any proof regarding the terms of the oral contract that contradicts the terms contained in the memorandum. The recipient or, for that matter, the party sending the memorandum, can introduce only proof regarding the terms of the oral contract that are consistent with the

terms found in the memorandum. Thus, the editor in the above example would be precluded from claiming that the contract called for delivery of six photographs because the quantity was stated in the memorandum and not objected to.

On the contrary, the editor would be permitted to testify that the original contract required the photographer to package the pictures in a specific way because this testimony would not contradict the terms stated in the memorandum.

One party to a contract can prevent the other from adding or inventing terms not covered in the confirming memorandum by ending the memo with a clause requiring all other provisions to be contained in a written and signed document. Such a clause might read:

> *This is the entire agreement between the parties and no modification, alteration, or additional terms shall be enforceable unless in writing and signed by both parties.*

To sum up, no one in business should rely on oral contracts alone since they offer little protection in the event of a dispute. The best protection is afforded by a written contract. It is a truism that oral contracts are not worth the paper on which they are written. Where a complete written contract is too burdensome or too costly, the photographer should at least submit a memorandum in confirmation of an oral contract to surpass the initial barrier raised by the Statute of Frauds. Moreover, by recounting the terms in the memorandum, you, the photographer, will be in a much better position later on to prove the oral contract.

Summary of Essentials to Put in Writing

A contract rarely need be—or should be—a complicated document written in legal jargon designed just to provide a handsome income to lawyers. Indeed, a contract should be written in simple language that both parties can understand and should spell out the terms of the agreement.

The contract would include:

- The date of the agreement
- Identification of the parties
- A description of the work being sold or, if a service, the service to be performed
- The price
- The signatures of the parties

To supplement these basics, the agreement should spell out whatever other terms might be applicable: pricing arrangements, payment schedules, copyright ownership, use rights, licenses, and so on.

Finally, it should be noted that a written document that leaves out essential terms presents many of the same problems of proof and ambiguity as an oral

contract. Contract terms should be well conceived, clearly drafted, conspicuous (i.e., not in tiny print that no one can read), and in plain English so that everyone understands what the terms are.

Questionable and Broken Contracts

Obviously, you do not want to find yourself involved in contracts of questionable validity, nor do you want to find yourself stuck with a contract that has not been honored. In the first case, how do you spot them? In the second case, what can you do to get justice?

Capacity to Contract

Certain classes of people are deemed by law to lack the capacity to contract. The most obvious class is minors, a fact of particular relevance to photographers since a photographer might wish to use a minor as a model. Note that some states have strict laws surrounding photography or videography and minors, so you should check with an attorney if you are not sure about the rules in your state.

A person is legally a minor until the age of majority, generally eighteen. A contract entered into by a minor is not necessarily void but generally is voidable. This means that the minor is free to rescind the contract until reaching the age of majority but that the other party is bound by the contract if the minor elects to enforce it.

In some states, a minor over eighteen must restore the consideration (payment) or its equivalent as a condition of rescission. Some states allow a parent to sign on behalf of a minor (see the model release forms at the back of this book); other states have a procedure for enabling minors to sign binding, nonrescindable contracts. This generally requires the approval of a judge.

Other people who lack the capacity to contract include insane and incompetent persons. Since the requirements for contracting with such persons are highly technical, the photographer who wishes to do so would be well advised to consult a lawyer.

Illegal Contracts

If either the consideration (which is normally money) or the subject matter of the contract is illegal, the contract itself is illegal. This problem will not generally arise in photography contracts, but it is possible that a photographer could unwittingly become a party to an illegal contract.

For example, the federal government and many states have enacted statutes, popularly known as Son-of-Sam laws, that prohibit criminals from receiving financial compensation from the exploitation and commercialization of their crimes. A publisher who contracts to pay a criminal royalties in return for the criminal's story would be violating the statute, and the contract would, therefore, be illegal. The same would probably be true of an agreement made by a photographer to illustrate a criminal's story in exchange for some payment.

A photographer may also become a party to an illegal contract if the work resulting from that contract is found to be either obscene or libelous. (Obscenity is discussed in chapter 4 and libel in chapter 2.)

Generally, a photographer is not liable for a deceptive or fraudulent use of his work unless he knew his work would be used in a dishonest manner, in which event the contract would be deemed void and liability also may result. Even so, a photographer should always try to guard against potential fraud claims by avoiding participation in a deception. As a general rule, if the subject matter to be photographed is obviously misleading, beware.

The Federal Trade Commission (FTC) is responsible for preventing "unfair methods of competition in commerce and unfair or deceptive acts or practices in commerce." This act also explicitly makes persons and business entities liable for deceptive advertising. The FTC has the authority to issue orders requiring corrective advertising.

There is no hard-and-fast rule for determining what constitutes an unfair or deceptive act or practice. As for *deceptive advertising*, the phrase means an advertisement that is materially misleading. An advertisement is deceptive if it has the "tendency" or "capacity" to deceive the public. The FTC may examine an advertisement and determine its potential effect on the minds of consumers without considering public opinion or even hearing evidence by complaining parties.

The FTC may even find an advertisement violates the FTC act despite consumers' testimony that they would not be misled by it. For instance, the truth-in-advertising law provides that a photographer will be liable for any deception in shooting an advertisement. General Foods issued a policy statement regarding food photography that provides useful guidelines for any photographer:

- Food will be photographed in an unadulterated state—the product must be typical of that normally packed, with no preselection for quality or substitution of individual components
- Individual portions must conform to amount per serving used in describing yield
- Package amounts shown must conform to package yield
- The product must be prepared according to package directions
- A recipe must follow directions and be shown in the same condition in which it would appear when suitable for serving
- Mock-ups may not be used
- Props should be typical of those readily available to the consumers
- Theatrical devices (unusual camera angles, small-size bowls, and spoons) may not be used to make false implications

The law generally treats an illegal contract as *void* rather than merely *voidable*—an important distinction. A voidable contract is valid until it is voided by the party possessing the right to rescind, whereas a void contract is not binding on either party, and neither party will be permitted to enjoy any fruits of the agreement.

A void contract results when both parties are at fault or where the illegality involves a morally reprehensible crime. If, however, the illegality involves an act that is wrong only because the law says that it is (as, for example, illegal parking or not obtaining a necessary business license), one party may have some rights against the less innocent party. A photographer who anticipates entering into, or is already involved in, a contract of questionable legality would be well advised to consult a lawyer.

Unconscionable Contracts

The law generally gives the parties involved in a contract complete freedom to contract. Thus, contractual terms that are unfair, unjust, or even ludicrous will generally be enforced if they are legal, but this freedom is not without limits. The parties are not free to make a contract that is *unconscionable*. Unconscionability is an elusive concept, but there are certain guidelines.

A given contract is likely to be considered unconscionable if it is grossly unfair and the parties lack equal bargaining power. Photographers who are just starting out are typically in a weaker bargaining position than advertising clients or owners of stock photography businesses and are, therefore, more likely to win a suit on an allegation of unconscionability. This is especially true where the photographer has simply signed a magazine's form contract. If the form contract is extremely one-sided in favor of the magazine and if the photographer was given the choice of signing the contract unchanged or not contracting at all, a court could find that the agreement was unconscionable. If that happens, the court may either treat the contract as void or strike the unconscionable clauses and enforce the remainder. It should be noted that unconscionability is generally used as a defense by one who is sued for breach of contract and that the defense is rarely successful, particularly where both parties are business people.

What Happens When a Contract Is Broken?

The principle underlying all remedies for breach of contract is to satisfy the wronged party's expectations; that is, the courts will attempt to place the injured party in the position that the party would have been in had the contract been fully performed. Courts and the legislatures have devised a number of remedies to provide aggrieved parties with the benefit of their bargains. Generally, this will take the form of monetary damages, but where monetary damages fail to solve the problem, the court may order *specific performance*.

Specific performance means that the breaching party is ordered to perform as promised. This remedy is generally reserved for cases in which the contract involves unique goods. In photography, a court might specifically enforce a contract to produce wedding pictures by compelling the photographer to deliver the photographs to the customer, but only if the photographs had been printed, qualifying as goods. A court would not be likely to compel a photographer to shoot or develop prints (thus performing a service) as a means of satisfying the aggrieved customer. The Thirteenth Amendment of the Constitution prohibits one from being forced to perform labor against one's will. Thus, for breach of a personal service contract, monetary damages are generally awarded.

Photographs Kept Too Long, Lost, or Damaged

Photographers or photography agencies may submit prints or transparencies to a potential purchaser on approval. If this submission is the result of an oral agreement—i.e., the photographs were requested—the customer may be liable for holding fees if the photographs are kept for an unreasonable time without payment.

Ordinarily, the delivery memoranda that accompany requested photographs contain clauses specifying that the customer is liable for any loss or damage to the photographs. A delivery memorandum may contain provisions that specify a certain amount the customer must pay for each lost or damaged picture. These provisions are enforceable if the amount they specify is a reasonable estimate of the value of the photographs and not a penalty. Delivery memoranda are designed to be signed and returned by the customer; however, they are usually effective and enforceable even if not signed, provided they are not objected to and the other party is a merchant, so long as any additional terms discussed in the oral agreement do not materially alter the parties' agreement. In *Ryan v. Aer Lingus*, the court found that a previously undiscussed provision in an unsigned delivery memorandum provided by the photographer was not binding on Aer Lingus because the requirement that Aer Lingus pay $1,500 for each lost or damaged transparency constituted a material change in the agreement. The court proceeded to determine the market value of the transparencies and awarded $300 per transparency.

Damages Against Loss of Film or Photographs

The law allows recovery of damages against film processors who lose or damage film or, in some cases, who lose or damage photographs. However, recovery may be limited to the cost of the film alone. In *Goor v. Navilio*, the plaintiff's vacation pictures were lost by the photography lab to which he entrusted them for processing. The film carton had the following disclaimer:

> *The film in this carton has been made with great care and will be processed in our laboratory without additional charge. If we find the film*

*to have been defective in manufacture or to have been damaged in our
laboratory, we will replace it, but we assume no other responsibility either
express or implied.*

The court held that recovery was limited to the replacement cost of the film
because of the written disclaimer.

In *Willard Van Dyke Productions v. Eastman Kodak*, the facts are similar to those
in *Goor*, except that the film carton stated that the processing was not included in
the price of the film; therefore, the court allowed full recovery of lost profits.

In *Mieske v. Bartell Drug Co.*, the plaintiff was a home photographer who
sued a drugstore for losing his thirty-two reels of home movie film. Although
the drugstore gave the plaintiff a receipt that included a clause disclaiming liabil-
ity beyond the retail cost of the film, the court found the disclaimer invalid and
unconscionable. The court reasoned that Article 2 of the Uniform Commercial
Code, which provides that unconscionable disclaimers will not be upheld, applies
to *bailments* as well as to the sale of goods. Bailment is the rightful temporary
possession of someone else's property; parking a car in a parking lot, for example,
establishes a bailment, as does leaving film with a processor. The court noted that
such disclaimers should not be upheld between a commercial film processor and
a retail customer because retail customers probably do not notice or understand a
disclaimer clause on a receipt. However, such a disclaimer might be valid among
people within the photography industry—people who would be expected to
know about and understand the disclaimer.

You should carefully read any limitation of liability agreement before signing
it since it has been held that these provisions are enforceable. When, for example,
a stock photography agency was unable to deliver a photographer's work, litiga-
tion resulted.

The photographer, who was also an attorney, admitted that he signed a stan-
dard photography agency agreement that stated that he had agreed to obtain his
own insurance and that the agency, exercising reasonable care, would not be held
responsible for the loss or damage to the pictures. The court, in *Rivkin v. Brackman*,
held that the limitation-of-liability agreement was enforceable, at least absent any
gross negligence or unconscionability on the part of the agency.

Concerning the amount of recovery, the cases all show that the photographer
can always recover at least the cost of the damaged film. In addition, the photog-
rapher can often recover the value of the photographs that would have resulted
had the film been processed properly.

There are various ways in which courts determine the damages a photog-
rapher receives in such cases. As a first step, the court will attempt to calculate
the market value of photographs that would have been made from the lost or
damaged film. Market value is determined by the prior use made of the photo-
graph, the current price for use of such photographs, and the extent to which the

photograph has already been used. For example, an old (though not an antique) transparency or negative might have less value than a newer one because its useful life as a commercial photograph is shorter. On the other hand, it might have historical importance. Also, certain subjects are more commercially valuable or salable than others. Finally, courts consider the ease or difficulty with which pictures may be retaken.

Sometimes the market value of film or pictures is hard to ascertain. In such cases, courts have uniformly held that a variety of factors may be used to determine the value of the film or photographs. One case involved a well-known scientist-photographer who delivered to the Museum of Natural History original color transparencies of indigenous species he took in the Antarctic. The museum failed to return eleven of the transparencies. Dr. Ray attempted to establish the cost of replacement or reproduction of the transparencies, based upon either the actual cash outlay or the value of the required labor and materials.

In his testimony, Ray told the court that the location where the transparencies were taken was remote; the transparencies were taken underwater, which was extremely hazardous; they were the best of the shots he took; and they had "data value," i.e., it was impossible to reproduce the conditions under which the pictures were taken. The court determined that the fair and reasonable value of the transparencies was $15,000 because, if there is a total loss of property with no ascertainable market value, the measure of damages is the cost to replace or reproduce the article and, if it cannot be reproduced or replaced, then its actual value to the owner should be considered in fixing damages.

In one case, photographer Brian Wolff realized the importance of having his paperwork in order. When *Geo* magazine had seventy-six of his photographs stolen from it, it became necessary to identify each chrome and place a value on it. Fortunately, the photographer's tear sheets contained this essential information.

In another case, one issue was the value of the photographer's lost slides. Experts in the industry testified that $1,500 per transparency was reasonable, given the photographer's status, the sales price for his other works, and the fact that some of the photographs were irreplaceable. Fifteen hundred dollars appears to be the standard price for a lost slide by a professional photographer; yet, some works have been valued even higher. For example, John G. Zimmerman received $3,000 per slide in 1988 when he was able to establish the exceptional and irreplaceable nature of his action-oriented slides spanning a forty-year period. Similarly, photographer John Stevens recovered over $22,000 for a lost slide of Salvador Dali.

Photographer Ethan Hoffman won a substantial judgment against Portogallo, Inc., when the lab lost ten rolls of film that were part of a larger series. The court awarded the photographer $1,500 per lost image for a total of $486,000 ($632,586 with interest added) based on the uniqueness of the subject matter,

Hoffman's status as a prestigious photojournalist, and the number of times his work had been published. In addition, Hoffman had commitments from two major magazines to publish some of the lost pictures.

Grace v. Corbis-Sygma involved a photographer who sued for loss of more than 40,000 photographs by his licensing agent. Neither the photographer nor the agency kept good records, but the court found that as bailee of the photographs, Corbis-Sygma was responsible for the missing images. The district and appellate courts rejected the $1,500-per-lost-transparency standard often used in the industry and stated that such a figure should be used only for unique and irreplaceable images.

The Second Circuit detailed a methodology for valuing the lost photographs. The number of lost images was divided by the total number of Grace's images turned over to Sygma, and the resulting percentage was multiplied by the highest earnings Grace had received in a year over the time Sygma had his images. Next, the court said the trial court should determine the number of years the lost photographs would have commercial value and multiply that number by the annual earning potential. Finally, the present value of the earning stream would need to be calculated.

Usher v. Corbis-Sygma involved yet more images lost by the Corbis-Sygma stock agency. In this case, the court found that Corbis was negligent and awarded the photographer $157,000 for the loss of more than 12,600 images, including photographs of the 2000 presidential campaign. The damages were based on the past earnings of Chris Usher, the photographer, with Corbis.

You may desire to insert a *liquidated damages* clause included in your contracts. Such a clause should provide that because of the difficulty in ascertaining actual damages, the parties have agreed on a per item value and that the specified value is reasonable. It should also state that the photographer would not sell the rights to any of the items for less than the stated amount.

In 1991, a Texas court upheld such a clause and awarded a photographer $51,000 for the loss of thirty-four of his slides. The court stated that a liquidated damages provision will be enforced if the harm caused is: "(1) incapable or difficult of estimation; and (2) the amount of liquidated damages is a reasonable forecast of just compensation."

The Assignment Agreement

Whenever you contract with a client for an assignment, whether it is a one-time shoot or a long-term assignment, there is always the possibility that someone will change their mind or that circumstances will change such that you, as the photographer, are left with no assignment, having already, perhaps, incurred some expense in preparation. In order to protect yourself against this happening, it is best to enter into an assignment agreement that details the consequences for either party's breach. (See appendix 1 for a sample agreement.)

- First, be sure to be clear on how you expect to be paid, i.e., whether it is per day or per photograph, as well as time of payment.

- You should include a clause on travel, preparation, and weather days. It is standard to receive one-half your standard fee for travel and weather cancellations.

- If you are being paid per day, specify how overtime is to be considered—whether by the week or by the day. This is especially important if you are going to be expected to put in long days.

- You should also predetermine whose responsibility it is to rent the space you will be using and who is paying for it.

- Include the amount of expenses you are anticipating, along with an ability to exceed the budget by 10 percent without prior approval. This will protect you in the event of unanticipated overages.

- The contract should, of course, specify the number and size of photographs requested, as well as a brief description of their content.

- A cancellation policy will most likely vary according to the type of assignment. If it is possible to schedule a reshoot in the near future that will not interfere with the result or your schedule, you may decide to waive a cancellation charge, providing your client gives you reasonable notice. However, try to provide for one-half fees in the agreement, along with an additional one-half fee plus expenses for any reshoot if you do not get notice. This is an area that you will most likely need to rely on all of your tact and negotiating skills in dealing with your client.

- If you are presented with a contract by your client, read it carefully to determine whether it states that the work is a "work made for hire." If so, the copyright in the work will belong to the client, not to you. Any assignment contract should explicitly state that the copyright in the work belongs to you or that rights not granted are reserved to you.

- Ownership of the original photographs and negatives should also be discussed. Will the client receive the originals and/or negatives or only permission to reproduce?

- You should require your client to obtain any necessary releases and to indemnify you for any costs you incur as a result of the client's not doing so.

- Depending on how the photograph is to be used, you may also wish to specify the credit line, if any, to be used.

-12-
Stock Photography

Many photographers are successful in selling their own work, either directly to clients or to intermediaries, such as galleries. Other photographers are employed on a regular basis—for example, as staff photographers for newspapers. A third group of photographers are independent and depend on stock photography vendors to make their work available to the largest possible number of potential buyers.

Until recently, when most publishers, advertising agencies, graphic designers, and others sought a photograph and did not have the resources to commission that photograph, they would either visit a stock agency in person or peruse the pages of a printed catalogue obtained from a stock agency that maintained drawers full of transparencies.

These days, those who want to locate an image go through an online photograph and video archive. Stock agencies maintain large banks of photographs classified by subject. Users no longer have to peruse a visual catalog and deal with original transparencies. Now searches by keyword, type of image, number of people, image format, and other factors can be conducted online and high-resolution images can be transferred over the Internet.

Getty Images (gettyimages.com), which recently bought competitor JupiterImages (jupiterimages.com), and Corbis (corbis.com), both based in Seattle, dominate the stock image market. These and other so-called "macrostock agencies" sell photographs from professionals at high rates. However, "microstock

agencies," such as Shutterstock (shutterstock.com) and Fotolia (us.fotolia.com), as well as Corbis' SnapVillage (snapvillage.com) and Getty Images' iStockphoto (istockphoto.com), sell images at relatively low rates and typically accept images from amateurs and professionals alike. Most microstock sites have a vetting process for photographers, requiring that the photographer complete a profile, pass a test about the site's guidelines, and provide sample photographs.

Because of the larger pool of stock photography available, most individuals, whether selling directly to clients or through stock photography vendors, have seen a decrease in the amount of money they receive for their work.

Contracting With a Stock Vendor

Most agencies will require a written agreement before they will deal with you. Such an agreement is likely to be a "click-through" agreement accessed online. Agreements can vary greatly, so be sure to carefully and thoroughly review the contracts. Some vendors may request captions and information as to whether a model release is available.

In the past, stock agents retained 50 percent of the proceeds of a sale, but with the consolidation of stock agencies into giant, multinational companies, many agencies retain 70 percent or more of the proceeds.

Many photographers prefer to place their work with more than one stock vendor when they have nonexclusive agreements. However, enough legal problems have resulted from this practice that many advise photographers to shoot slightly different views of important subjects when making use of more than one stock agency—and to avoid providing the same image to multiple vendors.

There are two basic types of licensing agreements: *rights managed* and *royalty free.*

Rights-Managed Licensing

This type of photography licensing agreement, sometimes referred to as "licensed images," involves negotiation of separate licenses for each use of an image. This is the traditional form of licensing, whereas royalty-free licensing (discussed below) is relatively new. Rights-managed licensing permits exclusivity arrangements, so that customers can be confident that they will not see the same image in a competitor's advertisement. The value of this type of license is determined by the use of the image (such as for advertising or news), the type of use (e.g., billboard or magazine), the length of the use, number of reproductions, and whether exclusivity is granted, as well as the size of the image as used.

Many photographers prefer to license their work under a rights-managed model, since the photographer retains more control over how the images are used.

Unfortunately for photographers, most photo banks using this licensing model choose to work with only well-established photographers. New photographers typically have only the royalty-free option, although as they gain experience,

they are likely to license some images through royalty-free channels and others through rights-managed channels.

Royalty-Free Licensing

Royalty-free stock photography allows the buyer to use an image multiple times for multiple purposes, with some restrictions, for a one-time fee. While there is no time limit on when the buyer can use the photograph, there is also no exclusivity, and the image may be sold by the photographer (or photo bank) with no restrictions. Microstock agencies use this model of licensing.

The price for a royalty-free image is determined solely by the digital file size. Frequently, royalty-free images are licensed as part of a subscription plan.

Professional photographers, whether experienced or not, are likely to become involved with online stock vendors. While the macrostock agencies continue to grow and newcomers periodically appear, the process of selling stock photographs remains in flux, and you should pay attention to the ever-changing landscape of this dynamic marketing vehicle.

-13-
Estate Planning

Proper estate planning will require the assistance of a knowledgeable lawyer and perhaps also a life insurance agent, an accountant, or a bank trust officer, depending on the nature and size of the estate. In this chapter, we will consider the basic principles of estate planning. This discussion is not a substitute for the aid of an attorney experienced in estate planning; rather, it is intended to introduce you to the basic principles, alert you to potential problems, and aid in preparing you to work with your estate planner(s).

Most fine art photographers, for example, want to have their work preserved. Commercial photographers often have personal work along with the commercial work that they hope will continue to generate revenues for their heirs. Even a photographer with modest assets should have an estate plan and a will prepared. Apart from the financial and tax planning aspects, it is important to specify what happens to your work after your death.

The Will

A will is a legal instrument by which a person directs the distribution of property in his or her estate upon death. The maker of the will is called the *testator*. Gifts given by a will are referred to as *bequests* (personal property) or *devises* (real estate). Certain formalities are required by state law to create a valid will. About thirty states allow only formally witnessed wills; that is, those states require that the instrument be in writing and signed by the testator in the presence of two

or more witnesses. The remaining states allow either witnessed or unwitnessed wills. If a will is entirely handwritten and signed by the testator, it is known as a *holographic will.*

A will is a unique document in two respects. First, if properly drafted it is *ambulatory*, meaning it can accommodate change, such as applying to property acquired after the will is made. Second, a will is *revocable*, meaning that the testator has the power to change or cancel it. Even if a testator makes a valid agreement not to revoke the will, the power to revoke it remains, although liability for breach of contract could result from such an action.

Generally, courts do not consider a will to have been revoked unless it can be established that the testator either (1) performed a physical act of revocation, such as burning or tearing up a will with intent to revoke it, or (2) executed a valid, later will that revoked the previous will. Most state statutes also provide for automatic revocation of a will, in whole or in part, if the testator is subsequently divorced or married.

To modify a will, the testator may also execute a supplement known as a *codicil*, which has the same formal requirements as those for creating a will. To the extent that the codicil contradicts the will, those contradicted parts of the will are revoked.

Payment of Testator's Debts

When the property owned by the testator at death is insufficient to satisfy all the bequests in the will after all debts and taxes have been paid, some or all of the bequests in the will must be reduced or even eliminated entirely. The process of reducing or eliminating bequests is known as *abatement*, and the priorities for reduction are set according to the category of each bequest. The legally significant categories of gifts are generally as follows:

- *Specific* bequests or devises, meaning gifts of identifiable items ("I give to X all the furniture in my home")

- *Demonstrative* bequests or devises, meaning gifts which are to be paid out of a specified source unless that source contains insufficient funds, in which case the gifts will be paid out of the general assets ("I give to Y $1,000 to be paid from my shares of stock in ABC Corporation")

- *General* bequests, meaning gifts payable out of the general assets of an estate ("I give Z $1,000")

- *Residuary* bequests or devises, or gifts of whatever is left in the estate after all other gifts and expenses are satisfied ("I give the rest, residue and remainder of my estate to Z")

Intestate property—that property not governed by a will—is usually the first to be taken to satisfy claims against the estate. Note that if the will contains a valid

residuary clause, there will be no such property. Next, residuary bequests will be taken. If more money is needed, general bequests will be taken. Lastly, specific and demonstrative bequests will be taken together in proportion to their value. Some states provide that all gifts, regardless of type, abate proportionately.

Disposition of Property Not Willed

If the testator acquires more property during the period of time between the signing of the will and his or her death, the disposition of such property will also be governed by the will, which, as we have seen, is ambulatory in nature. If such property falls within the description of an existing category in the will ("I give all my stock to X" or "I give all my real estate to Y"), then it will pass along with all similar property. If it does not and the will contains a valid residuary clause, such after-acquired property will go to the residuary legatees.

If there is no such clause that applies to this after-acquired property, such property will pass outside the will to the persons specified in the state's law of *intestate succession.*

When a person dies without leaving a valid will, this is known as dying *intestate.* The property of a person who dies intestate is distributed according to the law of intestate succession of the state in which the deceased was a resident, which specifies who is entitled to what parts of the estate. An intestate decedent's surviving spouse will always receive a share, generally at least one-third of the estate. An intestate decedent's surviving children likewise always get shares. If some of the children do not survive the decedent, the grandchildren of the decedent may be entitled to shares by *representation.*

Representation is a legal principle that means that if an heir does not survive the decedent but has a child who does survive, that child will represent the non-surviving heir and receive that parent's share in the estate. In other words, the surviving child stands in the shoes of a dead parent in order to inherit from the grandparent who dies intestate.

If there are no direct descendants surviving, the intestate decedent's surviving spouse will take the entire estate or share it with the decedent's parents. If there is neither a surviving spouse nor any surviving direct descendant of the intestate decedent, the estate will be distributed to the intestate decedent's parents or, if the parents are not surviving, to the siblings by representation. If there are no surviving persons in any of these categories, the estate may go to surviving grandparents and their direct descendants. In this way, the family tree is constantly expanded in search of surviving relatives.

If none of the persons specified in the law of intestate succession survive the testator, the decedent's property ultimately goes to the state. This is known as *escheat.* It should be noted that the laws of intestate succession make no provision for friends, in-laws, or stepchildren.

State law will often provide a testator's surviving spouse with certain benefits from the estate even if the spouse is left out of the testator's will. Historically, these benefits were known as *dower* in the case of a surviving wife or *curtesy* in the case of a surviving husband. In place of the old dower and curtesy benefits, modern statutes give the surviving spouse the right to *elect* against the will and, thereby, receive a share, often at least one-fourth of the estate. Here again, state laws vary; in some states, the surviving spouse's elective share is one-third.

The historical concepts of dower and curtesy are in large part a result of the law's traditional recognition of an absolute duty on the part of the husband to provide for the wife. Modern laws are perhaps better justified by the notion that most property in a marriage should be shared because the financial success of either partner is due to the efforts of both.

Advantages to Having a Will

A will affords the opportunity to direct distribution of one's property and to set out limitations by making gifts conditional. For example, if an individual wishes to donate certain property to a specific charity but only if certain conditions are adhered to, a will can make such conditions a prerequisite to the donation.

A will permits the testator to nominate an *executor*, in some states called a *personal representative*, to administer the estate. If no executor is named in the will, the court will appoint one. If the testator has an unusual type of property, such as photography, antiques, art, or publishable manuscripts, it is a good idea to appoint joint executors, one with financial expertise and the other with expertise in valuation of, for example, photography, antiques, art, or publishing.

If joint executors are used, some provision should be made in the will for resolving any deadlock between the two. For example, a neutral third party might be appointed as an arbitrator who is directed to resolve any impasses after hearing both sides. It is also advisable to define the scope of the executor's power by detailed instructions. Photographers may wish to appoint a special executor solely for the purpose of dealing with their photography collection. This person, commonly known as a *photographic executor*, should be experienced in the photography business, and you should determine whether he or she will treat your work in a manner consistent with your objectives.

It is essential in a will to avoid careless language that might be subject to attack by survivors unhappy with the will's provisions. A lawyer's assistance is recommended to set forth all of these important considerations in legally enforceable, unambiguous terms. A lawyer's help is also crucial to avoid making bequests that are not legally enforceable because they are contrary to public policy.

In addition to giving the testator significant posthumous control over division of property, a carefully drafted will can greatly reduce the overall amount of estate tax paid at death. The following information on taxing structures relates to federal

estate taxation. State estate taxes often contain similar provisions, but state law must always be consulted for specifics.

Living Trusts

A *trust* holds ownership of your assets. A *living trust* is a trust created during your lifetime and is generally revocable, though you may choose for tax reasons to create an irrevocable trust. You, or someone else, may be the *trustee* during your life.

Many companies try to sell living trusts, arguing that they are far superior to distributing your property through a will and that they are necessary to avoid a long, drawn-out, and expensive probate, as well as to reduce taxes, since nothing is left in the estate because it would have been distributed through the trust. However, many states exempt small estates from probate, and, even if your estate would be subject to probate, there are numerous other methods to avoid probate. Also, most probates are fast and inexpensive; thus, there is often no need to seek to avoid probate. Probate may also provide a means to eliminate uncertain claims exposure. In addition, the tax-saving methods that could be included in a living trust can be used in a will as well. Finally, despite what the advertisements may say, a trust *can* be contested.

Unfortunately, there are a number of living trust scams—some companies are selling legally deficient documents for thousands of dollars.

If you think a living trust may be for you, see an attorney to discuss your options. It may be that another estate planning mechanism will better suit your needs. If a living trust is right for your situation, you can have one drafted to suit your particular needs.

The Gross Estate—Estate Taxes

The first step in evaluating an estate for tax purposes is to determine the *gross estate*. The gross estate will include all property over which the deceased had significant control at the time of death. Examples would include certain life insurance proceeds and annuities, jointly held interests, and revocable transfers.

Under current tax laws, the executor of an estate may elect to value the property in the estate either as of the date of death or as of a date six months after death. The estate property must be valued in its entirety at the time chosen. However, if the executor elects to value the estate six months after death and certain pieces of property are distributed or sold before then, that property will be valued as of the date of distribution or sale.

Fair market value is defined as the price at which property would change hands between a willing buyer and a willing seller when both buyer and seller have reasonable knowledge of all relevant facts. Such a determination is often very difficult to make, especially when items such as photographs are involved. Although the initial determination of fair market value is generally made by

the executor when the estate tax return is filed, the Internal Revenue Service may disagree with the executor's valuation and assign assets a higher fair market value.

When an executor and the Internal Revenue Service disagree as to valuation and the parties cannot negotiate an agreed value, a court will decide the matter. In most cases, the burden will be on the taxpayer to prove the value of the asset. Thus, expert testimony and evidence of the sale of the same or similar properties will be helpful, such as cases involving original manuscripts, drawings, and photographs that support the executor's decision. In general, courts are reluctant to determine valuation by formula.

Some artists have intentionally destroyed some of their work during their lifetimes in order to avoid having those pieces included in their estate for tax purposes. Others have held back work deemed inferior only to have that work displayed after their death. The items that the French government obtained from the Picasso estate were considered extremely bad examples of the late artist's work and were probably warehoused by Picasso because he thought they should be overpainted. Perhaps identification of inferior work by marking or listing in a catalog would be of benefit to the executor.

Generally, estate taxes must be paid when the estate tax return is filed (within nine months of the date of death), although arrangements may be made to spread payments out over a number of years, if necessary. If an extension for time to file the estate tax return is completed, it is important to estimate the amount of federal and state taxes due and pay this amount with the extension requests to avoid underpayment penalties and interest, as these can be substantial. It is not uncommon for executors to be forced to sell properties for less than full value in order to pay taxes. This can be avoided by obtaining insurance policies, the proceeds of which can be set up in a trust. For an explanation of a trust, see the section called Distributing Property Outside the Will below.

The law allows a number of deductions from the gross estate in determining the amount of the taxable estate. The taxable estate is the basis upon which the tax owing is computed. The following section gives you a closer look at some of the key deductions used to arrive at the amount of your taxable estate.

The Taxable Estate

After determining the gross estate, figuring the *taxable estate* is the second major step in evaluating an estate for tax purposes. Typical deductions made from the gross estate to establish the taxable estate include:

- Funeral expenses
- Certain estate administration expenses
- Debts and enforceable claims against the estate
- Mortgages and liens

- The charitable deduction
- The marital deduction

The *charitable deduction* refers to the tax deduction allowed upon the transfer of property from an estate to a recognized charity. Since the definition of a charity for tax purposes is quite technical, it is advisable to insert a clause in the will that provides that if the institution specified to receive the donation does not qualify for the charitable deduction at the time of distribution, then the bequest shall go to a substitute qualified institution at the choice of the executor.

The *marital deduction* allows the total value of any interest in property that passes from the decedent to the surviving spouse to be subtracted from the value of the gross estate. The government will eventually get its tax on this property, when the spouse dies, but only to the extent such interest is included in the spouse's gross estate. This deduction may occur even in the absence of a will making a gift to the surviving spouse, since state law generally provides that the spouse is entitled to at least one-fourth of the overall estate regardless of the provisions of the will.

Federal estate tax is also reduced by state death tax credit or actual state death tax, whichever is less.

Once deductions are figured, the taxable estate is taxed at the rate specified by the Unified Estate and Gift Tax Schedule. The unified tax imposes the same rate of tax on gifts made by will as on gifts made during life. It is a progressive tax, meaning that the percent paid in taxes increases with the value of the property involved.

The Estate and GST (Generation Skipping Transfer) tax exemption, which is available to every estate, results in most estates not owing any tax. In 2009, the death tax exemption is $3.5 million, and the gift tax exemption is $1 million. Current law is set for estate taxes (but not gift taxes) to be repealed for one year in 2010, and the gift tax exclusion remains at $1 million. In 2011, estate taxes are slated to return, and the excluded amount returns to a unified estate and gift tax amount of $1 million.

Distributing Property Outside the Will

Property can be distributed outside of the will by making *inter vivos* gifts. These are gifts given during the giver's lifetime, either outright or by placing the property in trust where significant control of the asset has been released, prior to death. The main advantage to distributing property outside of the will is that the property escapes the delays and expense of *probate*, the court procedure by which a will is validated and administered.

One remaining advantage to making an *inter vivos* gift is that not only is the value of the asset gifted removed from the estate, but if the gift appreciates in value between the time the gift is made and death, the appreciated value will be

kept out of the estate as well and not be taxed. If the gift were made by will, the added value would be taxable since the gift would be valued as of date of death (or six months after). This value difference can represent significant tax savings for the heirs of someone whose business suddenly becomes successful and rapidly increases in value.

Another advantage to making an *inter vivos* gift involves the annual gift tax exclusion. In 2009, the annual gift tax exclusion is $13,000 per recipient. For example, if $15,000 worth of gifts were given to an individual in one year, only $2,000 worth of gifts will actually reduce the lifetime gift tax exemption amount allowed of $1 million. This amount is reported on an annual gift tax return of the person making the gift. The return will show the amount of the taxable gift and show the amount of the lifetime exclusion that has been used. No taxes will be due with the filing of the return unless the person has gone over his or her lifetime gift tax exemption amount. A married couple can combine their gifts and claim a yearly exclusion of $26,000 per recipient. The annual exclusion amount is periodically adjusted for inflation.

Gifts made within three years of death used to be included in the gross estate on the theory that they were made in contemplation of death. However, the tax code has done away with the three-year rule for most purposes. The three-year rule is still applicable to gifts of life insurance and to certain transfers involving stock redemptions, tax liens, or other property in which the decedent retained an interest in the property. The rule also applies to certain valuation schemes, the details of which are too complex to discuss here.

Gift tax returns must be filed by the donor for any year where gifts made exceeded $13,000 to any one donee. It is not necessary to file returns when a gift to any one donee amounts to less than $13,000. However, where it is possible that valuation of the gift will become an issue with the IRS, it may be a good idea to file a return anyway, since filing the return starts the three-year statute of limitations running. Once the statute of limitations period has expired, the IRS will be barred from filing suit for unpaid taxes or for tax deficiencies due to higher government valuations of the gifts. If a taxpayer omits includable gifts amounting to more than 25 percent of the total amount of gifts stated in the return, the statute of limitations is extended to six years. There is no statute of limitations for fraudulent returns filed with the intent to evade tax.

In order to qualify as an *inter vivos*, or living, gift for tax purposes, a gift must be complete and final. Control is an important issue. If a giver retains the right to revoke a gift, the gift may be found to be testamentary in nature, even if the right to revoke was never exercised (unless the gift was made in an irrevocable trust). The gift must also be delivered. An actual, physical delivery is best, but a symbolic delivery may suffice if there is strong evidence of intent to make an irrevocable gift. An example of symbolic delivery is when the donor puts something in a safe and gives the intended recipient the only key.

Another common way to transfer property outside the will is to place the property in a *trust* that is created prior to death. A trust is simply a legal arrangement by which one person holds certain property for the benefit of another. It is important to note that if the trust is revocable by the donor (such as in a living will), then the value of the transferred assets will be included in the gross estate of the decedent. The trust must be irrevocable in order for the amount to be excluded from the estate. The person holding the property is the *trustee;* those for whose benefit it is held are the *beneficiaries.* To create a valid trust, the giver must:

- Identify the trust property
- Make a declaration of intent to create the trust
- Transfer property to the trust
- Name identifiable beneficiaries

If no trustee is named, a court will appoint one. The *settlor,* or creator of the trust, may also be designated as trustee, in which case segregation of the trust property satisfies the delivery requirement. Trusts can be created by will (that is, you can place language in your will that will create a trust in specified circumstances), in which case they are termed *testamentary trusts,* but these trust properties will be probated along with the rest of the will. To avoid probate, the settlor must create a valid *inter vivos* trust—one given while the giver is alive.

Generally, in order to qualify as an *inter vivos* trust, a valid interest in property must be transferred before the death of the creator of the trust. If the settlor fails to name a beneficiary for the trust or make delivery of the property to the trustee before death, the trust will probably be deemed testamentary and therefore invalid unless the formalities required for creating a will were complied with.

A trust will not be considered to be testamentary simply because the settlor retained significant control over the trust, such as the power to revoke or modify the trust. For example, when a person makes a deposit in a savings account in his or her own name as trustee for another and reserves the power to withdraw the money or revoke the trust, the trust will be enforceable by the beneficiary upon the death of the depositor, providing that the depositor has not, in fact, revoked the trust.

Many states allow the same type of arrangement in authorizing joint bank accounts with rights of survivorship as valid will substitutes. Property transferred under one of these arrangements is thus passed outside the will and need not go through probate. However, even though such an arrangement escapes probate, the trust property will probably be counted as part of the gross estate for tax purposes because the settlor retained significant control. In addition, if the deceased settlor created a revocable trust for the purpose of decreasing the share of a surviving spouse, in some states the trust will be declared *illusory*—in effect, invalid. The surviving spouse is then granted the legal share not only from the probated estate, but also from the revocable trust.

Life insurance trusts can be used for paying estate taxes. The proceeds will not be taxed if the life insurance trust is irrevocable and the beneficiary is someone other than the estate, such as a friend or relative. This is especially important since, without a life insurance trust, survivors might be forced to sell estate assets for less than their real value in order to pay estate taxes.

Photographers may keep their names alive for future generations by selling bodies of work to museums and art galleries. This also serves to reduce the future appreciated value of these assets out of their gross estate. Bradley Smith, a photographer who had worked for *Life* magazine for over twenty years, sold his collection of photographs of paintings from all over the world in order to "dispose of them." However, without the type of international acclaim enjoyed by Smith, it may be more difficult to sell your work in bulk.

Another consideration would be to donate your work to a library, historical society, university, or the like. You can get a tax write-off based on the cost of the material, or your heirs could donate it for full value and take a charitable deduction on the estate return.

You should first discuss your plans with the institution before making any sort of transfer. Find out how your work will be cared for; look into the institution's means of support, the condition of their files, and the quality of prints released from their collections. You should not relinquish your work to any organization until you are confident that they not only want it, but also have the funds to properly care for it.

You should also discuss their plans for use of your work and any income that may be derived from it. Who will retain the artistic control and copyright? It could be anyone from the museum to one of your family members or a trusted friend. You could also license the museum or library to use your work for educational purposes only and retain any income generated from the work. If you possess a large, valuable collection of photographs, you may want to set up a foundation—create your own charity.

Ansel Adams made careful plans for the disposition of his work, which included both a charitable organization and a profit-making trust. Adams sold his negatives to the Center for Creative Photography (CCP) for a modest sum. When Adams died in 1984, he left detailed instructions about how his negatives could be used by CCP for educational purposes only. His fine prints and other works he had collected were donated to museums. However, Adams' estate retained the copyrights to exploit his work for the purpose of establishing the Ansel Adams Publishing Rights Trust, which retains control of all publishing, licensing, and reproduction rights. The trustees of this trust also supervise the archives where the negatives are stored. Profits from the trust are split two ways: part goes to support the archives at the CCP, and part goes to the Ansel Adams family trust, which manages the gross estate and personal property.

In all these matters, a famous photographer has the edge. The majority of photographers may have to settle for less favorable arrangements when selling or donating their work.

All professional photographers should give some thought to estate planning and take the time to execute a will. Without a will, there is simply no way to control the disposition of one's property. In addition, you should keep good records. Cataloging your work will aid both during your lifetime and after your death. Whether you dispose of your photography by will or in some other way, it is essential to identify the size of your holdings, as well as the copyrights possessed by you at death. Sound estate planning may include transfers outside of the will, since these types of arrangements escape the delays and expenses of probate. Certain types of trusts can be valuable will substitutes, but they may be subject to challenge by a surviving spouse. Since successful estate planning is complex, it is essential to work with a lawyer skilled in this field.

-14-
How to Find a Lawyer

Most photographers expect to seek the advice of a lawyer only occasionally for counseling on important matters, such as potential defamation or invasion-of-privacy liability. If this is your concept of the attorney's role in your profession, you should reevaluate it. If you are a serious photographer, you should establish a relationship with an attorney before you have a problem. An attorney experienced in art or photography law should be able to give you important information regarding areas of liability exposure unique to your work, such as portrayal of someone in a false light, invasion of privacy, pornography and obscenity, libel, copyright infringement, breach of the photographer-customer contract, and the like.

If you have employees, or use independent contractors, you should also get advice on your legal relationship with them. Ignorance of these issues can lead to inadvertent violation of the rules, which in turn can result in financially devastating lawsuits and even criminal penalties. Each state has its own laws covering certain business practices; thus, state laws must be consulted on many areas considered in this book. A competent business attorney is, therefore, your best source of information on many issues that will arise in the running of your business.

What is really behind all the hoopla about "preventive legal counseling"? Are we lawyers simply seeking more work? Admittedly, as business people, lawyers want business, but what you should consider is economic reality: *Most legal problems cost more to solve or defend than it would have cost to prevent them in the first place.* Litigation is notoriously inefficient and expensive. You do not want to sue

or to be sued, if you can help it. The expense is shocking, often costing well over $100,000 if the case does not settle before trial. The cost of defending a case filed against you is something you have little control over, unless you choose to default, which is almost never advisable.

The lawyer who will be most valuable to you will probably not be a Raymond Burr or Robert Redford character but, rather, a meticulous person who does most of his or her work in an office, going over your business forms, your employee contracts, or your corporate bylaws. This person should have a good reputation in the legal community, as well as in the business community. You might pay over $300 per hour for the attorney, but if the firm has a good reputation, then it likely employs a well-trained professional staff that can reduce the amount of attorney-time required.

One of the first items you should discuss with your lawyer is the fee structure for your legal services. You are entitled to an estimate, though unless you enter into an agreement to the contrary with the attorney, the estimate is just that. Lawyers specializing in fields such as business law, art law, and photography law generally charge by the hour, although you may be quoted a flat rate for a specific service, such as incorporation.

It is a good idea to hire a specialist, or a law firm with a number of specialists, rather than a general practitioner. While it is true that you may pay more per hour for the expert, you will not have to fund his or her learning time, and experience is valuable. In this regard, you may wish to keep in mind that it is uncommon for a lawyer to specialize in business practice and also handle criminal matters. Thus, if you are faced with a criminal prosecution for drunk driving, you should be searching for an experienced criminal defense lawyer.

Where to Get Information on Attorneys

If you do not know any attorneys, ask other photographers whether they know any good ones. You want a lawyer who specializes in business law, as well as in copyright, art law, and/or photography law. Finding the lawyer who is right for you is like finding the right doctor; you may have to shop around a bit. Your city, county, and state bar associations may have helpful referral services. A good tip is to find out who is in the intellectual property section of the state or county bar association or who has served on special bar committees dealing with intellectual property law. It may also be useful to find out whether any articles covering the area of law with which you are concerned have been published in legal publications, such as in state or county bar newsletters or magazines (which can generally be found online), and if the author is available to assist you. It may also be useful to see if there are articles by attorneys in any industry magazines, such as PICTURE Magazine, Communication Arts, or Artist's Magazine.

You can also search the Internet. These days, most attorneys have established Web sites. Such sites may have resumes of the firms' attorneys, as well as list of their areas of expertise.

After you have obtained some names, it would be appropriate for you to talk with several attorneys for a short period of time to evaluate them. Do not be afraid to ask about their background and experience and whether they feel they can help you.

Once you have completed the interview process, select the lawyer with whom you are most comfortable. The rest is up to you. Contact your attorney whenever you believe you have a legal question.

Litigation

As noted above, litigation is very expensive. There are some alternatives, such as the small claims court.

Small Claims Court

The name of this court and the rules may vary from state to state, but all of the systems are geared toward making the process as swift, accessible, and inexpensive as possible. In many states, hearings on small claim actions may even be held on weekends or evenings, which is more convenient for many business people.

The major savings in a small claims court proceeding is due to the fact that attorneys are customarily not permitted in such courts, unless they represent themselves or a corporation. Even in states where attorneys are not specifically barred by statute, the court rules are set up in such a clear, comprehensible way that an attorney is usually not needed. Most small claims courts have staff members who will guide you through the pleading and practice.

The procedure in the hearing is quite simple. The judge simply hears both sides of the case and allows the testimony of any witnesses or evidence either party has to offer. Jury trials are never permitted in small claims court, although the defendant may be able to have the case moved to a conventional court if he or she desires a trial by jury.

Not all actions, however, can be brought in small claims court. As the name implies, only claims for small amounts (depending on the state, the maximum claim is usually $5,000 or $10,000) can be made. Moreover, only suits for monetary damages are appropriate for small claims court; other forms of relief, such as an injunction (requiring or prohibiting certain action) or specific performance (which requires the terms of the contract to be performed), cannot be obtained there.

An action in small claims court has some disadvantages. First, the judgment is often absolutely binding (in many states, there is no appeal). The other major disadvantage of a small claims action is that the judgment may be uncollectable,

since in many states the usual methods of enforcing a judgment, such as the garnishment of wages or liens against property, are unavailable to the holder of a judgment from small claims court.

Mediation

There are methods of alternative dispute resolution that do not involve filing a lawsuit. Mediation involves using a neutral person to guide the disputing parties to resolution. The mediator does *not* decide the case. Rather, the mediator will try to help the parties reach an agreement, usually by asking questions, asking each party to try to see the other's point of view, and attempting to find creative solutions that allow each party to receive most of what it is seeking. If the parties are unable to reach an agreement, they may choose to have the dispute settled by arbitration or by litigation in court.

Arbitration

An arbitrator, unlike a mediator, does ultimately decide the case. Arbitration is usually binding; that is, there can be no appeal of the judgment, though nonbinding arbitration may be available. The parties present their cases to the arbitrator, using documents and witnesses, much like a trial. Unfortunately, many of the benefits of litigation in court, such as full discovery of the other party's case, may be unavailable. This means arbitration is usually best reserved for simpler issues, such as disputes over fair market value in connection with a commercial lease renewal. Arbitration is often less expensive than litigation in court, though this is not always so.

• • •

The attorney-client relationship is such that you should feel comfortable when confiding in your attorney. This person will not disclose your confidential communications. In fact, a violation of this rule, depending on the circumstances, can be considered an ethical breach that could subject the attorney to professional sanctions.

If you take the time to develop a good working relationship with your attorney, it may well prove to be one of your more valuable business assets.

For a list of volunteer lawyers organizations, see appendix 3 at end of this book. You may also check with professional associations, such as ASMP, for recommendations regarding attorneys who generally practice in the field.

Appendix 1—Forms

These forms are presented *as examples only*. Although these forms contain basic provisions, they may not apply to a specific legal problem or particular configuration of facts. Although a form may appear to contain all of the provisions you are seeking to address, it may not conform to all local and/or state regulations and laws where you live or where you use the form. Additionally, the forms in this appendix do not address laws of locations other than those in the United States. You should consult with an attorney when confronted with a legal question or issue.

List of Forms

Releases
> Model Release
> Release by Owner of Property

Bill of Sale/Invoice

Commission Agreement

Assignment Estimate/Confirmation/Invoice

Signature Blocks for Releases and Other Contracts
> Business
> Individual Adult
> Parent/Guardian Consent

Releases

To be valid, a Release must be signed. A Release may require the signature of an individual, of a company representative, or of a parent or guardian.

Model Release

For [*dollar amount*—e.g., "$1.00"] and other good and valuable consideration, the receipt and sufficiency of which is hereby acknowledged, I hereby confer on [*photographer's full name and location*—e.g., "Jane Doe of Portland, Oregon"] ("Photographer") and Photographer's assigns, successors, agents, and designates the perpetual and irrevocable right to use my photograph(s), my name (or any fictional name), likeness, voice, and/or reputation in all forms and media and in all manners, including composite or distorted representations, in all forms and media

for advertising, promotion, trade, or any other lawful purpose, including but not limited to print media, ebooks, the Internet, as well as all other forms of publication, storage, or transmission now known or hereafter invented. I waive any right to inspect or approve the finished version(s), the advertising, or other copy that may be used in connection therewith or the use to which it may be applied.

I hereby release and discharge Photographer and Photographer's agents, employees, officers, successors, and assigns from any and all claims and demands arising from or in connection with the use of my photograph(s), name (or any fictional name), likeness, voice, and/or reputation, including but not limited to claims for invasion of privacy, violation of right of publicity, and libel.

I represent and warrant that I have any and all necessary authority to validly enter into this Agreement. I have read the foregoing and fully understand its contents. This Release will be binding upon me and my heirs, legal representatives, and assigns.

[Add appropriate signature blocks; see end of this Appendix.]

Release by Owner of Property

For [*dollar amount*—e.g., "$1.00"] and other good and valuable consideration, the receipt and sufficiency of which is hereby acknowledged, I hereby confer on [*photographer's full name and location*—e.g., "John Doe of Portland, Oregon"] ("Photographer") and/or Photographer's assigns, successors, agents, and designates the perpetual and irrevocable right to copyright, publish, and use in all forms and media and in all manners, including composite or distorted representations, in all forms and media for advertising, promotion, trade, or any other lawful purpose, including but not limited to print media, ebooks, and the Internet, as well as all other forms of publication, storage or transmission now known or hereafter invented, as still, single, multiple, or moving photographic portraits or pictures of the following property that I own and have sole authority over to license for the taking of photographic portraits or pictures:

[*description of property – e.g., for real property, the complete address, or for personal property, a detailed description, or attach a photograph of the item*]

Such photograph(s) may be used in conjunction with my own or a fictitious name, and reproductions thereof may be made in color or otherwise or in the form of derivative works made through any medium, now known or hereafter invented. I waive any right to inspect or approve the finished version(s), the advertising, or other copy that may be used in connection therewith or the use to which it may be applied.

I release and agree to hold harmless Photographer and/or [*select one*: her/his/its] successors, assigns, agents, and designates from any liability resulting from such use of my name or the photograph(s) (or derivative of such photograph(s)) of my property named above. I waive any claims I may have based on such use, including

but not limited to claims for invasion of privacy, violation of right of publicity, libel, and trademark, copyright or other intellectual property infringement.

I represent and warrant that I possess any and all requisite authority to validly enter into this Agreement. I have read the foregoing and fully understand the contents hereof. This Release will be binding upon me and my heirs, legal representatives and assigns.

[Add appropriate signature blocks; see end of this Appendix.]

Bill of Sale/Invoice

Accounting software generally provides you with the ability to personalize your own form of Bill of Sale. We recommend that if you are comfortable enough with a computer, you use a reputable accounting program recommended for your business size. If not, the following form may be adapted to meet your business needs.

The material in this section should appear on the front of your invoice, with the Additional Terms section appearing on the back. Two copies of this document should be provided to your client for signature.

The following is an example Bill of Sale:

<div align="center">

Bill of Sale

[PLACE YOUR LOGO/CONTACT INFORMATION HERE]

</div>

Invoice No. _____

Date of Invoice: _____

For your reference, our Taxpayer ID Number is _____.

| **Terms:** | Cash Sale ❑ | Visa ❑ | Debit Card ❑ | |
| **Net** | MasterCard ❑ | Discover ❑ | Am. Ex. ❑ | Other: |

Card No. _____

Exp. Date: _____ _____

(Signature)

Ship to: _____ Bill to: _____ Sales Date: _____

_____ _____ _____

_____ _____ _____

_____ _____ _____

_____ _____ _____

_____ _____ Via _____

Item No.	Description: Medium, Title, Dimensions (height x width), or File Size of Digital Image	Price

All sales subject to terms and conditions on reverse of this invoice

Received in good condition:		
	Net	$_____
	Less Deposit	$_____
_____ *(Client Signature)*	Subtotal	$_____
Date: _____	Sales Tax	$_____
Reminder: Invoices are due in full upon receipt. Please refer to the invoice number at the top of this Bill of Sale when making payment. Please review your bill carefully and call or write us immediately if there is a problem.	Total	$_____

ADDITIONAL TERMS

Delivery. The balance of the sales price (including sales tax, if any, and shipping and packing charges) must be paid before the Work is delivered. No order will be binding upon Photographer until accepted by Photographer in writing, and Photographer will have no liability to customer with respect to purchase orders that are not accepted. No partial delivery of an order will constitute the acceptance of the entire order, absent the written acceptance of such entire order. Photographer will make a reasonable effort to meet the assigned delivery date, but Photographer will not be liable to customer in any way if Photographer does not meet the assigned delivery date.

Copyright. The Work(s) have been copyrighted by Photographer, who expressly reserves all exclusive rights in the Work(s) unless otherwise expressly agreed in writing. Any unauthorized reproduction is in violation of federal copyright law. Purchaser agrees not to remove Photographer's copyright notice from the Work(s).

Integrity. Photographer wishes to preserve the integrity of Photographer's artistic creations. So long as the Work remains in the purchaser's possession, the purchaser will exercise reasonable care in maintaining the Work.

Miscellaneous. This Order is a contract complete as written. It is deemed a contract made in [*add*: Your State] and it will be construed and enforced according

to the laws of the State of [*add*: Your State]. Any suit or action instituted by either party to enforce the terms will be brought in the courts in the State of [*add*: Your State]. Venue is proper only in [*add*: Your County] County in [*add*: Your State]. No agreement or understanding which alters or extends the meaning of this contract will be binding on Photographer unless in writing and signed by both parties. In the event suit or action is instituted to enforce collection or any of the terms of this contract, the prevailing party will be entitled to recover from the other party such sum as the court deems reasonable as attorneys' fees at arbitration, at trial or on appeal, in addition to all other sums provided by law. _____ percent (____%) interest will accrue monthly on any amounts not paid when due.

NOTE: Please sign and return one copy and retain the other copy for your files.

[Add appropriate signature block for the purchaser; see end of this Appendix.]

Commission Agreement

The following is a basic Commission Agreement that can be tailored for your particular situation. Be sure you carefully detail any uses the client may make of your work, if other than for personal use.

Between:	[*Photographer's Name*]	("Photographer")
	[*Address*]	
	[*Phone and Fax*]	
And:	[*Client's Name*]	("Client")
	[*Address*]	
	[*Phone and Fax*]	

Recitals

Whereas, Photographer is a photographer who desires to create one or more photographs in accordance with the terms set forth below (the "Work"); and

Whereas, Client desires to have Photographer create the Work for Client;

Agreement

Now, therefore, in consideration of the mutual covenants set forth in this Agreement, the parties agree as follows:

1. CREATION OF THE WORK.
1.1. Composition.
- Photographer will compose and shoot at least _____ photographs of: _____.

- The site of the shoot will be: _____.
- The size of the final Work will be: _____.
- The final Work will be provided on: [*paper type or CD, etc.*] _____.
- The Work is expected to be completed by [*date*] or within _____ days of the Effective Date of this Agreement; provided, however, that under extenuating circumstances that prevent Photographer from working, Photographer may extend the time by the length of the period of the extenuating circumstances.
- [*Add any other agreed upon details.*]

1.2. Proofs. Photographer will prepare proofs (the "Proofs") for Client's approval [*by (date)*] or [*within _____ days of the Effective Date of this Agreement*]. In the unlikely event Client is dissatisfied with the Proofs, within two (2) weeks of receipt of the Proofs, Client may request specific modifications in writing and may ask Photographer to reshoot the Work. If Photographer must reshoot, Client will pay Photographer _____ Dollars ($_____) per hour as a reshoot fee, plus any and all expenses and costs incurred as a result of Photographer reshooting; however, Photographer will not be required to work in excess of _____ (___) hours or to provide more than _____ reshoots. Failure to inform Photographer of approval or rejection of the Proofs within two (2) weeks will be deemed to be an acceptance of the last submitted Proofs.

1.3. Sole Photographer. Client agrees that if Photographer is to photograph an event, Photographer will be the only professional photographer present, and no other professional photographer will be involved in photographing such event.

2. PAYMENT.

2.1. Client will pay Photographer as follows:

- A deposit in the amount of _____ Dollars ($_____) upon the Effective Date of this Agreement;

- An additional deposit(s) at the time any reshoot is requested. Such deposit will be a reasonable amount estimated by Photographer of the costs and expenses required to reshoot.

- The balance due in the amount of _____ Dollars ($_____), plus any reimbursements not yet made to Photographer for expenses not covered by a deposit, upon receipt of the final Work.

2.2. Refusal of Work. If Client refuses to accept Work or refuses to pay the amount due upon delivery of Work to Client, Client will be in default of this Agreement and will pay eighteen percent (18%) interest on the unpaid balance until payment in full is made. No refunds will be given.

3. CLIENT'S USE OF PHOTOGRAPH(S).

Client acknowledges Photographer's exclusive ownership of the copyright, trade dress and other intellectual property rights in the Work. Client's use of Work is for personal use only, and Client will not sell or reproduce Work or authorize any reproductions thereof by parties other than Photographer. Any unauthorized reproduction (including scans, photocopies and any other means of reproduction) of Work is in violation of federal copyright law. Further, Client will not remove Photographer's copyright notice from the Work.

4. OWNERSHIP OF PHOTOGRAPHIC MATERIALS.

All photographic materials other than those set forth in Section 1.1 hereof, including but not limited to negatives, transparencies, proofs and previews, are the exclusive property of Photographer.

5. PHOTOGRAPHER'S USE OF WORK IN PORTFOLIO.

Client grants Photographer the right to use Client's name and likeness in connection with the display of the Work for Photographer's promotional purposes, for inclusion in Photographer's portfolios, including distribution in print and electronic form, and for any other purpose Photographer deems appropriate. Client releases and discharges Photographer, his/her agents, employees, officers, successors, and assigns from any and all claims and demands arising from or in connection with such use.

6. INDEMNITY.

In the event Photographer is rendered liable for any damages which result from Client's use of the Work, Proofs, or any other related materials, Client will hold Photographer harmless from and against such liability, including all reasonable attorneys' fees incurred at arbitration, on any trial or appeal. This section will survive the termination of this Agreement for any reason.

7. QUALITY DISCLOSURE.

Client is aware that color dyes in print photography may fade or discolor over time due to the inherent qualities of such dyes, and Client releases Photographer from any liability for any claims whatsoever based upon fading or discoloration due to such inherent qualities. Client also understands that colors on digital images will differ according to the monitor, printer, and/ or lab used and will hold harmless Photographer, as well as Photographer's agents, employees, officers, successors, and assigns, from and against any cost or expense, including but not limited to attorneys' fees incurred at arbitration, at trial or on any appeal, which may be incurred by reason of such color discrepancy. Photographer grants no warranties or conditions, express, implied, by statute or otherwise, regarding the Work, and Photographer

specifically disclaims any implied warranty of merchantability or fitness for a particular purpose.

8. FAILURE TO PERFORM.

If Photographer cannot perform this Agreement, in whole or in part, due to a fire or other casualty, strike, act of God or nature, or other cause beyond the control of the parties, or due to Photographer's illness or injury and if Client refuses a second shoot, then Photographer will return the deposit to the Client but will have no further liability with respect to this Agreement. This limitation on liability will also apply in the event that photographic materials are damaged in processing, lost through camera malfunction, lost in the mail, or otherwise lost or damaged without fault on the part of Photographer.

9. INDEPENDENT CONTRACTOR.

The relationship of Photographer and Client will be that of an employer-independent contractor.

10. ASSIGNABILITY.

This Agreement or the rights, responsibilities or obligations granted or assumed in this Agreement may not be assigned by Client, in whole or in part, without first obtaining the written consent of Photographer.

11. MISCELLANEOUS.

This Agreement constitutes the entire agreement between the parties and supersedes all prior agreements, understandings and proposals (whether written or oral) in respect to the matters specified. No agreement or understanding which alters or extends the meaning of this contract will be binding unless in writing and signed by the parties hereto. If any provision of this Agreement is judicially declared to be invalid, unenforceable or void by a court of competent jurisdiction, such decision will not have the effect of invalidating or voiding the remainder of this Agreement, and the part(s) of this Agreement so held to be invalid, unenforceable, or void will be deemed stricken, and the Agreement will be reformed to replace such stricken provision with a valid and enforceable provision which comes as close as possible to expressing the intention of the stricken provision. The remainder of this Agreement will have the same force and effect as if such part or parts had never been included. This Agreement is deemed a contract made in [your state] and it will be construed and enforced according to the laws of the State of [your state]. Any suit or action instituted by either party to enforce the terms will be brought in the courts in the State of [your state]. Venue is proper only in [your county] County in [your state]. In the event it becomes necessary for Photographer to turn Client's account over to an attorney or collection agency, Photographer will be entitled to recover from Client, and Client expressly agrees to pay, all costs incurred by Photographer related to such collection activities, whether or not any suit, action or other legal proceeding is instituted, and including but not limited to attorneys'

fees, costs and expenses, at arbitration, on trial or on appeal. In the event suit or action is instituted to enforce collection or any of the terms of this contract or for its breach, the prevailing party will be entitled to recover from the other party such sum as the court deems reasonable as attorneys' fees at arbitration, trial or on appeal, in addition to all other sums provided by law.

12. EFFECTIVE DATE.

This Agreement is effective as of the date all parties hereto have executed this Agreement.

13. COUNTERPARTS.

This Agreement may be executed in two (2) or more counterparts, each of which will be deemed an original but all of which together will constitute one and the same Agreement.

In Witness Whereof, the parties hereto execute and date this Agreement.

[Add appropriate signature blocks; see end of this appendix.]

Assignment Estimate / Confirmation / Invoice

This form adapted from *Business and Legal Forms for* Photographers, third edition (© 2002); it has been used with the permission of copyright owner Tad Crawford.

The text below should occupy two sides of a single page. As with the Bill of Sale, the tabular material should appear on the front of the page, and the terms should appear on the reverse side.

ASSIGNMENT ESTIMATE / CONFIRMATION / INVOICE
Assignment Estimate / Confirmation / Invoice (*Page 1*)

CLIENT

Address _____ Date _____

_____ ❑ Estimate

_____ ❑ Confirmation

Client Purchase Order No. _____ ❑ Invoice

Client Contact _____ Job Number _____

Assignment Description _____

Due Date _____ Location Site: _____

GRANT OF RIGHTS
Upon receipt of full payment, Photographer will grant to the Client the following exclusive rights:

For use as _____

For the product, project or publication named _____

In the following time period or number of uses _____

Other limitations _____

CREDIT
The Photographer ❏ will ❏ will not
receive adjacent credit in the following form on reproduction _____

FEE/EXPENSES
The Client will pay the Deposit set forth below prior to Photographer commencing the Assignment and will pay the Balance Due, including reimbursement of the expenses as shown below, within 30 days of receipt of an invoice.

EXPENSES		FEES	
Assistants	$_____	Photography Fee	$_____
Casting	$_____	Other Fees	
Crews/Special Technicians	$_____	Pre-production $_____/day	$_____
Equipment Rentals	$_____	Travel $_____/day	
Film and Processing	$_____	Weather Days $_____/day	$_____
Insurance	$_____	Space or Use Rate	
Location	$_____	(if applicable)	$_____
Messengers	$_____	Cancellation fee	$_____
Models	$_____	Reshoot Fee	$_____
Props/Wardrobe	$_____	Fees Subtotal	$_____
Sets	$_____	plus Total Expenses	$_____
Shipping	$_____	Subtotal	$_____
Styling	$_____	Sales Tax	$_____
Travel/Transportation	$_____	**Total**	$_____
Telephone	$_____	Less Advances	$_____
Other Expenses	$_____	**Balance Due**	$_____

Expenses Subtotal $_____

(Plus _____% Mark-up) $_____

Total Expenses $_____

PHOTOGRAPHER:

[For an appropriate signature block see the end of this appendix.]

CLIENT:

[For an appropriate signature block see the end of this appendix.]

Subject to Terms and Conditions on Back

Assignment Estimate / Confirmation / Invoice (*Page 2*)

Payment. Prior to Photographer commencing the Assignment, Client will pay Photographer the Advances shown on the front of this form, which Advances will be applied against the total due. Client will pay Photographer all additional amounts within 30 days of the date of Photographer's billing. Client will be responsible for and pay any sales tax. Time is of the essence with respect to payment. Overdue payments will be subject to interest charges of ____% monthly (____% per annum).

Value and Return of Originals. All photographic materials will be returned to Photographer by registered mail (with return receipt) or bonded courier (which provides proof of receipt) within 30 days of Client's completing its use thereof and, in any event, within _____ days of Client's receipt thereof. Time is of the essence with respect to the return of photographic materials. Unless a value is specified for a particular image either on the front of this form or on a delivery memo given to Client by Photographer, the parties agree that a reasonable value for an original transparency is $1,500. Client agrees to be solely responsible for and act as an insurer with respect to loss, theft, or damage of any image from the time of its shipment by Photographer to Client until the time of return receipt by Photographer.

Usage. Client understands and agrees that Photographer retains ownership of the copyright rights in and to the photograph(s), and Client will use the photograph(s) only in accordance with rights granted herein or as otherwise agreed by the parties in writing. Client will obtain written permission from Photographer before making any additional uses of the photograph(s) and pay an additional fee to be agreed upon.

Authorship Credit. Authorship credit in the name of Photographer, including copyright notice, will accompany the photograph(s) when it is reproduced, unless specified to the contrary on the front of this form. If required authorship is omitted, Client agrees that Client will pay as liquidated fees for the omission three times the invoiced amount.

Expenses. If this form is being used as an Estimate, all estimates of expenses may vary by as much as 10% in accordance with normal trade practices. Additionally, Photographer may bill Client in excess of the estimates for any overtime that must be paid by Photographer to assistants and staff for a shoot that runs more than eight consecutive hours.

Reshoots. If Photographer is required by Client to reshoot the Assignment, Photographer will charge in full for additional fees and expenses unless (a) the reshoot is due to any cause beyond the reasonable control of Client, in which case Client will pay only additional expenses but no fees; or (b) if Photographer is paid in full by Client, including payment for the expense of special contingency insurance, then Client will not be charged for any expenses covered by such insurance in the event of a reshoot. Photographer will be given the first opportunity to perform any reshoot.

Cancellation. In the event of cancellation by Client, Client will pay all expenses incurred by Photographer and, in addition, will pay the full fee unless notice of cancellation was given at least _____ hours/days prior to the shooting date, in which case 50% of the fee will be paid; provided, however, that weather delays involving shooting on location, Client will pay the full fee if Photographer is on location and 50% of the fee if Photographer has not yet left for the location.

Release. Client will indemnify and hold harmless Photographer and Photographer's employees and agents against any and all claims, costs, and expenses, including reasonable attorneys' fees and costs at arbitration, on trial or appeal, due to uses for which no release was requested or uses which exceed the uses allowed pursuant to a release or for any use not permitted by this Agreement.

Quality Disclosure. Client is aware that color dyes in photography may fade or discolor over time due to the inherent qualities of such dyes, and Client releases Photographer from any liability for any claims whatsoever based upon fading or discoloration due to such inherent qualities. Client also understands that colors on digital images will differ according to the monitor, printer, and/or lab used and will hold harmless Photographer, as well as Photographer's agents, employees, officers, successors, and assigns, from and against any cost or expense, including but not limited to attorneys' fees incurred at arbitration, at trial or on any appeal, which may be incurred by reason of any color issues associated with the Work. Photographer grants no warranties or conditions, express, implied, by statute or otherwise, regarding the photograph(s) purchased by Client, and Photographer specifically disclaims any implied warranty of merchantability or fitness for a particular purpose and noninfringement.

Assignment. Neither this Agreement nor any rights or obligations hereunder will be assigned by either of the parties, except that Photographer will have the right to assign monies due hereunder. Both Client and any party on whose behalf

Client has entered into this Agreement will be bound by this Agreement and will be jointly and severally liable for full performance hereunder, including but not limited to payments due to Photographer.

Miscellaneous. This Agreement constitutes the entire agreement between the parties and supersedes all prior agreements, understandings and proposals (whether written or oral) in respect to the matters specified. No agreement or understanding which alters or extends the meaning of this contract will be binding unless in writing and signed by the parties hereto. This Agreement is deemed a contract made in [*your state*] and it will be construed and enforced according to the laws of the State of [*your state*]. Venue will be proper only in the County of [*your county*], State of [*your state*]. In the event suit or action is instituted to enforce collection or any of the terms of this contract, the prevailing party will be entitled to recover from the other party such sum as the court deems reasonable as attorneys' fees at arbitration, on trial or on appeal, in addition to all other sums provided by law.

Signature Blocks For Releases and Other Contracts

Address/Contact Information. When a Release or other agreement is signed, it is prudent to obtain a clearly printed version of his or her name or the name of the entity, as well as his, her, or its contact information. In some agreements, certain contact information and sometimes the effective date of the agreement is provided at the top of page 1 or within the text of the agreement and can, therefore, be omitted from the signature block.

Notarization. If a document is to be notarized, the person signing it must do so in the presence of a Notary Public.

Date: Ask the person signing the document to write the date as well.

Business Signature(s). If an entity (e.g., corporation or LLC) is signing the document, if possible, it is prudent to also obtain the signatures of *two* officers of a corporation or *two* members of a limited liability company since some states require two authorized signatures. If you know that the law of your state requires only one signature, you need only obtain one, though there is no harm in having two signatures.

The following is an example corporate signature block:

[**Select one:** 'I/We'] represent and warrant that [**select one:** 'I/we'] have the authority to enter into this [**Release or Agreement**] and that this [**Release or Agreement**], when executed and delivered, will constitute a legal, valid, and binding obligation, enforceable in accordance with the terms herein.

(Business Name)

By: _____ By: _____

Print Name: _____ Print Name: _____

Title: _____ Title: _____

Date: _____ Date: _____

Address: _____ Address: _____

_____ _____

_____ _____

Phone: _____ Phone: _____

Individual Adult Signature. The following is an example of a signature block for use with an adult:

I am signing in my individual capacity and hereby affirm that I am of full age and have the right to contract in my own name.

(Signature)

Print Name: _____

Date: _____

Address: _____

Phone: _____

Minor Consent. If the minor can sign his or her name, obtain his or her printed name and signature on the Release. In addition to the signature of the minor, you *must* obtain the consent of a parent or other legal guardian. On such a Consent, do not omit the date in either signature block.

The following is an example of a consent block for use with a minor:

(Signature of Minor)

Print Name: _____

Date: _____

Address: _____

Phone: _____

I am the parent or guardian of the minor named above and have the legal authority to execute the above Release. I hereby consent to the foregoing.

(Signature of Parent/Guardian)

Print Name: _____

Date: _____

Address: _____

Phone: _____

Appendix 2: Table of Cases

Quantity of Copies of Books v. Kansas, 378 U.S. 205 (1964) – Chapter 4

Regina v. Hicklin, L.R. 3 Q.B. 360 (1868) – Chapter 4

Rinaldi v. Village Voice, Inc., 47 A.D.2d 180 (N.Y. App. Div. 1975) – Chapter 3

Rivkin v. Brackman, 167 A.D.2d 239, 561 N.Y.S.2d 738 (1990) – Chapter 11

Rock and Roll Hall of Fame and Museum, Inc. v. Gentile Productions, 71 F. Supp. 2d 755 (N.D. Ohio 1999) – Chapter 1

Rogers v. Koons, 960 F.2d 301 (2d Cir. 1992) – Chapter 1

Roth v. United States, 354 U.S. 476 (1957) – Chapter 4

Rowan v. U.S. Post Office Dept., 397 U.S. 728 (1970) – Chapter 4

Russell v. Marboro Books, 18 Misc. 2d 166, 183 N.Y.S.2d 8 (1959) – Chapter 3

Ryan v. Aer Lingus, 878 F. Supp. 461 (S.D.N.Y. 1994) – Chapter 11

Sandoval v. New Line Cinema Corp., 147 F.3d 215 (2nd Cir. 1998) – Chapter 1

Schrock v. Learning Curve International, Inc., 2008 WL 224280 (N.D. Ill. 2008) – Chapter 1

Sharon v. Time, Inc., 609 F. Supp. 1291 (S.D.N.Y. 1984) – Chapter 2

Shaw Family Archives, Ltd. v. CMG Worldwide, Inc., Cir. 486 F.Supp. 2d 309 (SDNY 2007) - Chapter 3

Sherrill v. Knight, 569 F.2d 124 (D.C. Cir. 1977) – Chapter 5

Shields by Shields v. Gross, 563 F. Supp. 1253 (S.D.N.Y. 1983) – Chapter 3

SHL Imaging, Inc. v. Artisan House, Inc., 117 F. Supp.2d 301 (S.D.N.Y. 2000) – Chapter 1

Sony Corp. of America v. Universal City Studios, Inc., 464 U.S. 417 (1984) – Chapter 1

Southeast Bank, N.A. v. Lawrence, 483 N.Y.S.2d 218 (1984), *rev'd* 498 N.Y.S.2d 775 (1985) – Chapter 3

Spahn v. Julian Messner, Inc., 21 N.Y.2d 124, 233 N.E.2d 840 (1967) – Chapter 3

Stahl v. Oklahoma, 665 P.2d 839 (Okla. Crim. App. 1983) – Chapter 5

Stanton v. Metro Corporation, 438 F.3d 119 (1st Cir. 2006) – Chapter 2

Stern v. Cosby, 529 F.Supp.2d 417 (S.D.N.Y. 2009) – Chapter 2

Szabo v. Errisson, 68 F.3d 940 (5th Cir. 1995) – Chapter 1

Texas v. Johnson, 491 U.S. 397 (1989) – Chapter 4

The Milton H. Greene Archives, Inc. v. CMG Worldwide, Inc., 2008 WL 655604 (C.D.Cal., 2008) – Chapter 3

Time, Inc. v. Bernard Geis Associates, 293 F. Supp. 130 (S.D.N.Y. 1968) – Chapter 1

Time, Inc. v. Firestone, 424 U.S. 448 (1976) – Chapter 2

Time, Inc. v. Hill, 385 U.S. 374 (1967) – Chapter 3

Time, Inc. v. Ragano, 427 F.2d 219 (5th Cir. 1970) – Chapter 2

Toney v. L'Oreal USA, Inc., 406 F.3d 905 (7th Cir. 2005) – Chapter 3

Triangle Publications, Inc. v. Chumley, 317 S.E.2d 534 (Ga. 1984) – Chapter 2

United States v. Eichman., 496 U.S. 310 (1990), 234 – Chapter 4

United States v. The Progressive, Inc., 486 F. Supp. 5 (W.D. Wisc. 1979) – Chapter 4

United States v. Williams, 553 U.S. 285; 128 S. Ct. 1830 (2008) – Chapter 4

Usher v. Corbis-Sygma, 320 Fed.Appx. 109 (2nd Cir. 2009) – Chapter 11

Virginia State Board of Pharmacy v. Virginia Consumer Council, Inc., 425 U.S. 748 (1976) – Chapter 4

Walt Disney Productions v. Air Pirates, 581 F.2d 751 (9th Cir. 1978) – Chapter 1

Westmoreland v. CBS, 770 F.2d 1168 (D.C. Cir. 1985) – Chapter 2

White Studio, Inc. v. Dreyfoos, 156 A.D. 762, 142 N.Y.S. 37 (1913) – Chapter 1

Willard Van Dyke Productions v. Eastman Kodak, 12 N.Y.2d 301, 189 N.E.2d 693, 239 N.Y.S.2d 337 (1963) – Chapter 11

Young v. United States, 71-2 U.S. Tax Cas. (CCH) P9643 (1971) – Chapter 7

Appendix 3: Organizations That Offer Help

Photographers' Organizations

Your best source for finding the professional who can help you may be a friend whose needs have been the same as yours. In addition to those sources, consider asking the photography or art department of your local college or university for the names of people or groups who might be of help, but if you are not able to receive a referral this way, you may refer to chapter 14 for suggestions on finding a lawyer.

The following are some of the best known and largest of the photographers' organizations.

In the United States

American Society for Photogrammetry and Remote Sensing
University College London
5410 Grosvenor Lane, Suite 210
Bethesda, MD 20814-2160
phone: (301) 493-0290
fax: (301) 493-0208
asprs@asprs.org
www.asprs.org

American Society of Media Photographers, Inc. (ASMP)
150 North 2nd Street
Philadelphia, PA 19106-1912
phone: (215) 451-2767
fax: (215) 451-0880
www.asmp.org

BioCommunications Association
220 Southwind Lane
Hillsborough, NC 27278-7907
phone/fax: (919) 245-0906
office@bca.org
www.bca.org

Boston Press Photographers Association
Post Office Box 51477
Boston, MA 02205-1477
www.bppa.net

Commercial Industrial Photographers of New England
Post Office Box 600291
Newtonville, MA 02460-0003
mail@cipne.org
www.cipne.org

Connecticut Fire Photographers Association
Post Office Box 1181
Hartford, CT 06143-1181
www.cfpa.freeservers.com

Evidence Photographers International Council
600 Main Street
Honesdale, PA 18431-1843
(570) 253-5450

Evidence Photographers International Council, Inc.
229 Peachtree Street, NE, Suite 2200
Atlanta, GA 30303-1608
phone: (866) 868-3742
fax: (404) 614-6406
csc@evidencephotographers.com
www.evidencephotographers.com or *www.epic-photo.org*

Florida Professional Photographers, Inc.
13424 White Cypress Road
Aspataula, FL 34705-9302
www.fpponline.org

Graphic Artists Guild
32 Broadway, Suite 1114
New York, NY 10004
phone: (212) 791-3400
fax: (212) 791-0333
admin@gag.org
www.graphicartistsguild.org

Gravure Association of America, Inc.
1200-A Scottsville Road
Rochester, NY 14624
(585) 436-2150

Gravure Association of America, Inc.
75 West Century Road
Paramus, NJ 07652-1461
phone: (201) 523-6042
fax: (201) 523-6048
gaa@gaa.org
www.gaa.org

Houston Center for Photography
1441 West Alabama
Houston, TX 77006
phone: (713) 529-4755
fax: (713) 529-9248
info@hcponline.org
www.hcponline.org

Illinois Press Photographers Association
c/o Steve Warmowski
1815 Mound Road
Jacksonville, IL 62650
(217) 245-4178
www.ippaonline.com/ippa

Indiana News Photographers Association
c/o Mr. Matt Detrich
Indianapolis Star
5602 West Washington Street
Indianapolis, IN 46241-2000
matt.detrich@indystar.com
www.indiananewsphotographers.org

Inter-Society Color Council
11491 Sunset Hills Road, Suite 301
Reston, VA 20190
phone: (703) 318-0263
fax: (703) 318-0514
iscc@iscc.org
www.iscc.org

International Alliance of Theatrical and Stage Employees (IATSE)
West Coast Office
10045 Riverside Drive
Toluca Lake, CA 91602
phone: (818) 980-3499
fax: (818) 980-3496
www.iatse-intl.org

International Alliance of Theatrical and Stage Employees (IATSE)
East Coast Office
1430 Broadway, 20th Floor
New York, NY 10018
phone: (212) 730-1770
fax: (212) 730-7809
www.iatse-intl.org

International Association of Panoramic Photographers (IAPP)
Church Street Station
Post Office Box 3371
New York, NY 10008
gs1060@yahoo.com
www.panphoto.com

International Fire Photographers Association
Post Office Box 272
Kutztown, PA 19530
www.ifpaweb.org

Michigan Press Photographers Association
155 Michigan Avenue
Grand Rapids, MI 49503
www.mppa.org

National Association of Government Communicators

201 Park Washington Court
Falls Church, VA 22046-4527
phone: (703) 538-1787
fax: (703) 241-5603
info@nagconline.org
www.nagc.com

National Association of Photographic Manufacturers

550 Mamaroneck Avenue
Harrison, NY 10528
phone: (914) 698-7603
fax: (914) 698-7609
natlstds@aol.com
www.techexpo.com/tech_soc/napm.html

National Press Photographers Association

3200 Croasdaile Drive, Suite 306
Durham, NC 27705
phone: (919) 383-7246
fax: (919) 383-7261
www.nppa.org

New Jersey Press Photographers Association

840 Bear Tavern Road, Suite 305
West Trenton, NJ 08628
www.njppa.org

New York Press Photographers Association

225 East 36th Street, Suite 1P
New York, NY 10016
phone: (212) 889-6633
fax: (212) 889-6634
office@nyppa.org
www.nyppa.org

Ohio News Paper Association
1335 Dublin Road, Suite 216B
Columbus, OH 43215
phone: (614) 486-6677
fax: (614) 486-4940
www.ohionews.org

Oklahoma Press Association
Attn: Photography
3601 North Lincoln Boulevard
Oklahoma City, OK 73105
(405) 499-0020
www.okpress.com

Ophthalmic Photographers Society
1887 West Ranch Road
Nixa, MO 65714
phone: (417) 725-0180
fax: (417) 724-8450
ops@opsweb.org
www.opsweb.org

Pennsylvania Press Photographers Association
c/o Pittsburgh Post-Gazette
34 Boulevard of the Allies
Pittsburgh, PA 15222
www.post-gazette.com

Photo Marketing Association, International
3000 Picture Place
Jackson, MI 49201
phone: (517) 788-8100
fax: (517) 788-8371
www.pmai.org

Photographic Historical Society
350 Witting Road
Webster, NY 14580
tphs@rochester.rr.com
www.people.rit.edu/andpph/tphs.html

Photographic Society of America
3000 United Founders Boulevard, Suite 103
Oklahoma City, OK 73112
phone: (405) 843-1437
fax: (405) 843-1438
www.psa-photo.org

PhotoImaging Manufacturers and Distributors Association
109 White Oak Lane, Suite 72F
Old Bridge, NJ 08857
phone: (732) 679-3460
fax: (732) 679-2294
www.pmda.com

Press Photographers Association of Greater Los Angeles
Post Office Box 143
Palos Verdes, CA 90274
www.ppagla.org

Professional Photographers of America
229 Peachtree Street, NE, Suite 2200
Atlanta, GA 30303
(404) 522-8600
www.ppa.com

Professional Photographers of Greater Bay Area, Inc.
Post Office Box F
San Mateo, CA 94402
phone: (650) 367-1265
fax: (650) 347-3141
fredenglish@ppgba.org
www.ppgba.org

Professional School Photographers Association International
3000 Picture Place
Jackson, MI 49201
(800) 762-9287
www.pmai.org

Society for Photographic Education
2530 Superior Avenue, Suite 403
Cleveland, OH 44114
phone: (216) 622-2733
fax: (216) 622-2712
membership@spenational.org
www.spenational.org

Society of Motion Picture and Television Engineers
3 Barker Avenue, 5th Floor
White Plains, NY 10601
phone: (914) 761-1100
fax: (914) 761-3115
www.smpte.org

Society of Northern Ohio Professional Photographers
30861 Jasmine Court
North Olmsted, OH 44070
www.sonopp.com

Society of Photo-Optical Instrumentation Engineers
Post Office Box 10
Bellingham, WA 98227
phone: (360) 676-3290
fax: (360) 647-1445
customerservice@spie.org
www.spie.org

Society of Photo Technologists
11112 Spotted Road
Cheney, WA 99004
phone: (509) 624-9621
fax: (509) 624-5320
cc5@earthlink.net
www.spt.info

**Society of Photographers and
Artists Representatives**
630 9th Avenue, Suite 707
New York, NY 10036
(212) 779-7464
info@spar.org
www.spar.org

**University Photographers
Association of America**
Auburn University Photographic Services
6L Building
Auburn University, AL 36849
www.upaa.org

**White House News
Photographers Association**
7119 Ben Franklin Station
Washington, DC 20044
(202) 785-5230
www.whnpa.org

**Wisconsin News Photographers
Association**
Post Office Box 23430
Green Bay, WI 54305
www.wnpaonline.com

Outside the United States

Canadian Association of Photographers and Illustrators
55 Mill St. Case Goods
Building 74, Suite 302
Toronto, Ontario
Canada M5A 3C4
phone: (416) 462-3677
fax: (416) 462-9570
administration@capic.org
www.capic.org

International Alliance of Theatrical and Stage Employees (IATSE)
Canadian Office
22 St. Joseph Street
Toronto, Ontario
Canada M4Y 1J9
phone: (416) 362-3569
fax: (416) 362-3483
www.iatse-intl.org

International Society for Photogrammetry and Remote Sensing
University College London
Gower Street
London, England
UK WC1E 6BT
www.isprs.org

Professional Photographers of Canada
www.ppoc.ca

Royal Photographic Society
Fenton House
122 Wells Road
Bath, England
United Kingdom BA2 3AH
+44 (0)1225 325733
reception@rps.org
www.rps.org

Societe Francaise de Photographie
71 rue de Richelieu
Paris, France 75002
phone: +33 (0)142 600 598
fax: +33 (0)142 600 457
contact.sfp@free.fr
www.sfp.photographie.com

Other Organizations:

Federal Trade Commission
600 Pennsylvania Avenue, NW
Washington, DC 20580
(202) 326-2222
www.ftc.gov

Library of Congress
United States Copyright Office
Publications Section, LM-455
101 Independence Avenue, SE
Washington, DC 20540
(202) 707-5000
www.loc.gov

National Institute of Occupational Safety & Health
(513) 533-8328
cdcinfo@cdc.gov
www.cdc.gov

Small Business Administration (SBA)
Answer Desk
409 3rd Street, SW
Washington, DC 20416
(800) 827-5722
answerdesk@sba.gov

United States Department of Labor Occupational Safety and Health Administration (OSHA)
200 Constitutional Avenue, NW
Washington, DC 20210
(800) 321-6742
www.osha.gov

Appendix 4: Books & Resources

Books:

Art Law in a Nutshell

by Leonard D. DuBoff and Christy O. King
West Publishing Co. (2006)
610 Opperman Drive
Eagan, MN 55123
(800) 328-9352
www.west.thomson.com

ASMP Professional Business Practices in Photography

by American Society of Media Photographers
Allworth Press (2008)
10 East 23rd Street
New York, NY 10010
(800) 491-2808
www.allworth.com

Business and Legal Forms for Photographers

edited by Tad Crawford
Allworth Press (2009)
10 East 23rd Street
New York, NY 10010
(800) 491-2808
www.allworth.com

Deskbook of Art Law

by Leonard D. DuBoff, Christy O. King, and Michael D. Murray
Oxford University Press (ongoing updates)
198 Madison Avenue
New York, NY 10016
(866) 445-8685
www.oup.com

First Amendment and Censorship

by Leonard D. DuBoff, Christy O. King, and Michael D. Murray
Oceana Publications (2005)
75 Main Street
Dobbs Ferry, NY 10573
(914) 693-8100
www.oceanalaw.com

The Law (In Plain English)® for Crafts

by Leonard D. DuBoff
Allworth Press (2005)
10 East 23rd Street, Suite 510
New York, NY 10010
(800) 491-2808
www.allworth.com

The Law (In Plain English)® for Small Business

by Leonard D. DuBoff
Sphinx Press (2007)
10 East 23rd Street, Suite 400
New York, NY 10010
(800) 432-7444
www.sourcebooks.com

Legal Handbook for Photographers:
The Rights and Liabilities of Making Images

by Bert P. Krages
Amherst Media (2007)
175 Rano Street, Suite 200
Buffalo, NY 14207
(716) 874-4450
www.amherstmedia.com

Government Resources:

"Fire Safety Fact Sheet"
United States Department of Labor
OSHA Information
200 Constitution Avenue, NW
Washington, DC 20210
(800) 321-6742
www.osha.gov

"OSHA Handbook for Small Businesses"
United States Department of Labor
Superintendent of Documents
U.S. Government Printing Office
Washington, DC 20402
(202) 512-1800
www.osha.gov

"Tax Guide for Small Business"
Publication 334
Internal Revenue Service
U.S. Government Printing Office
Washington, DC 20401
(800) 829-3676
www.fedforms.gov

Social Security Office
www.socialsecurity.gov
See telephone book under U.S. Government for your local office.

"Learning Through the Arts: A Guide to the National Endowment for the Arts and Arts Education"
National Endowment for the Arts
1100 Pennsylvania Avenue NW
Washington, DC 20506
(202) 682-5400
www.nea.gov
Under the NEA, see also: Grants; 800-518-4726

"Small Business Insurance & Risk Management Guide"
U.S. Small Business Administration
409 3rd Street, SW
Washington, DC 20416
(800) 827-5722
www.sba.gov

Other Resources:
Photolibrary New York
23 West 18th Street, 3rd Floor
New York, NY 10011
(800) 690-6979
www.photolibrary.com

National Center for State Courts
300 Newport Avenue
Williamsburg, VA 23185
(800) 616-6164
www.ncsonline.org

Index

Books from Allworth Press

Allworth Press is an imprint of Allworth Communications, Inc. Selected titles are listed below.

Business and Legal Forms for Photographers, Fourth Edition
by Tad Crawford (8½ × 11, 208 pages, paperback, $29.95)

The Professional Photographer's Legal Handbook
by Nancy E. Wolff (6 × 9, 256 pages, paperback, $24.95)

Selling Your Photography
by Richard Weisgrau (6 × 9, 224 pages, paperback, $24.95)

ASMP Professional Business Practices in Photography, Seventh Edition
by American Society of Media Photographers (6 × 9, 480 pages, paperback, $35.00)

The Business of Studio Photography, Third Edition
by Edward R. Lilley (6 × 9, 432 pages, paperback, $27.50)

The Photographer's Guide to Marketing and Self-Promotion, Fourth Edition
by Maria Piscopo (6 × 9, 240 pages, paperback, $24.95)

Digital Stock Photography: How to Shoot and Sell
by Michael Heron (6 × 9, 288 pages, paperback, $21.95)

The Real Business of Photography
by Richard Weisgrau (6 × 9, 224 pages, paperback, $19.95)

Licensing Photography
by Richard Weisgrau and Victor S. Perlman (6 × 9, 208 pages, paperback, $19.95)

Starting Your Career as a Freelance Photographer
by Tad Crawford (6¾ × 10, 304 pages, paperback, $14.95)

How to Succeed in Commercial Photography: Insights from a Leading Consultant
by Selina Matreiya (6 × 9, 240 pages, paperback, $19.95)

The Education of a Photographer
edited by Charles H. Traub, Steven Heller, and Adam B. Bell (6 × 9, 256 pages, paperback, $19.95)

Pricing Photography: The Complete Guide to Assignment and Stock Prices, Third Edition
by Michael Heron and David MacTavish (6 × 9, 160 pages, paperback, $24.95)

How to Grow as a Photographer: Reinventing Your Career
by Tony Luna (6 × 9, 232 pages, paperback, $19.95)

Talking Photography: Viewpoints on the Art, Craft, and Business
by Frank Van Riper (6 × 9, 288 pages, paperback, $27.50)

To request a free catalog or order books by credit card, call 1-800-491-2808. To see our complete catalog on the World Wide Web, or to order online, please visit *www.allworth.com*.